The Primary Colors

Also by Alexander Theroux

The Primary Colors

THREE ESSAYS

Alexander Theroux

HENRY HOLT AND COMPANY NEW YORK

Henry Holt and Company, Inc.
Publishers since 1866
115 West 18th Street
New York, New York 10011

Henry Holt® is a registered
trademark of Henry Holt and Company, Inc.

Published in Canada by Fitzhenry & Whiteside Ltd.,
195 Allstate Parkway, Markham, Ontario L3R 4T8.

Portions of this book appeared previously in
Art & Antiques and *Harper's Magazine.*

Library of Congress Cataloging-in-Publication Data
Theroux, Alexander.
The primary colors : three essays / Alexander Theroux.
p. cm.
1. Colors—Social aspects. 2. Colors—Psychological aspects.
I. Title.
QC 495.8.T44 1994 93-29692
814′.54—dc20 CIP

ISBN 0-8050-3105-7
ISBN 0-8050-4701-8 (An Owl Book: pbk.)

Henry Holt books are available for special promotions and
premiums. For details contact: Director, Special Markets.

First published in hardcover in 1994 by
Henry Holt and Company, Inc.

First Owl Book Edition—1996

Printed in the United States of America
All first editions are printed on acid-free paper. ∞

10 9 8 7 6 5 4 3 2
10 9 8 7 6 5 4 3 2 1 (pbk.)

For my Mother and Father

"It is strange how deeply colors seem to penetrate one, like scent."

—Dorothea Brooke in George Eliot's *Middlemarch*

The Primary Colors

Blue

BLUE IS A mysterious color, hue of illness and nobility, the rarest color in nature. It is the color of ambiguous depth, of the heavens and of the abyss at once; blue is the color of the shadow side, the tint of the marvelous and the inexplicable, of desire, of knowledge, of the blue movie, of blue talk, of raw meat and rare steak, of melancholy and the unexpected (once in a blue moon, out of the blue). It is the color of anode plates, royalty at Rome, smoke, distant hills, postmarks, Georgian silver, thin milk, and hardened steel; of veins seen through skin and notices of dismissal in the American railroad business. Brimstone burns blue, and a blue candle flame is said to indicate the presence of ghosts. The blue-black sky of Vincent van Gogh's 1890 *Crows Flying over a Cornfield* seems to express the painter's doom. But, according to Grace Mirabella, editor of *Mir-*

abella, a blue cover used on a magazine always guarantees increased sales at the newsstand. "It is America's favorite color," she says.

Paradoxically, it is the only one of all the colors which can be legitimately seen as a close neighbor to, as well as essentially symbolic of, dark and light both, oddly black in the night and almost white at the horizon by day. (". . . deep blue air that shows," observes Philip Larkin, "Nothing, and nowhere, and is endless . . .") It can darken, it can obscure, it may float to and fro like a mist, evoking serenity and power. Mirroring each other, the sea takes its color from the sky. As Helen Hunt Jackson observes in "My Lighthouses,"

> *I look across the harbor's misty blue,*
> *And find and lose that magic shifting line*
> *Where sky one shade less blue meets sea . . .*

It might be said to be not so much a color as a state of the light. It is also the Void: primordial simplicity and infinite space which, being empty, can contain everything or nothing. "I saw Venice turn blue because she forgot to care," sings lovelorn Charles Aznavour.

> *No color isolates itself like blue.*
> *If the lamp's blue shadow equals the yellow*
> *Shadow of the sky, in what way is one*
> *Different from the other?*

asks painter Fairfield Porter in one of his poems, "A Painter Obsessed by Blue."

The word sings. You pout pronouncing it, form a kiss, moue slightly, blowing gracefully from the lips as if before candles on a birthday cake. (Is that why Rimbaud insists the color of the vowel *o* is blue?) In the unambiguously grammatical, culturally neutral, core-vocabulary-informed, artificially constructed language Lojban, the word *blanu,* "blue," incorporates all of English *blue,* Chinese *lan,* the *la* of Hindi *nila,* the *azu* of Spanish *azul,* the *olu* of Russian *goluboi,* and of course outside the official six Lojban base languages, the word also incorporates all of German *blau,* along with the obvious resonations of French *bleu.*

Linguist Morris Swadesh's famous list of the basic one hundred words ("I, we, you, this, that, one, two, not, man, woman, dog, tree, hand, eye, neck, water, sun, stone, big, small, good," etcetera) includes the color terms "white, black, red, yellow, green," but not "blue." There are no color words in primitive Indo-European speech, in fact. Many languages lack a distinctive word for blue. Is it that people the world over instinctively feel it to be less than a primary color?

It was probably first marveled over in the whelks of Phoenicia, and in Tyrian mollusks. There is no blue in the caves of Lascaux: paleolithic artists used iron oxide pigments, mostly browns and reds, on

those perfect calcite walls. Later on, Egyptian blue (also called blue frit) was made by heating sand, soda, lime, and copper sulfide to make a blue glass, which was then crushed to form a powder, a pigment richest in color in its coarsest state. The more finely it was ground, the whiter the blue became. The Greeks called the color *kyanos* (hence "cyan") while the Romans would call it *caeruleus,* a name still used today for the artificial blue-green made from cobalt stannate. Blue enamel is used by Hephaestus on Achilles' great shield in the *Iliad* (Book XVIII), and in ancient Greece marbles were frequently painted with blue festoons—even the ancient Cycladic figures were painted. The metopes of many temples in ancient Greece had blue backgrounds, so as to appear deep in contrast to the triglyphs. There were authentic blue horses in the archaic work on the Acropolis and in Etruscan tomb-painting and bright blue coloring of hair.

In Greece and Rome, Alberto Savinio writes in *Speaking to Clio,* "Deep blue beards were very common in painted sculpture. All statues, before the spiritualist concept that 'art expresses the inexpressible,' were painted. The blue beard was probably the 'ideal' of black beards, that is, hair with deep blue reflections." Blue was apparently used very little anywhere in the murals of Pompeii, and not at all in the main parts of the pictures. Occasionally it puts in an appearance as a pale color of the atmosphere or of

buildings situated in the distance, but it is always in a subordinate position. A brilliant blue pigment of a turquoise tone, now known logically as Maya blue, was much used, however, by the Maya in painting murals. It was made of beidellite, a clay mineral.

In the Old Testament, the robe of an *ephod,* the elaborate trappings of the Hebrew priest, was to be made, along with its designs of pomegranates, entirely of blue (Exodus 28:5–35). (Any color mentioned in the Bible, except blue, which was used on cotton and linen, always referred to a wool fabric.) There is an injunction among the faithful, I believe, to wear prayer shawls with blue tassels, dyed blue by the ink of a now extinct nautiloid. (Now "tzitzis," as they are called, remain undyed.) Ivory, teeth, and all sorts of tusks often have a blue tinge. The tusks of the prehistoric woolly mammoth—the so-called "teeth of the Tien-shu rat" in China and Siberia, with each measuring up to sixteen feet, weighing up to 275 pounds, and spiraling into an almost complete circle—were bluish ivory. The mosaic masks of the Incas were of course blue, and there were certainly blue threads used in the ancient embroideries of the Paracas necropolis in Peru, circa 800 B.C., brilliant blues, and blue cloths made from macaw feathers. Blue threads also appear in the ancient linen garments found both in the caves of the Dead Sea Scrolls and at Dura-Europus on the Euphrates. Then there is the Blue Mosque in Tabriz, which

owes its name to the brilliant ultramarine faience that, fully covering the masonry surface, seems to take on dimension. (Wittgenstein says colors are forms of objects.)

It is the symbol of baby boys in America, mourning in Borneo, tribulation to the American Indian, and the direction South in Tibet. Blue indicates mercy in the Kabbalah, and carbon monoxide in gas canisters. Chinese emperors wore blue to worship the sky. To Egyptians it represented virtue, faith, and truth. The color was worn by slaves in Gaul. It was the color of the sixth level of the Temple of Nebuchadnezzar II, devoted to the planet Mercury. In Jerusalem a blue hand painted on a door gives protection. A blue spot placed behind a groom's ear in Morocco thwarts the power of evil, and in East Africa blue beads represent fertility. Sheep in the British Isles are haunch-marked with bright blue. Russian trading beads in the Yukon were made of blue glass. The gem hyacinth gives second sight. It is a superstition in Syria to wind blue string around the necks of animals to protect them from death. And Daniel Patrick Moynihan and Nathan Glazer in their book, *Beyond the Melting Pot,* mention the fact that the symbolic color of St. Patrick's Day in Ireland is not green, but blue. I once got engaged to a girl in London one Christmas Eve in a blue snowfall, recalling Wallace Stevens'

Snow glistens in its instant in the air,
Instant of millefiori bluely magnified

Chows have blue tongues. Potato spray in Ireland is blue. A blue spot can be found on the lower back of all newborn Asian babies (and some Mediterranean ones, too) which disappears after a week or so. There is "blue gold," stated to contain 75 percent gold and 25 percent iron. Massachusetts means "the blue mountains." And it has always been the favorite color in popular songs. Ozone is a faintly blue allotropic form of oxygen and may be condensed to a deep blue magnetic liquid. In heraldry, blue is symbolized by horizontal lines. The blueprint, invented by Sir John Herschel in 1842, was widely used (pre-Xerox) because it was the simplest means of "photographic" reproduction, requiring only water for fixation—it's a ferroprussic coating of the paper, and when you're done, the unwanted residue in the whites simply washes off. Ornithologist Roger Tory Peterson's favorite bird is the blue jay, which was also the subject of his first bird painting. In the Munchkin County in L. Frank Baum's world of Oz, blue is the dominant color: the grass, the trees, the houses all are blue, and the men wear blue clothes. It is the solid endearing color of the locomotive in Watty Piper's *The Little Engine That Could.* The sun is even blue on Saturdays in Richard Brautigan's *In*

Watermelon Sugar. And I'm told no household in the state of Texas is authentic unless a painting of bluebonnets hangs on the wall.

So many hues and variations of the color can be found. There is Dutch Boy azure. Pacific Pool Supplies blue. Eskimo Pie blue. The dusty pastel of cue-tip chalk. The cobalt-blue glass of the Gedächtniskirche in Berlin. There is a Sears color called Alice Blue Gown blue, named for the favorite color of Teddy Roosevelt's gorgeous daughter. (Later, "Eleanor Blue" would become a tribute to Eleanor Roosevelt's favorite color.) Paul Bowles describes the sea off the coast of Tangier as "peacock feather blue." The phrase "True as Coventry blue" refers to a blue cloth and blue thread, both made at Coventry, a city noted for its permanent dye. The chipped seventeenth-century gravestones in the venerable Old Granary Burying Ground in Boston, especially after a soaking rain, show tints of an unearthly blue shale. Tiffany blue is the inimitable blue of robin's eggs. Sloe blue has a touch of black. There is the friable blue mold of cheese. And that iridescent blue of the upper side of those butterflies known as "hairstreaks" (genus *Thecla*) and "Bluespots" (genus *Eumaeus*) has a silver in it like that on old movie screens. There is an elegant French-blue broadcloth shirt which I've seen only in T. M. Lewin & Sons in London. And a new watch by Timex with a night feature, the "Indiglo," lights up blue.

What about the deep lagoon-blue of Ohio Blue-Tip matches? Windex blue? The bluestem grass of Kansas? The cast of blue ash on a Havana No. 3 Corona or a Raphael Gonzales Lonsdale? Hockney's *Aqua Velva Mediterranean*? The unclouded April blue eyes of Simonetta Vespucci, Botticelli's immemorial model? Blue is everywhere. A Cape Cod sky and sea in August make one of the richest blues on earth. The bharal, or Himalayan blue sheep, a living theological quiddity that is curiously less sheep than goat, is slate blue with gold eyes. There are Gauloise *bleu,* IBM's logo, and the dark and light blue dishes of London's elegant United University Club (1822). The Blue Bathroom in Salisbury, Connecticut, New England's biggest cave, is uncanny. And what about those new fad toothbrushes which feature a blue dye on the bristles (probably carcinogenic!) which, when the blueness ebbs, indicates that it is time to buy a new one? On one I bought, the blue was gone in three weeks. Imagine an IRS expenditure, $40 for toothbrushes, followed by their auditing query, "Paintbrushes?" No, *tooth*brushes!

A blue called turnsole (sometimes called solsequiem) was commonly used by monks for putting gorgeous pen flourishes around letters (usually red) in illuminating books. One of my favorite bistros in Paris on the rue Didot in Montparnasse, le restaurant Bleu, a palette of blues outside and in, has an azure facade, and light blue walls within to match

the berets of so many of its grateful patrons. There is surely a blue to night, to shade, to shadows. To clouds. To trails in the windstream. To the morose blue faces of our vast and ancient mountains, with icicles hanging from their noses. To magic and mist and moonlight ("a nocturnal village, its roofs still blue with moonlight," wrote Proust). So many blues. Vegetable blues. Copper blues. Blue bice, or the color of ashes. Presbyterian blue. Urban horizon blue, which is surely a distinct color. And the color is delicate.

Blue in almost any shade is also a fugitive paint. (If you've ever owned a blue car, or blue jeans, you know what fugitive means.) It fades, maybe quicker than any other color. The destruction of the blue pigment on the lower part of the garment of Raphael's Madonna, the *Belle jardinière,* is a good example. And it's long been noted that no other part of the palette is so susceptible to distortion by the effects of age as the blues and violets.

Blue is a popular color in Japan, but its particular beauty to the Japanese is more subtle than exciting. (Curiously, the Japanese have only recently adopted a specific word for blue, a fact by which we may conclude that, predominantly myopic as a people, as opposed to hypermetropic, they have found more meaning, more fascination, at the red end of the spectrum.) Among the many colors of the morning glory—to Japan what the tulip is to Holland—

perhaps the most closely associated with this flower is the color *ai,* or indigo blue. As a dye, *ai* was made from the *Polygonum tinctorum,* a plant. The dye was available as early as the ninth century. In printmaking the Japanese artists favored *hanada-ino,* a light or dark blue tinged with pink. As a durable, stable color, it is also used for the work clothing of farmers and fishermen, for door curtains, usually heavy ones, kimonos, and the aprons of shopkeepers. And in Japanese theater it is also the color of villains, supernatural creatures, ghosts, and fiends.

Soot collected from the smoke of burning oil is prepared for Japanese ink-painting—*suiboko*—by combining it with a glue extracted from fish bones and compressing it into a fairly hard cake. It gives a lovely blue tone. The bluer the tone, the better the ink quality.

It is also a favorite color of the Amish. They often have blue gates. A blue gate, in fact, was originally the chief distinguishing mark among them of the bishop's house, but legend has it that, more than anything else, it stood as the advertising sign for an Amish daughter being ready to marry. (Also, look at an Amish wash line and observe the numerous blue garments.) The blue cotton farmer's shirt in Thailand, the *maw hawm,* is also traditional. Fishermen in the old town of Leigh-on-Sea in England, who sit along the waterfront of black-hulled bawleys with their holds filled with shrimp, whitebait, and sprats,

invariably wear blue jerseys. It is the tint and hue in clothes of sobriety, the equivalent on the color wheel of moderation, temperance, custody of the eyes. Doesn't it in its force also lend authority to umpires? Police? Guards in general? But for all that, it is a color no less sexy or eye-catchingly chic. As queenly Norma Desmond proclaims in *Sunset Boulevard,* "There's nothing like blue flannel for a man."

The name Manila, capital of the Philippines, may come from the Sanskrit *nila,* meaning indigo. (The Manila Bay area was famous for this dye.) It was extracted from certain plants native to India (whence its name) known to modern botany as *indigoferae,* the bearers of indigo. (What did the cow do when he ate blue grass? Mood indigo.) Indigo blue, incidentally, was the preferred color for shirts in nineteenth-century America. An indigo tub was kept in most kitchens, and the dye was commonly made, adding copperas to darken it, from creeping jenny and other flowers. Vat dye has the highest degree of fastness. It got its name from the old-time method of steeping indigo plants in vats to produce the classic blue dye used in denim. Denim, incidentally, a fabric imported from Nîmes (thus its name) in France, was first worn in America by peddlers, grubstakers, and hardscrabblers during the early California gold rush days—it was originally tenting material—and then given tough little rivets by Levi Strauss of San Francisco to secure the pockets.

John Hancock, the great patriot, loved coats of crimson velvet when set off by vests—his favorite—of sky-blue moiré antique. As to clothes, Mary Todd Lincoln, a serious shopaholic and glove fanatic—she once bought eighty-four pairs of gloves in one month—wore to the Inaugural Ball in 1861 a magnificent blue gown with a blue feather in her hair. And Walter Winchell, radio muckraker and New York *Daily Mirror* columnist of the thirties and forties (he always praised the Broadway season's first shows, asking, "Who am I to stone the first cast?"), almost invariably wore a blue suit, a blue shirt, a blue tie—and, habitually, a snap-brim gray felt hat. Apparently, he had never heard of or chose to ignore the famous caveat of Edith Head, chief costume designer at Paramount: "Color in fashion should not be repeated more than twice."

There are Blue Arabs. Indigo of course does not grow in the desert, but the Tuareg, or Targui, who roam various parts of the Sahara and of Sabah, a region in southern Libya, have traditionally bought cheap cotton from the British which did not hold dye fast, and when they perspired it often bled. The French, hoping in their colonialist way to enlighten the Tuareg, tried to sell them a "good French cotton" that did hold the dye, but in vain, however, for the Tuareg preferred the quality of the English stuff, the bleeding indigo of which left a permanent stain on their bodies nevertheless. Incidentally, among the

Tuareg it is not the women who wear veils, but rather the men, *les hommes bleues,* whose faces—and bodies—bear the traces of the dye. Some are said even to smear their bodies with indigo as a protection against sickness. Having done so for hundreds of years, their systems are so saturated with the coloring matter that their skin and hair have assumed a perpetual blue tint. Their children often are even born with an indelible blue complexion. Curiously, at times even rain in the Arabian desert is, according to Charles Doughty in his classic *Arabia Deserta,* veiled in a bluish mist. As to blue skin, in Alexei Tolstoy's novel *Aelita,* the heroine of the title is a delicate Martian girl whose skin is blue. Africa has also been called Great Blueland, because Africans in their deep blackness were often perceived to be colored blue.

Incidentally, the *bismallah,* a calligraphic formula that embodies the Arabic for "In the name of Allah, the merciful, the compassionate," is traditionally written within a mosaic or tiled square, usually blue in color, and often records the ninety-nine names of Allah—a good place to mention, in passing, the blue-tiled mosques of legendary Isfahan, blue as the poppies in Shiraz and unrivaled in the whole of Asia, the royal Masjed-i-Shah and the smaller, more exquisite mosque of Sheikh Lutfullah opposite, on the eastern side of the Maidan, the dome of which, within and without, is encrusted with glazed tiles,

blue, cool, and mysterious—within especially when the filtered light penetrates the intricate arabesques of the narrow windows. Their stateliness and beauty are beyond words.

A good fast blue vegetable dye for a pound of wool, cotton, silk, sisal, or jute, previously mordanted with alum, can be made with one-half ounce of indigo extract, four tablespoons of tartaric acid, and half a cup of Glauber's salts. A safe and simple method of dissolving indigo powder is with fermented human urine (8 tablespoons to 1 pint), which, although it takes two weeks, leaves no more offensive a smell than many other vegetable dye odors. Indians commonly followed this method, which is probably best for children, untrained in handling dangerous chemicals. The seed of the avocado long has been known to have yielded a bluish permanent dye. Finally, the Pueblo Indians for centuries out of number have dyed their baskets blue, twig by twig, by using navy beans and sunflower seeds (*Helianthus petiolaris*) smoked over black wool. So much more natural a dye than the many chemicals and toxicants of industry. How many nineteenth-century French gunsmiths, say, came down with tuberculosis from handling bluing salts?

A popular deep blue color in the Middle Ages was called "woad," an indigo hue that comes from a shrubby herb called in Latin *glastum* or *isatis*, which was cultivated in England from very early times and

whose green leaves contain a blue dye. The aboriginal Celts whom the Romans met on the shores of what is now England painted themselves with its juices. (Caesar was duly impressed by the blue war paint of the Britannians, which gave them a terrifying appearance. *"Omnes vero se Britanni vitro inficiunt,"* he wrote, *"quod caeruleum efficit colorem, atque hoc horribiliores sunt in pugna aspectu,"* and Tacitus saw "ghost armies" of painted Harians, wearing a grease of the same driving color.) Woad was a common clothing dye, used for coloring the garments of priests and royalty. The indigo blues used in the Book of Kells were taken from the woad plant, which artists sought out for such purposes. The woad industry flourished in Europe for centuries, but the countryside paid a terrible price in both the demand the plant made on the soil—for it exhausts the land it grows on—and in the poisonous water and air caused by the countless woad vats of the dye-making industry, a major source, among other things, of potash, which in the Middle Ages was crucial in the making of lye.

Blue water is deep, dense, heavy (it gets denser as it cools)—water density is measured by temperature and salt—while green water tends to be light, tropical, nutrient-rich, and shallow, warming the nearby land equally by circulation and gyre. Wherever the land constricts the sea, thinness of color is the result. Water is always mysterious. "I used to wonder why

the sea was blue at a distance and green close up and colorless for that matter in your hands," writes Sr. Miriam Pollard, O.C.S.O., in *The Listening God*. "A lot of life is like that. A lot of life is just a matter of learning to like blue."

And remember in César Vallejo's poem "Deshojacion Sagrada" ("Holy Leaffall") from *The Black Heralds* (1918) how, in its infinitude, blueness, making of the blue sky a blue sea, shows them virtually interchangeable?

> *Luna! Alocado corazón celeste*
> *por qué bogas así, dentro la copa*
> *llena de vino azul, hacia el oeste,*
> *cual derrotada y dolorida popa?*

> (Moon: reckless heart in heaven
> Why do you row toward the west
> in that cup filled with blue wine
> whose hull is defeated and sad?)
> tr. James Wright

Alaskan "blue days," with their clear luminous skies, are splendid. A painter's blue kind of twilight rises from the snowscapes in Alaska at midday that seems to fill the heart. Meadows below the tundra in Alaska are also blue with lupine in the spring. Such bold examples of blue (*qerrsuryak* or *qesurliq* in Yupik)! Moreover, there are rare "blue" bears in the

Glacier Bay area of Alaska, near Hoonah and Skagway. And of course in the University of Alaska museum in Fairbanks there is Blue Babe, a mummified steppe bison that lived 40,000 years ago during the Pleistocene epoch.

Why is glacier-ice blue? The glaciers I saw in Portage, Alaska, are tinted by the compression of ice, for the thickness and internal alignment of the large solid crystals with little space between them causes great refraction of light. White light striking the crystals doesn't escape but is scattered into a rainbow of colors. Colors like red and yellow with their low energy levels are absorbed by thick ice, whereas blue light has enough energy to escape the ice and remain visible. Ice with lots of air bubbles reflects *white* light. Many glacial lakes also have a deep blue color even on a cloudy day, because glacial silt carried off the glacier floats in the water and reflects blue light. There are even iceworms—annelids—feeding on algae and avoiding the sun, that live in glacier ice and whose survival depends on the constant thirty-two-degree environment offered by the permanent snow on top of glaciers. Remember Robert Service's "Ballad of the Leeworm Cocktail"?

> *Their bellies were a bilious blue,*
> *Their eyes a bulbous red,*
> *Their backs were grey,*
> *And gross were they, and hideous of head.*

Blue-shirt (*Blauserk* in Inuktitat, the Inuit language), or Mykla Jokull, now known as Gunnbjorn's Peak (12,500 feet)—the great metaphorical centerpiece in William T. Vollmann's saga-like novel *The Ice-Shirt*—is the great glacier in Greenland used as a landmark by Erik the Red in sailing west from Snaefellsness.

No animal has blue fur—not really, it is always smoky at best—or, oddly, for that matter, green, even though as a coloration there would be considerable camouflage for pasture animals in the latter. David E. H. Jones in *The Inventions of Daedalus,* however—who suggests along with other biologists that the "skin-shedding of creatures like snakes is a secondary excretion mechanism," something, he notes, we as humans share with our detachable surface features, like nails and hair—proposes that animals could actually be dyed "by dosing them with compounds of unhealthy but colorful metals: copper (blue), nickel (green), cobalt (pink)," and so on, which in coloring would camouflage them. Remember the well-known scientific verification of the arsenic poisoning of Napoleon by the detection of metal samples in his hair? Animals, thus colored, would thereafter be "capable of surviving in regions now barred to them by predators," Jones points out, and assures us with his "ingenious" but rather Rappaccini-like enthusiasm that not only could we have "genuine

permanently dyed-in-the-wool fabrics," but, "even better, by altering the dose metal during the growth of the fibers, multicolored tabby sheep could be produced." Finally, at last, we can have real blue sheep!

Colette, the French novelist, believed there are connoisseurs of blue—she would only write on blue stationery—and was very fussy about what she would accept as pure in that color. "The Creator of all things showed a certain closefistedness when distributing our share of blue flowers," she once wrote. "Myosotis, the forget-me-not? It does not scruple, the more it flowers, to verge on pink. The iris? Pooh! Its blue never rises above a very pretty mauve." Also color-conscious, Alexandre Dumas *père* always composed his novels on blue paper (he wrote poetry on yellow paper, nonfiction on rose); to do otherwise, he said, was "unspeakable."

Blue is the color of the sky, the traditional symbol of the male. (Man Ray emphasized the phallic connotations of bread by painting it blue.) The Wolof males of Dakar, but not the women, wear long blue robes. Painting animals each spring, an important ritual in Iraq, is done to fend off hostile spirits and to appease the gods, and color schemes are dictated by tradition. Iranian mothers sew blue beads on all their children's clothing, to ward off evil spirits that might endanger them, and it is common practice for the weavers of Shiraz, Bakhtiari, Baluchistan, and

Bukara to sew a string of blue beads along the edge of their rugs, lest they be cursed when someone shows envious admiration of their work. The genitals of bulls, to protect their fertility and reproductive prowess, are always painted blue. And Navajo and Zuni ringmakers say blue is the masculine color of turquoise, green the color for women.

But all symbols adhere to the principle of antithetical dualism. The ambivalent symbolism of the color blue may derive from the fact that it is also the color of water, which has always stood for the archetypal image of woman. In the Christian tradition, blue is the color of the Virgin. The sign of the Virgin for astrologers is below the horizon—it belongs to the nocturnal blue world. The ancient Egyptian women, than whom no one was more feminine, wore blue-black lipstick, and even outlined the veins on their breasts in blue, coating the nipples with gold. For that matter, Rita Hayworth wore a lipstick in the film *Down to Earth* called "blue red." And old RKO actor Ivan Lebedeff, who boasted he had royal blood, a vaunt in Hollywood limited to not a few, said that all Russian aristocrats had blue gums, a fact he rather unfortunately often felt put upon to demonstrate at parties.

For the Aztecs *Xiuhtecuhli* ("the prince of the turquoise") is the name of both the solar (male) color and of the jade skirt worn by the goddess of eternal renewal. The practice of painting blue the

houses of virgins about to be married still survives in Polish folk custom, and in ancient Breton folklore naked women painted blue took part in religious rituals. The antithetical male/female symbolism of blue suggested in iconography is perhaps reflected in the fact that this color is also associated with symbolic castration, and hence with the immortal androgyne.

In Tibetan Buddhism the concepts of awareness and wisdom, called *dharma-dhātu*—attributes of the immortal androgyne—are of a blinding blue color. Speaking of Tibet, typical of that country are its colored pavilions, with milk-blue roofs, clinging to the mountainsides, sometimes a mile high. And the blue fissures of those mountains that pass into Lhasa, walls of azure ice thawing softly above the holy city, while they remain the eternal dreams of Kew, continue unalterably as the facts of Katmandu. In Tibet, by the way, sticking out one's tongue upon meeting someone is a traditional gesture of goodwill and respect, intended to show that one is not a Bon practitioner, for practitioners of Bon, the shamanistic religion that preceded Buddhism, were said in legend to have blue tongues.

Again, in the Chinese esoteric tradition, blue is associated with immortality. The Blue City in Jewish tradition is the city of the immortals. No wonder blue is the color associated with the *hieros gamos,* the sacred marriage between Earth and Sky. "To most

persons, as to myself," wrote Albert Lavignac, professor at the Paris Conservatory, in *Music and Musicians,* "the ethereal, suave, transparent timbre of the flute, with its placidity and its poetic charm, produces an auditive sensation analogous to the visual impression of the color blue, a fine blue, pure and luminous as the azure of the sky. The strings of the orchestra represent, as a class, the colors of the distance." Yet there is oddly enough not a single mention of the color blue in the many hundreds of allusions to the sky in the Rig Veda or the Greek epics. In the Bible, although there are over four hundred references to the sky or heaven, the color blue is not once named. You want paradox? Blue is usually thought of as a "cool" color, but the very hottest stars are bluish white, while it is the comparatively cool stars that shine the "warm" color red: the hotter a hot glowing object is, the more light it radiates in the short blue, as well as the longer yellow and red, wavelengths.

Its odd strength but soft moody ethereality is yet only another enigma in the color. Time and time again, various descriptions of the musical impression left by *Lohengrin* have pointed to the personal authenticity of the prelude and its magical use of divided violins (four tutti parts, four solo). Wagner's own description of these sounds, as it was later with Nietzsche, was "ethereal blue," while Thomas Mann would speak of them as "silvery blue."

Blue is one of a dolphin's color transformations in death. Truffles turn a bluish hue during the onset of decay. And isn't blue monkshood, or aconite, poisonous? It is also the color of strangled victims. "I saw the baby lying on the scale. It was cyanotic," said fanatical Doctor Schein in the movie *Skullbones.* (Cyanosis is the bluish coloration of the skin caused by a lack of oxygen.) In the musical *My Fair Lady,* Eliza Doolittle speaks vividly of an aunt being "fairly blue with diphtheria." Death in Shelley's *Queen Mab* has "lips of lurid blue." Old people's eyes in their puffiness often appear pouchy blue. Novelist Sinclair Lewis had ice-blue eyes, which were astigmatic. And perfectly white cats with blue eyes are always, or almost always, deaf. It's interesting: the color you see—say in bluebells or blue irises— is the color the object is rejecting. Leaves are green the better to specialize in radiation toward the red (heat-energy) end of the spectrum. They are energy gobblers. Dark blue cotton is the dress of ritual mourning in Egypt. And mourners who ululate their sorrow also smear their faces with indigo and rub handfuls of ashes from the banked fires into their loosened black tresses.

Gerard Manley Hopkins wrote, "And you were a liar, O blue melancholy," the same blues, no doubt, of the Mississippi jazzmen. A "blue note" in music, W. C. Handy's interpolated minor third, is in fact an *off* note—or as old black musicians say, a "worried"

note—that is just a little bit flat, most often a flatted third. "I tell you, Mr. [Samuel] Bowles," wrote heartbroken Emily Dickinson to the one man she loved probably more than any other, after he sailed for Europe, "it is a Suffering to have a sea—no care how Blue—between your Soul, and you." And Henry Thoreau was so taken with Bronson Alcott's azure eyes that he called him a "sky-blue man." "Eyes of a blue dog" is the weird mantra, mysteriously unattainable, in an epistemologically bizarre story, where dream and reality never conjoin, found in García Márquez' *Innocent Erendira and Other Stories.* Hindus do not admire the blue eyes of Europeans, which they find something of a deformity and call "cat's eyes." But what human eyes have ever been as blue as a blue-point Siamese cat's?

Apparently Tennyson remembered from Darwin how blue-eyed cats are generally deaf and utilized this information to make Gawain cry,

> *I will be deafer than the blue-eyed cat*
> *And thrice as blind as any noon-day owl*
> *To holy virgins and their ecstasies*
> *Henceforward . . .*

Hitler had blue eyes. The Examining Angels in the Koran have blue eyes as the most repulsive of all their features. And Arabs, in fact, often tend to fear blue eyes—and red hair, incidentally—as evil signs.

In the novel *Dune* by Frank Herbert, the characteristic effect of a diet high in mélange, caused by a severely addictive spice, is the weird "Eyes of Ibad," a condition in which the whites and pupils of the eyes turn a deep blue. Novelist Patrick White in his memoir *Flaws in the Glass* described his father's blue eyes in a photograph of 1911 as "giving him that blind look." And Alfred, Lord Tennyson, who was very shortsighted, wore blue spectacles, when not wearing a monocle. No, blue can be a paradox. Hideous manticores, which have triple rows of teeth, also have sweet blue eyes. And to me it is one of the creepiest aspects of Dr. Seuss' cold-hearted, Christmas-hating Grinch. Jack Benny once held a radio contest to see who could best describe the blueness of his eyes. The winning entry chosen was "As blue as the thumb of an arctic hitchhiker." And Julia Ward Howe in her *Reminiscences* wrote, "I remember well the sad expression of Mr. Lincoln's deep blue eyes, the only feature of his face which could be called other than plain."

"I loathe blue," said Edith Head in her autobiography, *The Dress Doctor*, who was also well-known for her fashion pronouncement that color is the greatest accessory. She gave no reason in particular, but was it because the color can dominate so? Nietzsche held the rather quaintly paradoxical theory that blue and green "dehumanize nature more than any color." He offered this, ostensibly, to ex-

plain why a certain school of fifth-century Greek painters avoided using the color blue in their work—the four-color painter Polygnotus used only white, black, yellow, and red—but was the German philosopher secretly inveighing against God's earth and sky? In his poem "Fragmentary Blue," Robert Frost does, in point of fact, find the vast relentlessness of blue skies theologically intimidating. Did Nietzsche have it in for the color blue? What could he have possibly been thinking when he noted "in *Lohengrin* there is much blue music," that the effect of such music can be compared to "the influence of opiates and narcotics"? Could he have known of mescaline? That it stimulates an unusual sensitivity to the color blue? That hallucinations on the drug are usually that color?

Oh, there are many negative things about blue. In the psychology of colors, blue is commonly judged to be "disturbing." Never paint a bedroom blue if you want guests to stay. (The opposite opinion is also advanced.) In a poem by the German baroque lyric writer Philipp von Zesen (1619–89) we find the expression "death-blue" room. It is in the blue chamber that Bluebeard's wife, Fatima, finds herself face to face with the circumstances of her own death. The fairy tale itself was first known in France as a *conte bleu* and appeared between the covers of the Bibliothèque bleue, those primitive paperbacks that were usually read aloud at *veillées* in country villages. How

many "blue rooms" there are! At Windsor, in the Newport mansions, in the Hotel Roosevelt in New Orleans, in the White House, etcetera. Pilots refer to the lavatory in a commercial airliner as "the blue room." The Smithsonian's Blue Room, actually a sort of inner-sanctum lockup vault for rare gems and not open to the public, is painted government-issue blue and carpeted, I might add, in an equally drab hue. And when living in Paris in 1931, Djuna Barnes' blue attic room at No. 9 rue St. Romain was the site of many of her eerie photographs.

Was Marcel Proust, sequestered in his cork-lined bedchamber with its twelve-foot ceiling, sealed windows (two), and felt-lined shutters, asking by way of color for solitude? An exact recreation of that room at the Musée Carnavalet at 32 rue de Sévigné in Paris shows not only that his bedspread was a policeman-blue, a dark satiny hue, with ruffles at the bottom, but that the color informed the scheme of the entire chamber. "The most striking thing in the room, apart from the cork, was the color blue," wrote his housekeeper Céleste Albaret in her memoir of 1973, "the blue of the curtains, to be precise, which reflected the big chandelier that hung from the ceiling—a sort of bowl ending in a point, with lots of lights and several switches, which was never lighted except for visitors or when I tidied the room in M. Proust's absence. There was a thick white marble mantelpiece with two blue-globe candelabra

and a matching bronze clock in between. The candelabra were never used either. The only light came from the small long-stemmed bedside lamp—like a desk lamp—which lighted up his papers while leaving his face in shadow."

A man wearing a blue hood in Netherlandish paintings symbolized a cuckold. Blacks, according to H. L. Mencken, were often referred to in the nineteenth century by those of German descent as *"die Blaue."* French forensic doctors refer to hanging victims with purplish congested faces as *pendus bleus.* The monster in Mary Shelley's *Frankenstein* was bluish in color. (From AC current perhaps? Those metal connections on the sides of his head are inlets, for *electricity*!) Ebenezer Scrooge is described as having blue lips. Didn't Edward G. Robinson, boxer Sonny Liston, anti-Arab racist Meir Kahane, and Charles Foster Kane have the same? (*Citizen Kane* is a black-and-white movie, but you can tell.) Wearing navy blue, or any dark color, attracts mosquitoes terribly. There are no blue tulips; a standing reward of millions of dollars has been offered for one to be bred. The chief gardener in Paris, however, has bred a blue rose that bears the name of Antoine de Saint-Exupéry, author of *The Little Prince.* And yet, ironically, when promising show blooms are injured by high winds, stormy weather, or blazing sun, roses are said to fade or—horticulturally speaking—to "blue." Strangely, blue is the only color we can *feel,*

with blues in the night connoting sadness, isolation, even bruises. "A leaf drops and I'm blue," says heiress Barbara Hutton in *Unanswered Prayers*. No, Rosemary Clooney is right when she sings, "You can't lose the blues with colors."

But are not tears blue? I'm quite sure they should be, if they aren't. I have always thought that was why tears were so heartbreaking. Edna St. Vincent Millay did not agree, in spite of the fact that, of all the poetic lines about tears ever penned, she wrote the most beautiful:

Shall I despise you that your colorless tears
made rainbows in your lashes, and you forgot to weep?

On the color wheel, blue is closest to white. The two colors are often wed. Automobile magnate Henry Ford believed machine blue and eggshell white, the colors of his fantasy, were beneficial for maintaining "order and morale," a fixation that he never relinquished: five thousand men were engaged continuously in keeping the vast Ford plant in Detroit spic-and-span, and every month they used eleven thousand gallons of both colors in painting the facilities. (They endure as the company colors.) Blue is of course the worst color for copying, seen as if it isn't there. Architects use non-repro blue pencils, the lines of which won't show up on copies. As to "blue Monday," the Monday before Lent was often spent in dissipation, and it is said that dissipation

gives everything a blue tinge. Hence, "blue" means tipsy. There is the blue, lead-laden air of Cairo and other polluted cities. One found in parts of bombed-out London during World War II tiny purgatory-blue flames, rather like crocuses, fluttering alive in banks of earth and rubble because of burst gas mains. And what about the dreadful disease called Blue Lung? Hustler Minnesota Fats supposedly got it from years of inhaling pool chalk. Regan, the twelve-year-old girl who was diabolically possessed in the creepily dark exploitation film *The Exorcist,* wore blue pajamas—and was covered with a blue blanket. Walter Pater, aesthete, on Swiss lakes: "Horrid pots of blue paint." Then there is blue color-blindness—tritanopia. The color blue as a tint in eyeglasses, by the way, is the worst for humans, letting in dangerous ultraviolet rays. (Gray is best.)

Nostradamus prophesied that the anti-Christ would wear a blue turban, although in Sikhism that very same symbol signifies a mind as broad as the sky, with no place for prejudice. The Hope diamond, so rare, so lovely, carries in the matchless blue brilliance of its facets a mysterious curse. Ever hear of blue flag? This beautiful iris (*Iris versicolor*), with its leaves, underground rhizome, and other fleshy portions, is poisonous. And then of course Picasso's Blue Period (1901–1904) produced his most lugubrious pictures. Living in Paris in dire poverty, he portrayed beggars, café habitués, and

poor working people sunk in lethargy, melancholy, and despair, using a predominantly blue palette to convey the hunger and cold his subjects felt. (Could this explain why Dorothy Parker, in the hospital, put gay blue ribbons on her wrists, after she had tried to slash them, and fluttered them for her friends?) C. G. Jung, incidentally, interpreted the Blue Period of Picasso's as representing *nekyia,* a mythic journey into hell. The artist "dies," observes Jung, "and rides on a horse into the Beyond, into the kingdom of the dead. There reigns the blue of the night, of moonlight and of water, the Duat blue of the Egyptian underworld." And of course it was the sacrificial color of the Mayans. Mayan priests were painted blue when the victims' hearts, still beating, were cut out.

It is thought that sharks don't like blue, and the slave traders of past centuries believed that no shark would attack a Negro. As sharks first mangle parts of the body which are not covered, even today West Indians dye the light skin of their palms and soles a darker color before they go fishing in shark-infested waters. (Is that why the Jumblies, who went to sea in a Sieve, have blue hands?) One of the deadliest creatures in the sea is the blue-ringed octopus of the Pacific Ocean, a cephalopod that can reach sizes of fourteen feet. Its venom, injected through its horny beak, is so potent that a bite can kill a man in two hours.

Was it for the color of washwater that Nicholson Baker in his novel *The Fermata,* discussing ultra-centrifuges, which resemble clothes washers, wrote that "blue should be a standard color for washing machines but perplexingly is not"?

Birds see colors, although not as humans perceive them. A bird is able to see reds, greens, and yellows very sharply—bees, incidentally, see in yellow and blue—but it has an imperfect perception of blues. An oil tincture in their retinas makes them see, as it were, through yellow spectacles. Sight at that end of the spectrum, curtailed by the yellow bias, is altered. This can be demonstrated rather easily in a chicken house. Put a bluish piece of paper over a flashlight and shine it on the ground, scatter some grain on the floor, and then watch the birds gobble the grain enthusiastically just up to the edge of the blue area, but not within it. There they can't see the grain. Filtered color! Lights through lenses! Whole volumes could be written on the subject. Mary Pickford, "America's Sweetheart," played many love scenes in front of rolling cameras, but she insisted they never excited her. Discussing "the disillusionment of screen lovemaking," she observed disdainfully that in the blinding glare of the bright blue calcium lights back in the 1920s, a screen lover bending to kiss her suddenly had purple lips and blue teeth. Interested in another variation of color? Black type on a yellow ground, seen

through white tissue, assumes a tinge of blue. Ever notice?

There are many more blues than there are words to name them. There is smalt. Tenebristic blue. Plumbago blue has a delicate red tone to it. Phthalo, a cyanine blue, is also known in the Dutch pigment trade as Rembrandt blue. Neuwied blue is a lime blue sold in drop pigment form. And then there is a whole order of undertones. Cerulean blue. Manganese. Prussian blue—the only color Ruskin allowed his pupils to paint with at the Working Men's College—is used to get blue lake, a reduced or let-down variety. What delicate and differing tones in the Blue Siberian iris, asters, Nemophila—baby-blue eyes—and bluebells. And what tints in the blueness of crabs, herons, macaws, certain rare foxes, and the shiny blue buffalo of Thailand! Stems of drill spring blue ivy give a gummy liquid which, curiously enough, when mixed with urine, yields lake. (And by the way, methylene blue, specifically a drug known as Urised, when added to drinks—a college prank—turns the urine a bright deep blue.) Seal blue, another version of the color, containing a lot of gray, is the unique tint of surgeons' uniforms, which, when worn during surgical demonstrations, shows up better than white or green on television monitors. Raising blue lobsters is a pet project of

Sam Chapman, an aquaculturist at the Darling Marine Center in Maine, and their shells shine like cobalt, blue and filmy like a photo soaked in dyes. There are cobblestones in Old San Juan, down by the docks and in the Old Town, that are a strange moon-blue. A specially denominated color is Disney blue, the now standard background for all animated cartoons. And there is "dump cart" blue, a paint used on New England barns in the old days with mixtures involving skim milk and other natural elements.

And, writes Wayne Koestenbaum in *The Queen's Throat,* "The first opera I ever saw: *Aïda.* San Francisco War Memorial Opera House, 1969. I was eleven. By the last act I was exhausted, bored. All I remember now is the color of the sky above the Nile—beyond midnight blue, a shade redolent of witchcraft and spice."

Willa Cather speaks in her novel *Death Comes for the Archbishop* of "the blue that becomes almost pink and then retreats again into sea-dark purple— the true Episcopal colour and countless variations of it." There is the mineral blue of a cartoon criminal's jaw, needing a shave. Speaking of cartoons, have you ever noticed Superman has always had blue hair? And the French have a special affection for that dense shimmering sky blue that the School of Paris, around 1400, particularly liked to use,

which then remained a favorite of French painters for centuries as seen in the works of Poussin, Nattier, Perronneau, and Quentin de la Tour, until it finally culminates in Cézanne's lovely and pellucid watercolors. Cézanne also created blue forms to replace actual cypresses.

Indigo is strange. We have the seven Newtonian colors simply because they had to match the notes on the musical scale, not to mention the days of Creation. Hence Isaac Newton's introduction of indigo, which the more simplified textbooks nowadays leave out. Bremen blue, known as blue bice, is also called blue verditer and "blue ashes." Cobalt blue, also called Leyden blue, was used in the mid-seventeenth century to decorate Delftware, the Dutch earthenware covered with an opaque tin enamel. The name comes from the fourteenth century, the kobold being an evil demon thought to inhabit the mines where workers died of what we now identify as arsenic fumes from the ore. (Isn't it weirdly true that blue become bluest equals black?) But cobalt as a coloring agent for glass dates to 2000 B.C. in Mesopotamia, where it was found at Khemsar, 120 miles south of Tehran, "in the form of flowerlike masses growing, as it were, on the surface." By A.D. 1300 sources had been found in China, and the famous underglazed blue porcelain, pottery, and artwork of the Hsuan Te and Ch'eng Hua periods (1426–1435 and 1465–1487, respec-

tively), made, much of it, in the legendary Imperial porcelain works which was located in the city of Jingdezhen, began its circumambulation of the globe—becoming Ming blue, Mohammedan blue (a dark violet blue shade), and Persian blue before it took Europe by storm. European collectors possess few examples of the best blue-and-white porcelain, however, mainly because exporting anything was a fragile undertaking and much of the ware was of coarser quality. A stunning example of the rich power of pure cobalt can be seen in Edward Hopper's sea in *Blackhead, Monhegan.*

Lapis lazuli—*azzurro oltremarino* ("blue from beyond the sea")—is the raw material from which the original ultramarine pigment was prepared. Powdered lazulite was mixed with a measure of egg white as a binding agent. A semiprecious stone, it was first used in Sumerian mosaics about 3000 B.C. (Originally, mosaics were made from pebbles collected from beaches and riverbanks and set in wet cement.) It was found in the Tutankhamen treasure and the *pietra dura* tables of Renaissance Italy. During the 1920s Sir Leonard Woolley, the British archaeologist, excavated Ur of the Chaldees, Abraham's biblical home, and in the royal cemetery he found five game boards, with patterns resembling something like backgammon layouts, that were made of wood, adorned with animals and rosettes, and intricately decorated with a mosaic of shell,

bone, red paste, and—only five dots were found—
lapis lazuli. Was it the sapphire of ancient writers?
Theophrastus describes the σάπφειρος as being
spotted with gold-dust, a description quite inappro-
priate to modern sapphire, as does Pliny. And possi-
bly an allusion to the same characteristic may be
found in Job 28:6. The Hebrew *sappīr*, denoting a
stone in the high priest's breastplate, was probably
lapis lazuli.

In Egyptian mythology, lapis lazuli was associ-
ated with daybreak. And it intrigued that people. It
was a favorite stone for amulets and ornaments such
as scarabs. The ancient lapis on King Tutankhamen's
celebrated 3,500-year-old funerary mask is every bit
as valuable as the gold. Lapis was also used by the
Assyrians and Babylonians for cylinder seals. Egyp-
tian alchemists developed vibrant blue enamel in
prehistoric times in about 3800 B.C., the discovery
being a by-product of copper smelting. An experi-
menter mixed a powder of chrysocolla with natron
and applied a flame. The color was sometimes im-
proved by heating the stone. The result was hard,
glossy blue enamel that was then melted and applied
to beads and pebbles. And what are we to make of the
inscription by Nebuchadnezzar II (605–562 B.C.) in
which he declares that he built Etemenanki, now
popularly identified as the Tower of Babel, at Baby-
lon, "with baked brick enamelled in brilliant blue"?

Before the twelfth century, when the secret finally

got to Europe by way of Sicily, that melting pot of cultures, this exquisite stone—at the time available only in Afghanistan and Sinai—was considered as priceless as gold. A fine quality has been imported to Europe especially from Afghanistan since medieval times. Lapis is now also found in Chile. A breathtaking example, Raphael's 1510 *Alba Madonna,* was painted with ground lapis lazuli. And the extensive use on the angels' robes and halos of gold and ultramarine in Fra Angelico's *Christ Glorified in the Court of Heaven* indicates that this was, indeed, an important commission.

It was always the most expensive pigment for painters, meant, first of all, for supernatural beauty, perfection, glory. The goldlike flecks of pyrite crystals in lapis lazuli have often been compared to stars in the sky. (A certain magic attaches to lapis: it is always supposed to be fingered when reciting Chapter 26 of the Egyptian Book of the Dead.) Imagine what those rich delphinium-dark blues, never mind the use of matching gold, cost Duccio and DaConegliano and Fra Lippo Lippi and the Lorenzettis! Imagine the cost to Raphael, to Titian, to Giovanni Bellini simply to dip into that blue for the robes of those Madonnas! What niggardliness wouldn't be forgiven in places where its application could be avoided? What hectoring not understood when students wasted it? Penny-pinching painters squeezed the very last dabs out of that pigment. An

artificial ultramarine was generally used in the nineteenth century, although that was not always the case. While painting a mural commissioned and paid for by the university in the Oxford Union, Dante Gabriel Rossetti, working with William Morris and Burne-Jones, Pre-Raphaelite painters all, knocked over an entire potful of lapis lazuli, which surely must have cost a fortune, leaving a huge, beautiful, useless pool of dark blue leaking into the floor. The committee in charge of paying their expenses, which was staggered by the bill they ran up for soda water alone, almost died!

Azurite, a blue mineral derivative of copper—called "Armenian stone" in Pliny's time, when Armenia and Spain were the chief sources of its supply—was for a long time often used as a substitute for the brilliant but costly ultramarine, which is rarely offered on the market today. It was not only plentiful but, because it was mined in Europe (where lapis is not found), also went under various names like "German," "Hungarian," "Lombard blue," "Ragusa," and so forth. The sky in El Greco's *Christ Driving the Traders from the Temple* is painted with azurite. And in Leonardo's 1485 *Virgin of the Rocks* (oil on wood), an initial layer of gray was painted over with azurite before the final layer of ultramarine was applied. The use of ultramarine was stipulated in Leonardo's contract for this work, a common practice among the greatest painters because of the

prohibitive costs of the pigment. At the same time, the permanent intrinsic value of the blue from lapis put such paintings in a class with gems, and wealthy Renaissance patrons of the arts often felt exalted owning them.

I have always wondered, how expensive was blue for Botticelli? And whether his lavish use of royal blue for the dress and robe of the Virgin, for example, personally cost *him* anything? Did the rarity of blue affect compositions? And what about frescoes by people like Piero della Francesca? Their bright blue skies must have been costly—or had there been a cheaper way to do it? Did Marco Polo return from the Orient with new, better, more plangent, lambent, luminous, lacustrine blues? How was Maya blue obtained, and why were all those figurines of noblemen and women and priests found buried on the island necropolis of Jaina in Mexico covered in blue pigment? Why are Moselles bottled only in bluish green bottles? And why did the ancient Greeks wear blue for deep mourning? Was it to blind themselves with surface iridescence? Just what was Venetian blue, and what did it mean to Canaletto? Had wars been fought over the pigment? Are there not tribes that cover themselves with blue mud in Africa? And what makes this mud blue? (It's a "terrigenous marine sediment," but how is it formed? Would it color bricks?) Can blueberries make a blue? How did Arcimboldo paint his plums?

There is much blue clay on Cape Cod. The familiar sky-blue paint with which early Cape Codders liked to cover their wagons came from mixing the blue clayey tills, or drifts, with skimmed milk. And in Madagascar, there is a special clay—I've seen it used in pots in the markets of Antsirabe—called *tanimanga* (literally, "earth-blue"), largely found in that country alone and on the banks of rivers and streams. It is a moist, gray earth, black, even yellowish, which is mixed with a little soft sand and water to soften. But the finished pots, after the kiln, come out orange-brown, however. So maybe that's as far as blue clay ever goes.

Andrew Wyeth has always used blue sparingly because, for his temperas, he uses Botticelli's method of grinding lapis lazuli, and not only is it expensive, but the blue also tends to pierce out brilliantly, sometimes unbalancing compositions. The mechanization of paint grinding was commonplace for artists in the 1830s. Collapsible tin tubes, invented in Britain in 1840, had been introduced in France, but by mid-century still cost more than the traditional paint bladders. Speaking of blue, modern pigment making came into being with the creation of Prussian blue in 1704. In attempting to make an artificial crimson from salt, potash, and organic materials, a German chemist named Diesbach found, instead of the red he hoped for, a deep powerful

blue. So he marketed the process in 1724 and thus was born the artificial pigment industry.

A color may be too pure. Modern shades and colors often appear hideous, ironically, *because* of their extreme purity. Old-fashioned blue, which had a dash of yellow in it but now seems often incongruous against newer, staring, overly luminous eye-killing shades, was one of the most exquisite hues ever worn in the fashionable world. Women in the 1870s leaned toward "ciel" blue, a pale sky tint with a changeful silver shimmer in it that fought the leaden hue or greenish tinge that gaslight developed in many evening blues. (My favorite blue, used on the walls of my bedroom, is a Benjamin Moore paint that being custom-mixed I had taken deeper, deeper, deeper. The formula is: #832 plus BB3X, MG-1X, RO-10.)

A few final observations on blue stones. The sarsen stones used to build the megalith in England we now know as Stonehenge in 1900 B.C., stones taken from the Preseli hills in South Wales by sled, raft, even possibly glaciers, are blue, in fact are *called* "bluestones." The famous Kimberly crater in South Africa, a blue mass, packed solidly full of blue rock, scattered through which, like raisins in a pudding, are diamonds. Since of all colors of diamonds blue is among the rarest, a special interest and value are attached to what is the finest of all blue diamonds, the ink-blue Hope Diamond, a perfect brilliant

weighing 45.5 metric carats. It is 1⅛ inches long and ⅞ of an inch broad and has an extraordinary sapphire-blue color. And then in 1967, a Masai tribesman unwittingly unearthed a rare transparent blue zoisite, the first "new" gemstone found in decades. Mr. Henry B. Platt, a great-grandson of Louis Comfort Tiffany and president of Tiffany's at the time, successfully promoted the newly discovered stone as a "Tiffany" gem. It was a shiny navy blue, and Platt proceeded to name it "tanzanite" for its country of origin, Tanzania.

The color blue figures powerfully in art. It is popular as a dry scumble. It was a favorite on John Singer Sargent's palette, although his blue in all probability was a "Prussian Green" (a Winsor & Newton tube color), a mixture of Prussian blue and gamboge, a.k.a. Hooker's green. It often informs as a "shot" color the unquiet Mannerist style. There is that matchless depth of blue found in Maurice Denis's *The Road to Calvary* and in the cool blue of Titian's *The Man with a Blue Sleeve*—usually identified as the poet Ariosto—with its delicate purple highlights. What of the full magnificent blues in Gauguin's *The Beautiful Angel* (1889)? And Jean-Frédéric Bazille's *Family Reunion* (1867)? Blue appears as a mere puff of smoke in Braque's *The St. Martin Canal* and as a full occlusive purple blue in Yves Klein's acrylic on fabric on wood, *I.K.B. 79* (1959). In 1917, in Texas, Georgia O'Keeffe, explor-

ing contrasts and harmonies of shape in non-objective terms, did a numbered series of water-colors and abstract compositions entitled, simply, *Blue*. There is the breathtaking stained-glass blue in the Matisse Chapel in Vence. (Matisse used the same blue for his "cutouts" as he did for his 1907 *Blue Nude*.) The Blue Rose Group (circa 1907) was the leading movement of the Russian avant-garde. And, of course, *Der Blaue Reiter* (The Blue Rider), Kandinsky's 1903 painting in which a blue horseman mixes with his shadow, gave its name to the most important movement of modern art in Germany.

The French Impressionists endowed blue with a new importance—not as the basis of composition in color but as the tone of color and light which gave a picture coherence and unity. They succeeded in fusing their pictures into unity in a blue-hued space, in harmonizing that work under the sway of different delicate and light blues, relating objects to one another with homogeneous bluish hues. The Mediterranean is rarely as poetically blue as it is, say, on Raoul Dufy's canvases, often modern seascapes with postcard skies of violent blue. "Nature, my dear sir," he told a critic, "is only an hypothesis." And who's to say he's wrong? The blue found in certain of his paintings like *Blue Mozart* and *Port of Marseilles* is, to borrow a phrase from medieval theology, not a color but a mystery.

I am convinced that Marcel Proust had Claude

Monet's exquisite *Nymphéas bleus* in mind when he wrote so splendidly in *Du Côté de chez Swann,* "I noticed the tone of the water had changed to a bright kingfisher blue, verging on violet, the colour of Japanese cloisonné. Here and there on the surface lay the strawberry blush of a waterlily bloom with scarlet heart and white petals . . ." (tr. Scott Moncrieff).

Thomas Gainsborough's famous *Blue Boy,* a painting that, arguably, gave an archetypal pose to the gay world, was painted in 1770 as a practical refutation of Sir Joshua Reynolds' theory that the cold colors, of which blue is the chief, could never be used effectively in portrait painting.* Who can explain the endless variety of this color? Consider the vibrant blue watercolor wash of Childe Hassam's exquisite *Yonkers from the Palisades,* with its six or seven shimmering different tints of blue. Or the intensely rich midnight blue of the deep waters in his watercolor *Looking into Beryl Pool* (1912), painted at the Isles of Shoals off the Maine/New Hampshire coast. Or Whistler's *Peacock Room,* with its rich blue walls. Or the exquisite blue in Murillo's

* "It is possible that in a picture of the Virgin in the Basilica of San Clemente (middle of the ninth century) we have the first isolated example of a composition built around blue. In this picture the Mother of God is seen clothed entirely in blue robes, the Child on her lap on the other hand entirely in yellow, while the background against which she stands out is again yellow" (Kurt Badt, *The Art of Cézanne,* 1965).

Immaculate Conception of the Virgin's robe, as blue as the sky in May—although Giovanni Bellini's *The Madonna of the Meadow* may be the most exquisite blue robe ever painted, except perhaps for the blue of the Virgin's mantle in the Sistine Chapel, where one's breath is almost taken away with the impression of exquisite blueness. (Blue alone ranks with gold as a color of holy light, as for example in the haloes, colored alternately blue and gold, of the angels in the mosaic in the apse of St. Maria in Domenica in Rome.) Or the saturated hues of azure and royal blue in Winslow Homer's 1901 *Coral Formation,* where he allowed the deep blue washes to dry in such a way as to suggest the crystal clarity of the deep water. Or the brightness of the *Blue Jay* in Audubon's often reproduced plate. "How right Audubon was," observed Roger Tory Peterson in *Wild America,* "to put his maximum drive and energy into that plate."

And what about the emaciated blue of Cézanne's *The Bathers?* The bluish-green/yellow, almost chlorine color of his *Seated Woman in Blue?* Mary Cassatt's wonderful azure lamps? The gem-blue eyes of Modigliani's lovely *Jeanne Hebuterne?* The weird, unseeing pale blue eyes of his mysterious *Seated Boy with Cap* and *Little Girl in Blue* and *The Gay Apprentice?* The intent, cloudless gaze from the sky-blue head of Tchelitchew's *Portrait of Charles Henri Ford in Blue?* The flat opulent heart-stopping blue of

Diebenkorn's vast *Ocean Park No. 79*? Or even Andy Warhol's reproduced images of the fat-again, thin-again, tiresomely over-regarded actress E. Taylor, tinted and called *Blue Liz as Cleopatra*? (According to color psychologist Max Lüscher, the color blue is especially favored by the overweight in clothing and various accoutrements.) How did Yves Klein get that rare opaque blue for his series of blue paintings, which, though done in oil, look like tempera? Or Francis Bacon for the white-blue fat of prostitutes? (Biographer Daniel Farson relates how Bacon, always mad for exactness of color, once drew attention to a rail in the right-hand panel of his painting *Triptych 1976* which had the same color blue as that "of President Kennedy's assassination limousine.") And didn't Maxfield Parrish create a spectacular new shade of blue, uncanny, deep as a well, rich as powdered lapis, to depict the color of the evening sky? Exactly how are the fresco-secco blues of Giotto so soft and clothlike and luminous?

And what of the icefield-white blues of Zawadowski? (Paul Bunyan's blue ox, remember, was found during the winter of a blue snow. And who can forget Elvis' Christmas, "when those blue snowflakes start falling"?) Or Pissarro's dream-blue snow in *Snow at Louveciennes*? ("White does not exist in nature," said Renoir.) Who, incidentally, that has ever dabbled in watercolors or oils is not

aware that a small amount of blue added to white paradoxically makes white appear whiter? Yet isn't it well known that white sheets can be made more dazzlingly white by adding a bit of blue dye to the wash water but not directly onto the clothes? One formula for blue dye goes:

¼ teaspoon ultramarine blue
1¾ cups sodium bicarbonate
½ cup corn syrup

Consider, finally, the southern rose window, the masterpiece of Eugène-Emmanuel Viollet-le-Duc, in the cathedral of Notre-Dame in Paris. Christ the Redeemer stands at the center surrounded by the Apostles and, radiating around, a heavenly choir of confessors and martyrs. But it is in the outermost circle of the rose that are hidden eleven tiny medallions, telling the story of St. Matthew, which have been long recognized above others as the most precious treasures of glass in the entire Cathedral. They are pure twelfth-century blue and are supposed to have been salvaged from the transept rose of 1180, which preceded the rose of Jehan de Chelles. The exquisite blue light which once filled most of its windows was quite impossible to duplicate after 1200.

The glaziers of Chartres and Amiens and Reims

thought of blue as the key to all colors. Varieties of it were nearly infinite. Any window without good luminous blues, properly made to give tone to the whole design, was dull and muddy. Incidentally, the war scare over the Sudetenland issue in September 1938, preliminary to the war itself, caused the removal of the *grand rose,* the magnificent circle window in eighty-six parts, as of much other fine glass throughout France.

I suspect the American poet Wallace Stevens ("The pale intrusions into blue are corrupting pallors") of identifying the imagination, symbolized for him by the color blue, with the infinite sky, just like any lawyer daydreaming over a brief. Poet William Cullen Bryant found in the fringed gentian this very color ("colored with heaven's own blue"). And we know the sky is blue because it is the short wavelengths that are most dispersed by atmospheric motes. The color is found at the short end of the wavelength spectrum. Furthermore, the shift of spectral lines toward shorter wavelengths caused by the Doppler effect is called the "blue shift." Blue has long been seen as the color of the imagination. In 1943, critic R. P. Blackmur published an odd but provocative essay, "In the Country of Blue," in which he states that Henry James' fictions about artists and writers are flawed because they "emphasize imagination at the expense of reality." The artist's special gifts, felt Blackmur, not only fail to

enrich his humanity but insatiably, as it were, devour the artist himself. In Nabokov's fiction there is a spree of blue surnames: Dr. Azureus, Stella Lazurchik Sinepuzov ("blue bellybutton"), and the college astronomer Starover Blue in *Pale Fire*. In Nabokov's system of colored hearing, the *x* sound—for example, Axel Rex—evokes steely blue. "I must keep quiet for a little space and then walk very slowly along that bright sound of pain, towards that blue, blue wave. What bliss there is in blueness. I never know how blue blueness could be," says Albinus in his death vision in Nabokov's *Laughter in the Dark*.

A like bliss is echoed by the character Marcel, who, looking at Giotto's *capolavoro* in the Scrovegni Chapel in Proust's *À la recherche du temps perdu*, is overwhelmed. ". . . I entered the Giotto chapel [in Padua], the entire ceiling of which and the background of the frescoes are so blue that it seems as though the radiant day has crossed the threshold with the human visitor . . . its pure sky a slightly deeper blue now that it is rid of the sun's gilding."

Then there are the azure seraphim of which the children in the tales of Hans Christian Andersen dream. It is a color that moves easily from reality to dream, from the present to the past, from the color of the daytime into the blue amorphous tones of deepest night and distance. Snow on mountains,

rendered by distance as blue, seems connected in harmony with the undersides of clouds. Classical painting used no blue. According to Oswald Spengler, this was because blue—and green—were to the Greeks vaporous, "essentially atmospheric" and "not substantial," a perspective color, ethereal as the color of the heavens, the sea, the shadow of the Southern moon, the unactual. Is it for its moderating tone that blue in aviation is therefore advisory (with yellow caution and red warning)? Locals in that part of the country claim to see an eerie blue light from Highway 90 between Alpine and Marfa, Texas, near the Chinati Mountains, and attribute it to a ghostly Indian's campfire. The specter always vanishes when approached. Young Ishmael in *Moby-Dick* watergazed—dangerously, felt Melville—into blue water, just as, far less dramatically, I have often gone into mild reveries every Christmas staring at the lights, of any color really, but almost always more profoundly when they were blue. In his *Farbenlehre,* Goethe called blue the color of "enchanting nothingness." It does not press in on us, it draws us into the remote, evoking impressions of boundlessness and expanse. Among Spaniards and Venetians, the elite affected blue or black, aware of the aloofness inherent in these colors. That is why blue was the favorite color of Novalis, for whom the state of total nonexistence had a bluish color, and Eichendorff, to whom even noon appeared a sultry blue:

In the dark blue sultriness,
Day's turmoil lies dreaming.

How wonderfully memorable, and how exact, are those images of blue in Rilke's *Letters on Cézanne*. And who could ever forget that strange story by Octavio Paz called "The Blue Bouquet," where a hapless fellow one dark night is set upon, fatally, by an importunate thief with a knife who whispers, "My girlfriend has this whim. She wants a bouquet of blue eyes."

The most memorable film with blue as a motif has to be the musical *High Society*. There is the blue ocean of Newport. The sea, the sky, the vistas. Then that perfectly appointed blue pool and, to match it, the smart pool furniture. So also in the vast open rooms the commodious drapery, everywhere, especially in Uncle Willie's mansion. The shades, the tints, the hues. Powder blue, sky blue, navy blue, salt blue, ivy blue, Wedgwood blue, snow blue, blueness of light and lupin and lilac! Consider even the array of shelved blue books in the library scene as Sinatra and Crosby sing their duet, "What a Swell Party This Is." And everyone's clothes, formal and casual both. Dexter's (Bing Crosby) social and sporty getups. Uncle Willie's (Louis Calhern) tuxedo. Mike's (Frank Sinatra) hat, coat, and slacks. Fiancé George's tie and slacks. Mr. and Mrs. Lord's expensive clothes. And raffish blue carnations sprout

in all the buttonholes. Tracy's (Grace Kelly) apparel, shoes, heart-meltingly beautiful eyes. Her spiffy Mercedes is also blue, as are, notice, even the random cars coursing along the boulevard! It was a color, especially powder blue, generally popular in early fifties movies.

But can anything match for sensuality or splendor the ice-blue satin dress that Grace, virtually defining the color, wore when she won the Academy Award for *The Country Girl*?

Alfred Hitchcock once gave a dinner where all the food was blue—but, come on, what are we talking about, I mean, after blueberry pie? Blue-cheese balls? Stilton, "King of the English Blues" (which is perforated with needles so veins of mold can develop)? A bunch of Kadarka grapes from Hungary? Robin's eggs? (A Devonshire custom on May Day is to eat blue eggs and diabread.) Are kidneys blue? Is there a trace of blue in raisins? And what about bluepoint oysters? And crabs? Children eat plaited blue barley sugar in Samuel Butler's utopian *Erewhon* (1872). Marianne Moore in her poem "The Fish" refers to "crow-blue mussel shells." We've mentioned blue lobsters. The sheen of eggplant is swirled with blue. And when ordering a rare steak in France, *saignant,* one can expect to find it slightly bluish at the center. Blue cornmeal is made from blue tortilla corn, until recently available only in and around Santa Fe, New Mexico, where blue corn is

grown by local Indians. Some poppies produce white seeds, a favorite in Scandinavia, but it is the blue poppy seeds that bring the highest price on the international spice market. (Heavy dustings cover bagels in New York City.) Turkey, the Netherlands, and the distant Australian state of Tasmania are the top suppliers of blue seed to the United States. I wonder what Hitchcock served the guests to drink at his party. No drink is blue. Blueberry schnapps is merely a concoction.

As is a "Blue Devil," made with Curaçao, the mixture for which goes:

½ measure of rum
½ measure of gin
¼ measure of Curaçao
juice of ½ lemon
Serve with a cherry, and the rim of the glass
 dipped in blue Curaçao and sugar.

Is the carpological reference wrong, by the way, in poet Paul Eluard's line *"La terre est bleue comme une orange"*? I would argue for the defense: *not* a piece of nonsense. The earth is indeed like an orange because it is round and an orange can turn blue when it is moldy.

A good blue-food story? Liberace, a renowned cook, once baked two large pans of lasagna for close friends, and sliding the pans out of the oven, as he

happily saw the tomato sauce bubbling satisfactorily, he proceeded as usual to sprinkle on layer after layer of Parmesan cheese. Suddenly something was badly wrong. Watching in horror, he gasped, writes his biographer Bob Thomas, "as patches of blue began to spread over the top of the lasagna like an evil mold in a science fiction movie. As he studied the phenomenon, he automatically sprinkled the second pan. Again the blue mutations. He looked at the can of cheese in his hands. It was Comet cleanser."

Is it possible the Kitchen God was punishing the famed pianist, a gourmand, at least by all accounts I've read, for using *boxed* Parmesan?

Strangely, our particular discrimination of colors goes with our having names for them. Thus once we have the word "pink," a whole class of pale reds acquires a separate identity. It is a curious fact that in the majority of the world's languages the same word means both "blue" and "green." In the earliest Egyptian hieroglyphic poems, the Pyramid Texts, the sky, for example, is usually referred to as "Green, Green as living plants." Could this possibly have meant that the ancient Egyptians could not perceive the shorter wavelength of blue light 5,000 years ago? (I read somewhere, years ago, that our ability to perceive blue rests on our having a very developed retina, with many cones, and that this was one of the last evolutionary events in the development of humanity.) Later, of course, Egypt

was to become famous for its "Egyptian blue," a type of faience paste, and for the ancient cultural compulsion of painting many things blue or turquoise. The original color of all ancient scarabs, by the way, which were always ritually placed over the hearts of mummies, was an iridescent bluish green, like various kinds of cockchafers and beetles still abundant in Egypt. And it is generally accepted that the golden age of Korean ceramics was the eleventh and twelfth centuries under the creative hands of Koryŏ Dynasty (936–1392) potters, who perfected the world-famous blue-green celadon. While the best authentic Koryŏ pieces are the prized possession of museums and private collections, modern copies, especially vase and cup sets and teapots, can be found all around Korea. And I love both this fact and the slightly limp *jeu de mots*: apposite to it: gangrene turns a leg blue.

When Ezra Pound wrote "Blue, blue" of Chinese grass he could count on Western readers assimilating his odd phrase by way of a standing association of Cathay with blue China patterns. (And remember Felise, Swinburne's enchanting creature? "Those eyes the greenest of things blue, the bluest of things grey . . .") In this connection, Brent Berlin and Paul Kay in *Basic Color Terms* demonstrate, exhaustively and empirically, the very simple thesis that anywhere in the world, as a language develops and acquires names for color, the colors always enter in

the same order. The most primitive are black and white. Then red. Then either green or yellow; then the other one of that pair (yellow or green), these four colors comprising, by the way, the only colors the Greeks ever knew. (Xenophanes knew of three colors in the rainbow: purple, red, and yellow, and even Aristotle spoke of the tricolored rainbow.) But green then includes what we think of as blue; that is, blue/green always comes in together as a single word. (Remember Thoreau saying, "Walden is blue at one time and green at another, even from the same point of view"?) Next they get separated under two names, meaning that the fifth color word to be added is always a name for blue. Thus in Chinese T'ang poetry the same character is used for sky-color and grass-color; not so in Modern Chinese. Hence Pound's *Cathay*: "Blue, blue, is the grass about the river," faithful to Fenollosa's notes which were faithful to Professor Mori's teaching. Though elsewhere, when Pound found in the notes

> *guest house blue blue*
> *blue willow color new*

he emended it for the sake of euphony to

> *The willows of the inn-yard*
> *Will be going greener and greener.*

In short, the color blue is in part a pure linguistic artifact. So we shouldn't be surprised that Selsun Blue shampoo is green—"If all the green of spring was blue, and it is," wrote Wallace Stevens in "Connoisseur of Chaos"—nor perhaps that in those old Westerns done by Republic Pictures in the forties and early fifties, where Roy Rogers wore frilled shirts, turned-back gloves, and his trousers tucked into his cowboy boots, the sky by means of a weird color process was always blue-green. A parallel can be found in classical European languages, in which there is a striking lack of names for the green-blue range. The Icelandic word for blue (*bla-r*), incidentally, denotes every shade of blue and black and can describe the color of a clear sky, a fist of coal, or the sheen of a raven. What we call blue is always designated "dark" in Homer, in whose epic poems the color blue does not appear. This essential colorlessness of the blue end of the spectrum, typified by Homer's description ὕδωρ μέλαν ("black water"), persists in Italy to this day. Norman Douglas once described the difficulty he had in persuading Calabrian peasants that the Mediterranean was blue; to them, and to their forefathers, it had always been black. Vergil uses the word "caeruleus" hundreds of times, by which he probably means the color of the sea, which might be either green or blue. Where it applies to nature in Vergil, however, the word almost always meant blue, with the possible

exception of *Aeneid* III, 432, where *"caeruliis ca-nibus"* may be translated, as most commentators agree, "the seagreen dogs." Vergil uses the word "ferrugineos" to describe a hyacinth. This word in *Georgics* IV, 282, undoubtedly indicates a dark color, which is probably blue.

Concerning dark water, I recall being utterly pet-rified as a little boy at the pitiless *blackness* of water—"When it sinks almost to black, it echoes a grief that is hardly human," wrote Kandinsky—described by Edgar Allan Poe and enhanced by the dark billowing thrill of my Father's theatrical read-ings to us at bedtime, by candlelight, of that vast terrifying whirlpool and its unforgiving vortex in Poe's "A Descent into the Maelstrom":

Suddenly—very suddenly—this assumed a distinct and definite existence, in a circle of more than a mile in diameter. The edge of the whirl was represented by a broad belt of gleaming spray; but no particle of this slipped into the mouth of the terrific funnel, whose interior, as far as the eye could fathom it, was a smooth, shining, and jet-black wall of water, inclined to the horizon at an angle of some forty-five degrees, speeding dizzily round and round with a swaying and sweltering motion, and sending forth to the winds an appalling voice, half shriek, half roar, such as not

even the mighty cataract of Niagara ever lifts
up in its agony to Heaven.

And turnabout, in the miraculous chromology of
black tending to blue, there is William Styron's
memorable description of the old black man of the
title in his wonderful story called "Shadrach": "I had
never seen a Negro of that impenetrable hue: it was
blackness of such intensity that it reflected no light
at all, achieving a virtual obliteration of facial fea-
tures and taking on a mysterious undertone that had
the blue-gray of ashes."

Absinthe of course was often called "the green
fairy"—even the hour of drinking it had a name,
l'heure verte. It was banned in France in 1907 as a
dangerous intoxicant. And yet a curious connection
between green and blue can also be found here. A
discreet inquiry at a café for *la bleue* or *un midi moins
dix* ("the blue" or "a ten to noon," slang for this
legendary drink) could get you a bottle. Interestingly
enough, the temperance league that wanted the
drink abolished was recognized by its blue cross
symbol. Gin, incidentally, was often called "blue
ruin," blue from its tint, ruin from its effects. The
cheap suit worn by Picasso's early *Boy with a Pipe*
(1905) is a good example of the color gin blue.
Incidentally, dusk is often referred to as the blue
hour. As Tennessee Williams once wrote, "*L'heure
bleue,* so flattering to blonds."

So have I then successfully managed to avoid for any Navajo jewelry aficionados the age-old question of whether turquoise is a kind of blue or a kind of green? Or have I got away with finessing it by suggesting that green and blue are, themselves, the same? ("And the purple green of Kentucky blue," wrote Amy Lowell in her poem "Evelyn Ray," leaving us something to ponder.) And yet how could I be right, especially when after Linus asks Lucy in the *Peanuts* strip, "Why is the sky blue?" she answers, "Because it isn't green"?

As to turquoises, I have always felt in those changeful stones that, when pale, they hideously recall the eyes of those suffering from trachoma, but when they are deep blue the color seems to have no magical depth, no transparence, and no richness.

Oscar Wilde collected Blue Willow china. (Action on a Blue Willow plate depends on this color for life.) An inhabitant of Nova Scotia is called a "blue nose," a nickname related to the prevailing easterly winds there or to a type of blue potato. Lodges of Ancient Craft Masonry are called "blue lodges," blue being the distinctive Masonic color from the blue vault of heaven, which is the proper covering of a symbolic lodge. Ford Madox Ford, whose fish-blue eyes people tended to remember as staring, in his poem "Buckshee" referred to the sky as "the spacious and amethystine, palpitating blue." The inner eyes of Norwegian wildflowers are as blue

as Norway's twenty-five-ore stamp. Fashion or French lady dolls of the 1860s often have cobalt eyes. "Blue Peter," from the French *partir,* "to leave," is the name given to a blue flag with a white square in the center, indicating that a ship is about to leave port. "Blue laws" refer to the severe regulations of the early government of New Haven, Connecticut. Blue of course stood for canned goods (red for meats) on small American rationing tokens during World War II. And pale blue should be worn for television cameras. Blue icing is always used on TV cakes. And can you have a blue heart? Indeed, you can. It's a Central Intelligence Agency decoration, the Firm's version of a Purple Heart.

Speaking of entertainment, shooting *The Emperor Waltz* (1948) in Canada's Jasper National Park, director Billy Wilder in a fit of crazed revisionist tampering—part affectation, part megalomania—not only spent $20,000 to have truckloads of pine trees brought up from California and replanted everywhere but also had four thousand daisies shipped in and planted, whereupon he, not liking their color, had them all sprayed with blue paint. (He also had the roads in the area repainted ocher.) It was a dull movie.

Are tattoos blue (or red) the better to show up on Caucasian skin? (Originally Asiatic skin; sailors brought the custom back from China.) Prehistoric man ground up ocher and other colored clays, and

Neolithic farmers tattooed their faces with a design of blue tridents. In the British army until 1879, the letters *D* and *BC,* which stood for *Deserter* and *Bad Character,* were tattooed on human skin with needles and India ink, an ink also used in the East. In Japan, tattooing became a high art, where black inks mixed with different tints of red obtained from cinnabar appeared blue. But, tell me, are there any tattooed Negroes? What dye is used? Does the absence of such dyes explain the rudest form of tattooing, commonly practiced especially among Australian aborigines and various African tribes, which consists of cutting gashes on the skin and filling the wounds with clay, thus forming raised scars?

Blue is often used for distance—consider Gillis van Coninxloo's landscapes. It is the color for Yale, Oxford, and in Canadian politics for the Conservatives of Quebec. Blue glass is used to ward off evil in Armenia. Au Nain Bleu, Paris's classic toy store, can still be found at 27 boulevard des Capucines. There is *langue bleue,* an artificial language, a modified form of Volapük created by Bollack in 1899. "Blues" was the name given to Confederate paper money to distinguish it from that of the North, known as "greenbacks." (When it became worthless after 1865, it was known as "shucks.") And in the Confederate South, despite Union blues, blue cockades

were worn as the symbol of secession. Oakland A's pitcher Vida Blue wore a blue baseball glove. "The Blue Kerchief" is a beautiful Russian song about a soldier who carries this love token into battle. "Mr. Blue" was a song sung by the Fleetwoods as well as the title of a small, mysteriously lovely novel written in 1928 by Myles Connolly. Another Miles, Davis, gave us one of jazz's greatest albums, *Kind of Blue.* And although Duke Ellington once thought of becoming a painter but didn't, disappointing his adoring mother, in his compositions and jazz tunes he showed a continuing loyalty to color, especially his favorites, "Azure," "Blue Again," "Riding on a Blue Note," "Blue Ramble," "On a Turquoise Cloud," "Blue Bubbles," "Blue Goose," "Blue Rose," "Lady in Blue," "Mood Indigo," and "Blue Cellophane," all culminating in the great suite he rendered from an old song for the Newport Jazz Festival in 1956, "Diminuendo and Crescendo in Blue," one of his classics. "Blueskins" was a nickname applied to Presbyterians. It was also the sobriquet of English burglar Joseph Blake (executed on November 11, 1723) for his dark, almost chthonic complexion. And does anyone remember those rare, dark-blue (and smelly) old 45 r.p.m. records, handmade by old record-sellers, which when held up to the light looked a sort of ghastly and cadaverous purple?

Goethe first suggested in 1810 that our response to colors depends largely on biological cues, reckoning that blue produced anxious, tender, and yearning responses. In psychometric or psychological terms, blue is said to favor the extrovert. The sedative value of blue colors is used to advantage in hospitals, particularly when dealing with the emotionally disturbed. Crying infants can be more readily quieted by blue light than red. Blue light retards pulse-rate and lowers blood pressure, whereas red light has the opposite effect, accelerating the pulse and raising blood pressure. The Blue Fairy in Disney's *Pinocchio* is a great comfort to children. A blue lagoon, under a blue sky, is a cliché of comfort and escape. ("The water basins, in whose depths the blue sky lies basking, shine like eyes," observed Proust.) Movie stars have long demanded blue backgrounds for their emotional close-ups. And speaking of movies, although night scenes in silent films were always shot in the day, in release prints those scenes were always tinted blue. The results were both convincing and beautiful.

It is the color of space, of force and power; of rushing American rivers—the Flathead, the St. Francis, the mighty Housatonic, the Loup and Bear and Deschutes, the James and Watauga and Monongahela. It represents tradition, contentment, timelessness, fulfillment, fullness, and lasting immemorial values. It is also, as we have noted, the color

of depth. The depth of blue of Muncho and Atlin lakes in British Columbia, the waters of Alaska's Kenai Peninsula, must be seen to be believed. The deep blue of Oregon's enchanting Crater Lake, the deepest lake in North America, almost intolerable in its beauty, can swamp with emotion the flickering power of analysis. The lake is 1,932 feet at its greatest depth. Fed only by snow and rain—and drained by sun and wind alone—the lake suffers no silt from running water, the sunlight striking it reflecting the blue rays, while the rays of the other colors are absorbed, all serving to make it the bluest blue lake in the world. (The Red Sea, incidentally, is very, very blue.)

"The deeper blue becomes," wrote Kandinsky in *On the Spiritual in Art,* "the more urgently it summons man towards the infinite, the more it arouses in him a longing for purity and, ultimately, for the supersensual." The color indeed, like Goethe's Eternal Woman, like mystery itself, seems to beckon us ever and ever onward, becoming, in Kandinsky's words, "the infinite penetration into the absolute essence—where there is, and can be, no end."

Yellow

YELLOW IS A color, for all its dramatic unalterability, with a thousand meanings. It is, surprisingly, at least to me, a child's first color preference. Wallace Stevens called yellow the "first color," with an attendant suggestion of decay and dissolution ("the grass is yellow and thin"), but more often uses it affirmatively, linked with the sun: "The sun is clownish yellow." It is the color of cowardice, third prize, the caution flag on auto speedways, adipose tissue, scones and honey, the nimbus of saints, school buses, urine, New Mexico license plates, illness, the cheeks of penguins, the sixth dog's livery in greyhound racing, highway signs, Pennzoil, and the oddly lit hair before adulthood of all Australian aborigines. Easter is yellow. So is spring, and much of the beauty of autumn. It is redolent of old horn, dead coins, southernwood, and the generous sun. It

is the color of butter, arsenic, sponges, candlelight, starving lawns, translucent amber, and cathode transmission-emitters in electrical chassis wiring. It represents wisdom, illumination, intuition, power and glory, the hue of confessors, divinity, magnanimity, ripening grain, eternity, and the gates of heaven. In Egypt it is the color of happiness and prosperity.

It has many tints and hues. Banan is the proper term for the yellow color of a ripe banana. (Yellow taxicabs or beach wagons painted yellow that were once used by resorts to meet guests at train stations were called "banana wagons.") A "high yaller" referred, mostly in the last or early part of this century, to a very light-skinned or xanthomelanic black or octoroon, an attractive color in women to Southern men (and in the popular novels of Frank Yerby), and octoroon balls were extremely popular down South, especially New Orleans, in the 1800s. Nat "King" Cole in "Honey Hush" sings, "I'm steppin' out with them high yellows / Snubbin' all the other fellows." The race of nomadic negroid pygmies on the western border of Uganda called Mbuti are reddish yellow. Jazz singer and semi-nude dancer Josephine Baker's lovely skin in 1924 was dubbed "banana-colored." Or was it for her girdle of bananas, which flew hither and yon, when she did the Charleston or Black Bottom in the *Revue Nègre,* wearing nothing

else? (The great banana epic was Busby Berkeley's film *The Gang's All Here,* starring Carmen Miranda, in which concentric circles of showgirls, folding and unfolding gigantic bananas, go dancing around in a fruit-filled world.) Why, W. C. Handy even wrote the oxymoronic song "Yellow Dog Blues" in 1914. And Libby Holman in the popular Broadway show *Three's a Crowd* (1930) sings the song "Yaller," the languishing plaint of a mulatta girl who in the miserable way she grows up feels shunned by both blacks and whites, several lines of which go:

Oh Lord, you can make a sinner a saint,
Why did you start me and then run out of paint?

Incidentally, Richard B. Harrison, who played the part of the Lord in *The Green Pastures* on Broadway in 1930, an Old Testament play with an all-Negro cast, wanted to play his part without makeup—he was doubtful that blacks saw God as colored and suspected that they saw him, somehow, as sort of a white Negro—and was finally requested to put on a coat of yellow greasepaint.

There is tangerine yellow, a sort of honeysuckle. Golden ironweed. Celandine, a greenish yellow. Yellow, which is often associated with green (O.E. *geolo*), is etymologically connected to that color by way of *chloros* (Gr.) and to gall, the yellowish

fluid secreted by the liver. Gamboge is reddish yellow in hue. Carthamus is also yellowish red in hue, somewhat like chili oil or the color of a stained dinner plate after a meal of Indian curry or many a dish in the American Southwest. There's Long Beach, a light yellowish brown color. Brass is dull yellow, canary bright. Yellow figures only as gold, a metal, not a color, in English heraldry, where tinctures—as colors in heraldry are called—comprise merely two metals, five colors, and eight furs. Then there is Cadillac Gold. (Donald Trump hated the original flat yellow handrails at the Trump Plaza. "See that gold Cadillac down the street?" he told his interior designer. "That's the color I want those handrails. Gold. Cadillac Gold. Not yellow like a daisy.") A flavescent touch can be found in the green of all early spring buds. And there is a distinct touch of yellow in a peacock's green feather, the faint iridescence of it on a pigeon's neck. Henry David Thoreau described his neighbor Abner Buttrick's house, a unique yellow, as having been painted "with the pumpkin pies left over after Thanksgiving." And sunflowers are as brightly gold as golden-thighed Samian Pythagoras.

Saffron also has a yellowish orange cast, not unlike many varieties of mustard, like turmeric, which brings to mind the "Butternuts," nineteenth-century settlers in the interior of the country—Ohio, Indiana, and Illinois—who remained rural,

pro-Southern, localist in their orientation, and un-compromisingly hostile toward Yankees of New England heritage who settled the northern portion of these states. They were named for the clothes they wore, for they invariably dressed in homespun clothes dyed with the oil of walnut or butternut trees. It was more than anything a brownish yellow, a sort of luteolus (from *lutum,* mud), one of those perfectly good English words completely ignored nowadays as pretentious and arch, except by literate people like Vergil, who in his day used the word "luteus" as a synonym for yellow.

The single arch in the desert of Ctesiphon, lutes-cent and venerable, the largest single span of brick ever made by man, is all that remains of the ancient kingdom of Parthia.

In one of the stories in Gabriel García Márquez' collection *Strange Pilgrims,* "Sleeping Beauty and the Airplane," the narrator notes (and I agree) that "there is nothing more beautiful in nature than a beautiful woman"; one of the most poignant evocations of that belief in the story becomes a passing delicate observation on the color yellow: "Around her neck she wore a chain so fine it was almost invisible against her golden skin."

As a color, yellow can accommodate size. It is the color of pyramids. Huge buildings. Ten-wheeler trucks. And heavy machinery. Earth-moving equipment. Cats. Bulldozers. Cars, as well. (I habitually

think of the Volkswagen Beetle, the best-selling car of all time, as being yellow. The Franklin Mint, in fact, does a die-cast model of it in only that color.) It is also delicate and light. Daffodils. A kernel of corn. The umbels and anthers of flowers. And although Emily Dickinson in several poems treated yellow flowers—owned that it was her domestic task to "make the yellow to the pies [presumably knead the dough] and bang the spice for cake," and mentioned several times that it was her only brother Austin's habit to walk about rakishly sporting a "yellow-brimmed planter's hat"—she also in a chromotological moment took notice to point out:

> *Nature rarer uses Yellow*
> *Than any other Hue.*
> *Saves she all of that for Sunsets*
> *Prodigal of Blue.*
> *Spending Scarlet, like a Woman*
> *Yellow she affords*
> *Only scantly and selectly*
> *Like a Lover's Words.*

And what of the pale golden light filtering into the lovely Norman transepts through the high-fretted windows in the elegant cathedrals of France

and England? Or moonlight? A favorite haiku of mine is Jack Kerouac's

> *The low yellow*
> *moon above the*
> *quiet lamplit house.*

Light in its glory is as golden in its grace. I once learned from a friend who belonged to the Appalachian Mountain Club the art of photographing "waterlight," a special aura of bewitchingly lovely translucence. Novelist and poet Lydia Maria Child compared spiritual light to that of the "natural sun." We are all of us washed in yellow sunshine. It "shines from one source and shines alike upon all," she wrote in her novel *Hobomok,* almost echoing the meritocratic Swedenborgianism she later came to embrace, "but is reflected and absorbed in almost infinite variety, and in the moral, as well as the natural world, the diversity of the rays is occasioned by the nature of the recipient." There is also yellow in the heart of heat, and it may be noted in passing that Finnish, oddly, has only one verb for "to shine" (of the sun) and "to broil" (*paistaa*). Kandinsky in his drama *The Sound of Yellow* (1912) shows the universe emerging out of a dark chaos by symbolical rays of light. There is a vital force regarding light in everything from the sunstarts on water in a Renoir

painting to the patch of light beneath the visor of Gort, the eight-foot robot in the film *The Day the Earth Stood Still,* to Henry James' observation in *The Bostonians,* "The whole moral history of Boston was reflected in Miss Birdseye's spectacles." And what of October sunlight that pours through windows with that faint tinge of silver in which wild wondrous winter frosts are foreshadowed?

I used the word "flavescent." Flavia was an old Roman name, at one time the family name of the Roman emperors. The name would have started as a nickname, for it means "golden yellow" or "flaxen" and would have been used to describe someone of that coloring. Someone with tawny or dark yellow hair clearly must have been the founder of the family which gave us the name Fulvia, the best-known holder of which was the noble wife of Mark Antony, who fought actively on his behalf in the civil war, in spite of his dalliances with Cleopatra. The masculine forms of these names, Flavian or Flavius and Fulvius, seem rarely used today, except in Italy and of course for the yellow cat who is the pet of Hadrian VII, fictional hero of the brilliant but eccentric writer Baron Corvo (Frederick Rolfe), a feline affectionately named Flavio.

A yellow baseball was actually used for the first time in the Major Leagues on August 2, 1938, at Ebbets Field at the behest of Larry MacPhail, general manager of the Brooklyn Dodgers, when they

defeated the St. Louis Cardinals, 3–2. It was used in only three other games, in the following year. The Cards beat the Dodgers in two of the games, 12–0 and 5–2. The Dodgers defeated the Cubs, 10–4, in the other game. After that game, the ball was never used again. I once owned a splayed yellow glove, the color and shape of a failed quiche, when I was a kid, and rather fanatically kept it soft with neat's-foot oil, that magical yellow elixir made from cattle bones and skin. A yellow ball, incidentally, is also now used in professional table tennis.

And yellow tennis balls are now the official color at Wimbledon. The famous helmet of Harold ("Red") Grange, No. 77, was yellow. Amelia Earhart's favorite car, which she called "the Yellow Peril," was a sleek 1922 Kissel Kar with big nickel headlamps and a long yellow body with bat-black fenders. ("My roadster was a cheerful canary color," said AE, who drove it from the West to the East Coast. She added, "It had been modest enough in California, but it was a little outspoken for Boston.") London buses, incidentally, were in the nineteenth century not red, as they are now, but rather dandelion yellow, as Oscar Wilde, alluding to such a bus, describes it in transit, though somewhat inexactly ("crawls like a yellow butterfly") in his lush poem "Symphony in Yellow." And Fels-Naphtha, a yellow scouring soap—don't we almost always think of tallows or fatty tallow products used for cleansing as

yellow?—leaves the pungency of its disinfectant smell in the very walls. In 1896, a single-frame cartoon called *Hogan's Alley,* a creation of Richard Outcault for the *New York World,* though he was later seduced by William Randolph Hearst to work for the rival *New York Journal,* was the most popular comic in New York. Of the large cast of wild tenement-district urchins it featured, the most popular was the Yellow Kid, a wild, frenetic, irrepressible, and in many readers' eyes, "vaguely foreign and sinister-looking" character who was also the gang's ringleader. (Early cartoons, by the way, were done mostly in yellow print.) With the hiring of another cartoonist, George Luks, who began competitively drawing yellow kids for the *World,* the term "yellow journalism" was suddenly given added impetus and focus.

Interestingly enough, a fellow named Wilson Mizener was also known in Nome at the turn of the century as "the Yellow Kid," a nickname that had nothing to do with cowardice but rather more fascinatingly with his ingenious entrepreneurial technique, employed while working as a cashier in an Alaskan saloon, of pouring a bit of syrup in his hair. When weighing out gold dust from a miner's stash, he would surreptitiously brush his hand through his hair to "bank" a few particles! And remember the town of Yellowknife in the Northwest Territories?

"Yellowknife" was a term often used for an Indian or settler with a copper knife.

London fog is correctly described in T. S. Eliot's poetry as yellow, but with coal having been banned in the sixties, it tends toward silver gray. Hazes are often yellow, as are night mists, miasma, noxious effluvia, and eerie contagions once thought to emanate from putrescent matter, swamps, bogs, and so forth, and then to float in the air. A vertical column of warm air, I once noticed from a glider, appears yellow in full sunlight. And did you know that "Willy-with-the-wisp-and-Peggy-with-the-lantern" is an oddly mysterious yellow light that appears at night in England over marshy ground? I also saw a volcano in Java with yellow-white hissing steam blowing from the crevices of the pit at 6,500 feet above sea level and dirty yellow water in South America, vile as a Wasserman test, which with a few drops of iodine mixed in a bottle of it before drinking, I was seriously assured, could be disinfected, though I never ventured to try it. Sulfur exudes poisonous fumes from the noisily bubbling pools of it—deep in craters and deposits in Java, the Gunong Slamet, and the Preanger Regencies—and imperils the health of those hapless morts who hoist it up by chunks in baskets from thousands of feet below, for use, later, in spraying, food and wine preparation, and the distillation of sugar. The dank yellow

swamp in H. G. Wells' *The Island of Doctor Moreau* (1896) exudes a pungent vapor. Saffron, perhaps simply for its color and its connotations of haziness, has been used in various countries as a tranquilizer and in sleeping potions. There is a numbing ingredient in *jambu,* a yellow daisy that grows throughout Brazil and is sometimes used as a cold remedy and an anesthetic. In 1834 John James Audubon, in an attempt to suffocate a golden eagle with fumes of charcoal and sulfur, the better to sketch it without disfiguring its plumage by gunshot or the use of an axe—he eventually stabbed it in the heart—was almost swallowed up in thick yellow vapors that had him on the floor gasping.

During the arc-light era of long ago, street lanterns equipped with Welsbach burners, flickering romantically, diffused a singular yellow glow within a restricted radius and gave neighborhoods a certain fancy. Yellow is the nimbus. One need only look at Louis Anquetin's *Avenue de Clichy: Five O'Clock in the Evening,* where, drawing on a childhood memory, he suffused his view of a Paris street in a deep luminous blue, relieving it, however, by the sulfurous yellow flare of gaslight on the charcutier's awning. And one of the most magnificent sentences in all of literature, found in *Moby-Dick* (Chapter 70), takes its cue from this idea: "An intense copper calm, like a universal yellow lotus, was more and more unfolding its noiseless measureless leaves upon

the sea." Yellow is vagueness and luminousness, both. "The eternal silence of the great white desert. Cloudy columns of snow drift advancing from the south, pale yellow wraiths, heralding the coming storm, blotting out one by one the sharp cut lines of the land," wrote Captain Robert Falcon Scott, just before freezing to death in Antarctica.

George Sand, once dreaming beside a path of yellow sand, mystically saw life flowing by. "What is more beautiful than a road?" she wrote. "It is the symbol and image of an active, varied life." But was she speaking of her name? Herself? Something in the color of the sand?

There has always been an eerie quotient, an otherworldliness of sorts, a numinousness, associated with the color yellow. The people of Saba in *The Travels of Sir John Mandeville,* though they turn black as they grow older, are born yellow. And women, otherwise naked but for sandals, wear yellow kerchiefs on their heads in Pierre Louys' *Les Aventures du Roi Pausole* (1900). In William Morrow's enchanting *The Wood Beyond the World* (1894), magic yellow rings alone will bring travelers to the Wood. In H. Rider Haggard's *Allan Quartermain* (1887), the country of Zuvendia derives its name from its gold mines, and in their own native language *Zuvendis* means "yellow land." The strange mad people in Edgar Rice Burroughs' *Tarzan the Untamed,* who revere parrots, have sharp upper

canines, and breed lions, have yellow skin. As do the bronze-age Xexots of Xexotland on the continent of Burroughs' Pellucidar, that hollow interior of the underground world. And the dominant color in Winkie Country, just west of Emerald City in L. Frank Baum's magical Oz, is—O amarillo!— bright yellow.

Azazello's "cream" in Mikhail Bulgakov's novel masterpiece, *The Master and Margarita* (1967), a magic ointment that shines her skin and puts her in touch with magic and the supernatural, freeing and transforming her utterly—"Hooray for the cream!" she cries—is yellow. So is the TV cartoon family the Simpsons, the skin of whose endearing characters in the loopy looniness of Pop-Art reveal a sort of Roy Lichtensteinian yellow. The color, in a word, seems ably wed to their behavior. And have you ever noticed that most of the nitwittish creatures in the Dr. Seuss books are also a distinct yellow, like the Sneetches; the Great Birthday Bird; the Drum-Tummied Snumm from the country called Frumm; the scraggle-foot Mulligatawny from McGrew's Zoo; as well as the It-Kutch, the Preep, the Obsk, and the Proo, the Nerkle, the Nerd, and the Seer-sucker, too, to say nothing of all the birds and animals and people in the *Sleep Book,* including the Offts, Snorter McPhail and his band, the Bumble-Tub Club, Jo and Mo Redd-Zoff, the Collapsible

Frink, the stilt-walkers, not to mention the Lorax's flaring and commodious mustache! Is it because it is such a comic color? Innocent yet mad? Lighthearted but oddly unsettling? Why perhaps most Fisher-Price toys are as yellow as chopsticks?

In T. H. White's *The Once and Future King* (1939), Chariot, the (edible!) castle of the enchantress, Morgan le Fay, rises from a lake of milk bathed in a buttery glow, and the drawbridge is yellow butter. The courtyard of the Royal Palace of Cocaigne in James Branch Cabell's *Jurgen* (1919) is covered with yellow marble. (There *is* such a thing as yellow marble.) The frighteningly emaciated Thinifers who work to exhaustion, drink nothing but water, and are as hard as nails in André Maurois's *Patapoufs et Filifers* (1930) are yellow as custard. A dwarf hides behind a head of lettuce to lay traps for the hero in the Countess d'Aulnoy's seventeenth-century fairy tale classic, *Le nain jaune*. And the creature in Carl Sandburg's *Rootabaga Stories* (1922) called the flongboo, which uses its tail to light its home in a hollow tree and to illuminate its path across a prairie while hunting at night, is yellow.

Scriabin, who believed musical keys implied equivalents in color, thought D major was yellow. (I've listened repeatedly and actually *can* envision sunlight in Bach's Sonata in D Major, Wagner's Polonaise, Borodin's String Quartet No. 2 in D Major,

and several of Haydn's string quartets.) "My hearing became enormously keen," wrote Theophile Gautier, while smoking hashish. "I heard the noises of colors: green, red, blue, yellow sounds came to me in perfectly distinct waves." Jazz critic Whitney Balliett has written that the unison clarinets in Duke Ellington's band suggest to him chrome yellow. There is also definitely something in its tonal coloration of flatness and boredom. I once knew a young woman from Moorestown, New Jersey, whose voice, I used to think, was pale yellow, as enervatedly she droned on and on in her dull, unimaginative way.

Our sun is yellow. A nuclear furnace, the dominant body in our solar system both in mass and size, the sun's apparent magnitude is −26.8, almost 50 magnitudes brighter than the faintest observable stars, which means it's about 100,000,000,000,000,000,000 times as bright. It produces its energy by converting atoms of hydrogen into atoms of helium. Energy is generated in a central inner core hotter than Tophet itself and then carried by radiation to a subsurface zone, where it produces convective motions, the gases of the corona being so hot, the swirls of particles streaming outward so powerful, it has no clearly defined outer boundary and can actually disturb the magnetic fields of the earth. The sun is classified as a yellow-dwarf star, midway between the

largest and the smallest stars and between the hottest blue-whites and the coolest red stars. In astrological studies, in the Early Zodiac, yellow is the color of the Sun ruling Leo. "The Sun is God," whispered painter J.M.W. Turner, a few weeks before he died, with the setting rays of it on his face.

An eerie yellow fog, uncannily gritty and moist with sand, shrouded Basle, Switzerland, in May 1937, having been whipped across the Alps from the Sahara Desert, according to the best guesses of scientists, in a ferocious blowing storm. Volcano ash, of course, from one state can darken skies entire states away.

The Temple of Nebuchadnezzar II, particularly the fourth level, was devoted to the sun. In the constellation of Auriga, incidentally, the star Capella is yellow, as is Bellatrix in the constellation of Orion. Then there is the clean yellow sunshine Nietzsche spoke of that he found in Bizet's music. "Sunshine suggests the imbecile, barnyard joy of the human kohlrabi," wrote H. L. Mencken in *Prejudices: Fifth Series,* "the official optimism of a steadily delighted and increasingly insane Republic." While Wallace Stevens in "Sea Surface Full of Clouds" can write

> *In the morning in the blue snow*
> *The catholic sun, its majesty,*
> *Pinks and pinks the ice-hard melanchole*

The word in Mexico for the god who supported the sky was *Kan,* yellow. Yellow stripes on a Native American Mandan warrior's right arm represent deeds of valor in battle, and a painted yellow hand, that he has taken prisoners in violent engagements. The color has a spiritual cast. The saffron robes of Buddhist monks symbolize renunciation, desireless-ness, humility. And to the Hindu yellow embodies light, life, truth, immortality. In Tibet, yellow signifies the direction north, as it does among the Creek, Hopi, and Zuni Indians. The Dge-lugs-pa, formerly the Gelukpa, sect of Tibet, who believe in the endless reincarnation of a *bodhisattva,* are also called Yellow Hats. A young monk carries the traditional hat of yellow wool in his hand for the first few years, and then wears it over his left shoulder. The sect was founded by Tsong-Ka-pa (1355–1475), who opposed the Nyigma-pa ("old school") sect, whose monks wear red hats, which continue to emphasize the esoteric rites and sorcery deriving from the Bon religion. An umbrella of yellow silk, a symbol of dignity, is one of the traditional Tibetan good-luck symbols. The "Yellow Turban" Uprising during the 2nd century A.D. in China took its name from revolutionaries during the Han Dynasty for the particular headgear they wore. It is the color of the Vaisya or third mercantile caste in India. It is also the favorite color in the quillwork designs on moccasins among

the American Plains Indians, as well as the bright jersey worn by the triumphant leading cyclist in the world-famous race, the Tour de France.

A subjective list of things that seem yellow to me are maiden aunts, gumdrops, diffidence, the letter *H,* all women's poems (except Emily Dickinson's, which of course are red), lewd suggestions, debt, the seventies, Nat "King" Cole's song "China Gate," sadness, the Yale English department faculty, the name as well as the country of Brazil, August, the Houses of Congress, the word "hills," lampshades, physicians, insurance agents, the thin, squealing noises of children in playgrounds (". . . making fun of life," according to British folklorist Iona Opie), political compromise, the state of Nebraska, illness in general, old wagon wheels, whispering, and the vapid name Catharine.

Many cities can be found with flavic origins. Along with Amarillo, Texas, there's Gulen, Norway. The village of Geleen in Holland. Possibly Sarkad, Hungary. Xanthus was an ancient town of Lycia in Asia Minor. And there is in the republic of Turkey— for *Sari* is the Turkish root for yellow—Sarigöl, Sarikavak, Sarikemer, Sariramiş, Lake Sarykopa. In Khazakstan sits the town of Sarïŝagan on the shores of Lake Balkhash and also the Sarï Iŝikotrau Desert. Lake Balkhash, by the way, is almost bisected by the Sarimsek Peninsula. There is also the Sarïkamïŝ

Depression in Uzbekistan (also a Turkic-speaking region) on the Ust Urt Plateau, between the Caspian and Aral seas. The name *Sarï Kamïš* in Turkish, and I believe also Uzbek and Kazakh, means "yellow reed or cane." Finally, there is a Sarïkol Range, meaning "yellow arm" or "yellow branch" in the Turkic languages, in the Eastern Pamir Mountains on the Tadzhikistan-China border. Tadzhik is an Iranian (and thus Indo-European) rather than Turkic (and thus Altaic) language, but I suspect the Tadzhiks borrowed the name Sarïkol from a local Turkic language, most likely Uigur. There is also an Iranian dialect called Sarîkolî spoken in the southwest part of the Xinjiang Uygur Zizhiqu (the Sinkiang Uigur Autonomous Region) of China, near the Tadzhikistan border. Sarîkolî, which is no doubt connected with the Sarïkol Range of that area, is a variant or dialect of Shughnî, a Pamirian Iranian language distinct from though related to Tadzhik. Aren't consonants fun? Want a few more?

In Kansu Province in western-central China, there is a small Turkic-speaking ethnic minority called the Sarïg-Uygur or "Yellow Uigur" (so called from being mistaken by their local Chinese neighbors for a branch or tribe of the far more numerous and well-known Uigur of Xinjiang Province?) a bit farther west. The Sarïg Uygur language, related to but distinct from that of the Uigur proper, is also related to several other Turkic languages of western

China and the immediately adjacent areas of the former USSR, such as Tuva, Khakass, Shor, Salar, Teleut, Abakan, and Oirot, all spoken by small ethnic groups of a few thousand or tens of thousands of souls each. The Sarïg Uygur do not use their own language as a written language but rely for that purpose on the closely related but distinct Uigur proper. (Uigur has been written since 1947 in the Cyrillic alphabet, after being traditionally written in the Arabic alphabet, paralleled by Khazak, Kirghiz, Uzbek, and Türkmen.) As to why the Sarïg Uygur are called *Yellow* Uigurs, I can only guess, though it is possible it might come from their traditional habit of wearing garments dyed yellow, or from their being led by saffron-robed Buddhist monks against their mainly Muslim neighbors, or from being a bit more yellow-complected and racially Mongoloid than the more part-Caucasoid true Uigur. I suppose, had he ever heard of these exotic people, H. P. Lovecraft might have used them in one of his macabre stories as sorcerers from the wind-swept Plateau of Leng who worshipped Robert W. Chambers' "King in Yellow," the name of which derives from the title of an imaginary book, comparable to Lovecraft's *Necronomicon,* and effectively used by Chambers, a turn-of-the-century American novelist, in some of his horror stories as a forbidding book that literally drove all of its readers insane.

Yellow is the Chinese color for royalty. During the Ch'ing dynasty (1644–1911) only the emperor could wear yellow. It was the special color he wore to worship the sky. The Yellow Emperor, Huang Ti (2698–2598 B.C.), who is regarded as the inventor of writing, the bow and arrow, and wooden carts, as well as the founder of dietetics and acupuncture, is buried in the Yellow Tomb (Huang Ling) in Sho-anxi. His title referred of course, not to the color of his skin, but to his position. Imperial parties, processing, were borne in yellow sedan chairs and palanquins of yellow satin flashing with gold, led by swarms of cavalry bearing thousands of flags and mounted officials hovering around the flanks of the cavalcade. With the Chinese, gold on yellow indicates special happiness, while yellow on black signifies an old man's death. (It may be mentioned here that the Chinese esteem black [*hsuan*], not yellow, as the most expressive of all colors—it signifies, according to Kurt Herberts in his *Artists' Techniques,* the "inexhaustibility of the essence of the world"— and [the Chinese] have developed such a high degree of sensitivity to the possible uses of it that they use black alone as five different colors.) In Chinese opera, an actor's face painted yellow means piety. "Yellowfish," incidentally, was for a long time a vile racial term used on the Pacific coast for illegal Chinese immigrants. Yellow tubes are often used in China in burial ceremonies to pay homage to the

earth. At celebrations held at temples of Confucius, say on his birthday, in autumn, young people, playing flutes and crowned with pheasant feathers, always wear yellow. Nankeen, the natural yellow color of Nankin cotton (and today the fabric), is named of course after the city of Nankin in China. Chinese rice wine is yellow. A "clouded" or dense wine with a syruplike liquid reminiscent of sherries, it is buried in earthenware vessels for years. A yellow wine from Shaoxing is rather famous. Even the yellow fruit we know of as the banana was originally Asian, migrating with the Spanish conquistadors to America in 1516. In China, earthenware pottery, covered in pewter leaf on a sort of primuline yellow glaze, was often filled with food which was supposed to nourish those who left for the "yellow fountains," that is, the next world.

Not everything yellow is acceptable to the Chinese, however. They dislike butter, for one thing. And in Mrs. I. L. Hauser's *The Orient and Its People* (1876), we read, "Chinese cooks can scarcely repress their disgust, when obliged to keep for their foreign master's use, the 'yellow scum' that rises upon milk." (They prefer curds.)

The Yellow River (Huang Ho) in China gets its name from the color as the direct result of the natural movement of the water which in turmoil causes layers of yellow mud to build up. This mud, called loess, is exceptionally fertile and in places along the

river 650 feet deep. The river is extremely turbid, transporting enormous quantities of loess, about two pounds per square foot, depositing it everywhere as alluvium. Ocean color yields clues of other things. Whereas deltas and coastal villages and settlements tend to impart to water a brownish cast. Horace in his *Odes* several times refers to the *"flavum Tiberim,"* the yellow Tiber, a river commonly plied in his day. The Yellow Sea in China in color lives up to its name, deriving its earthy fullness of tone no doubt from the many villages along its estuaries, and the same can be said of virtually any muddy watercourse. The normal look of Flanders and much of northeastern France, incidentally, where by November 1918 there were two million English casualties in that barbaric war, to say nothing of those on the German side, was of a fluid stinking mud that was a predominantly evil yellow.

"Imagine slender, tall Chinese women like snakes erected upright," Kazantzakis wrote during his first visit to Singapore. "Never did the human body look so like a sword. And through the dresses slit open at the sides, at each step, the yellow blade of the leg glistens."

A page from Jean-François Champollion's manuscript of his great work on the deciphering of hieroglyphics, published in 1824, shows, among other

things, the way colors were used by the Egyptians, and whereas the sky is predictably blue, the earth red, and the moon yellow, while men's skin is always red—from long hours of working in the field?—women's skin is always shown as yellow.

As to fashion, Nero Wolfe, the corpulent detective created by Rex Stout who weighed 278 pounds, declared his favorite color was yellow. But it is a strangely acute color. Not many people look very good wearing it, with the exception of blacks and dark-haired and darker-skinned people. Consider the recent U.S. postage stamp of Elvis Presley, sporting a yellow jacket. And Douglas Fairbanks, a man whose swarthiness resembled an eggplant's, had dozens of yellow pajamas of heavy silk made for him in China. Bette Davis, when she was a young Warner Bros. star, was known for going around wearing yellow horned-rim glasses. And who can forget Judy Garland in her sunburst yellow dress, singing "You Stole My Heart Away" in Vincente Minnelli's film *Till the Clouds Roll By*? Grace Kelly in *High Society* wears a lovely shoulderless yellow dress as Frank Sinatra croons "You're Sensational." And what about the celadon green raw silk dress, hinting of yellow, that she wore in *Rear Window,* with its straight box jacket, wide neckline, and tight hip that caused such a furor fashionwise? Blondes and redheads, however, have trouble with yellow.

Darker and more neutralized yellows and greenish yellows, such as $Y\frac{8}{1}$, $Y\frac{5}{4}$, $Y\frac{2}{2}$, hues associated with disease and sickness and indecency, are the most unpopular and disliked of colors in clothes. Ford Madox Ford's wife, Elsie, wore long floating yellow garments so often that a disapproving group of neighbors behind her back derisively referred to her as "the Mustard Pot." Golfers commonly wear the color to feel outdoorsy and free. Ancient Egyptians wore yellow mourning robes symbolizing the withering of leaves at the onset of winter— Shakespeare's "sere and yellow leaf"—as do Burmese monks to this day! And in ecclesiastical color symbolism, saffron stands for confessors. There are, most notably, golden yellow chasubles, maniples, and copes.

At the Yellow and White Exhibition in 1883, held at the Fine Art Society in London, James Abbott McNeill Whistler, encouraging outrage, affectedly wore yellow socks, and his attendants yellow neckties, while little yellow and white butterflies were distributed. "The whole thing is a joy," he wrote, "and indeed a masterpiece of mischief."

Aubrey Beardsley, the decadent illustrator, affected lemon-yellow gloves and even had his entire studio on Warwick Square painted a deep, rich yellow with black wood trim. And Mrs. Bridell-Fox, who met Robert Browning in 1836, told his

biographer Mrs. Orr—and Virginia Woolf had him so appear in her novel *Flush* (1933)—that "he was then slim and dark, and very handsome, and— may I hint it?—just a trifle of a dandy, addicted to lemon-coloured kid gloves and such things." And isn't it symbolically the color of slouching, cruel insouciance, jovial decay in *The Great Gatsby* with Daisy, the Eggs, the sportscar? Beautiful Constance Lloyd's bridal dress was pale yellow, with a veil of saffron silk strewn with tiny pearls, the day she married Oscar Wilde. And sometime later, in the 1920s, Baronin Elsa von Freitag-Loringhaven, a friend of novelist Djuna Barnes, wore—along with black lipstick—bright yellow face powder. Alfred Jarry, eccentric author of *Ubu Roi,* for Mallarmé's funeral wore a pair of Madame Rachilde's bright yellow shoes. Loathsome, overreaching Sammy Glick in *What Makes Sammy Run?* drives a yellow Cadillac. And Honest Abe Kusich, the dwarf book- maker in Nathaniel West's novel *The Day of the Locust,* complete with black shirt, always sported a yellow tie. In education, there are the identification colors of various doctoral hoods: citron (social work), golden yellow (science), and lemon (library science). Have you ever seen yellow furs? There are yellow bears.

Yellow ribbons, worn by sweethearts, according to John Wayne in *She Wore a Yellow Ribbon,* became in America from the 1980s on, thanks to a popular

song sung by Tony Orlando and Dawn, "Tie a Yellow Ribbon Round the Old Oak Tree," a symbol, whether wrapped around trees or wherever, of remembrance, loyalty, and love—of Cory Aquino's slain husband (and political party) in the Phillipines, for example, and, during the Desert Storm War in Iraq in 1991, at least in its wretched excesses, of a fanatical jingoism in America where virtually every object in sight sprouted yellow bows, although it was *our* army which killed 150,000 mostly innocent Iraqis. In 1876, the Centennial year, women wore yellow ribbons as a symbol of the struggle for women's rights. A poem, "The Yellow Ribbon," composed by Marie LeBaron and put to the music of the Irish ballad "The Wearing of the Green," ends with the words "We boast our land of freedom, the unshackling of the slaves; we point with proud, though bleeding hearts, to myriads of graves. They tell the story of a war that ended slavery's night; and still women struggle for Liberty, and Right." In the 1890s, the *Yellow Ribbon Speaker,* a popular book in the U.S., was comprised of: "Equal Rights Readings and Recitations, in Prose and Verse, compiled by Rev. Anna H. Shaw, Alice Stone Blackwell, and Lucy E. Anthony." And in 1981 another yellow ribbon campaign was undertaken in America by the Homemaker's Equal Rights Association.

And in the film *Oklahoma!* there are full bursts of sunny yellow in Curly's (Gordon MacRae) shirt and

the clapboard of Laurie's (Shirley Jones) house, all redolent of love, youth, and renewal during the singing of the splendid "People Will Say We're in Love." (Shirley Jones' blondness and beauty—classic American looks—could alone light up the screen.) There are all the yellow parasols, flouncy dresses, hats, and even the Claremore train station, butter-bright as the sun. And what about the waving wheat that sure smells sweet when the wind comes sweeping down the plains?

Perfume fragrances are embodied in gold or yellow, as with Chanel, for the oriental concept of Samsara, sculptor Robert Granai came up with a red bottle based on a Tibetan figure; the yellow bottle cap, according to Timothy Greene in *Smithsonian,* "represents the deep closed eyes on many Buddhist statues." Speaking of perfume, ambergris, that rare substance found in the sperm whale that looks like "rare Windsor soap," "worth a gold guinea an ounce to any druggist," as Herman Melville tells us, is "a hue between yellow and an ash color." Does yellow suggest virility as well as serenity? Viking strength? What is hinted at, for instance, when Quince suggests to Bottom in *A Midsummer Night's Dream* (I, ii) that he might wear a yellow beard for the character of Pyramus?

Pencils of course are yellow. It is virtually the *sign* of pencilness. Even Scripto's throwaway plastic pencil in the 1980s—a fake—was yellow. The famous

Koh-I-Noor, "the original yellow pencil," which was exhibited for the first time at the Columbia Exposition in 1893—and is still sold today—was painted golden yellow. (Koh-I-Noors made in 1938 in a factory in Bloomsbury, New Jersey, were given fourteen coats of golden-yellow lacquer, the ends of the pencils sprayed with gold paint, and all lettering was applied in 16-carat gold leaf.) According to Henry Petroski's definitive work, *The Pencil* (1990), "Its suggestion of the Oriental source of the finest graphite [at least until the turn of the century] . . . made yellow a brilliant choice." But pencils painted yellow were found in fact as early as the middle of the nineteenth century, and they were most likely painted that color, in spite of the odd fact that it became a sign of quality in the last decade of the century to cover the imperfect wood used in some of the pencils. Today, three out of four pencils made are painted yellow.

To some degree, it's an egalitarian color. In the sixties and seventies it became, and remained, a popular and relentless color, suggesting to youth perhaps renewal, hope, and spontaneity. Every product had lemon infusions, from shampoo to detergents to soft drinks. Remember "Harvest Gold"? It was easily the most popular appliance color of the time, and had the weak undermedicated tint of nausea. The other grim tone of the period, arguably even more hideous, was "Avocado." Refrigerators,

stoves, washing machines, etcetera, with these colors, nowadays as outdated as disco LPs, can't even be given away and in fact are often offered free in classified ads. Regarding wretched excesses, in the 1970s there were leisure suits that had both the nap and color of baby vomit. Colors in sunburst yellow and the hues of manure and mustard and mung beans were very popular, as well.

Why is blond such a coveted color in hair? It was the highly desired color of enchantment throughout the Renaissance, of course. Simonetta Vespucci, the stunningly beautiful model for both Botticelli's *Birth of Venus* and *Primavera,* among other well-known beauties of that age—such as Isabella d'Este, Guilia Farnese, and even Lucrezia Borgia, who, exquisitely painted by Pinturicchio, was known for washing gold into her hair—was singled out as a paragon of beauty not only for her family and face but particularly for her honey-colored hair. (Whenever I look upon her radiance in *Birth of Venus,* I am somehow reminded of the Duke Ellington remark "Pretty can only get prettier, but beauty compounds itself.") An unknown Renaissance poet asks,

> *What shall I say of the color of their hair?*
> *That each one wants hair long and blonde*
> * and beautiful*
> *But for this one must sit in the sun*
> *What does it matter? Everything for this.*

Caterina Sforza, countess of Imola and Forli, wife of Count Girolamo Riario, in fact, took the time to compile a fashion handbook, *Esperimenti,* in the exotic pages of which are provided several formulae for turning hair blond and beautiful. A recipe used by the Countess Nani, which is cited in Rachel Erlanger's biography of Lucrezia Borgia, called for "two pounds of alum, six ounces of black sulphur, and four ounces of honey, the whole to be diluted to achieve a shade called *filo d'oro.*" Our ancient romancers, of the legends of fable and chivalry and Charlemagne, according to mythologist Thomas Bulfinch, always dwelt "with great complacency on the fair hair and delicate complexion of their heroines [and heroes. "Behold Pelides with his yellow hair," wrote George Santayana in *Before a Statue of Achilles.*] This taste continued for a long time, and to learn to render hair light became an object of study. Even when wigs came into fashion, they were all flaxen. Such was the color of the hair of the Gauls and of their German conquerors. It required some centuries to reconcile their eyes to the swarthy beauties of their Spanish and Italian neighbors." Venetian ladies during the nineteenth century, who passionately yearned for its blond distinction, counterfeited their hair with dye. Anent dyed blondes, Rita Hayworth willingly submitted to her husband Orson Welles' request that she cut and dye her hair "topaz blonde"—it had already been dyed red, for

her original hair was brown—for *The Lady from Shanghai,* his enigmatic film of greed, deception, and violence.

Is it the shine of golden hair, the "flash," the fact that it's so instantly the cynosure of so many eyes that gives it such appeal? (Gentlemen prefer blondes, remember, but blondes prefer diamonds.) And is that why blondes are thought to be so available? Easy? Dim-witted? (What do you get if you stick five blondes in a freezer? Frosted flakes.) Treated like whores in the Middle East? Or is it because truly lovely, iridescent, really natural blondes, the paradigm, are comparatively so rare? What on earth, including cornflowers, butterflies, the rich deep gold on Norwegian bridal pins, or even pure Javanese sunshine is as gold as the Breck girls' hair? Or its light? Or the fresh puffs of scent coming from it which recall for me lines from Maria Gowen Brooks' long poem "Zophiël, or the Bride of Seven":

> *Oh, my Phronema! how thy yellow hair*
> *Was fragrant, when, by looks alone carest,*
> *I felt it, wafted by the pitying air*
> *Float o'er my lips and touch my fervid breast!*

The third chakra, one of those vortices of energy situated along the plexus or middle of the body—

the center for personal power, self-image, and the emotions—is yellow. Could that be the traditional irresistibility of blond and shining hair?

It may be observed, however, that a certain amount of dim-wittedness and pusillanimity, even evil, has often been associated with yellow hair. The hair of Eugene Sue's Wandering Jew, the beast-tamer Morok, is "yellow and dull . . . straight and lank." Like Chaucer's mercenary Pardoner ("heer as yelow as wax / But smothe it heeng as dooth a strike of flax"). The yellow-haired Berbers in Arabia, mentioned by Doughty, are "a remnant of the former peoples of Barbary." Along with many other xanthocroids like Dorothy Parker's Big Blonde, e. e. cummings' Olaf, and a lot of those Breughel country bumpkins with bulging codpieces and little brains. Speaking of hair, remember in old barber shops those long-necked bottles of yellow bay rum—you couldn't help but stare at them from your chair—with brand names like Troll and Noonan?

What of yellow eyes? Can they be found in any creatures besides animals and reptiles? Indeed, they can. Frankenstein's poor monster looked out of "yellow, watery, but speculative eyes." Dickens' character Verity Hawkyard's yellow face seems to tinge his very eyes. Leon Trotsky, upon first meeting Stalin in Vienna in 1913, spoke of his "dim but not commonplace" appearance, "a morose concentration" in his

face, and an expression of set hostility in his "yellow eyes." Arab boys often have yellow eyes. And who that saw her in the *The Girl with the Golden Eyes*—a film based on Balzac's novel in which, on the very first page, he rather oddly refers to the entire Parisian populace as "yellow"—could ever forget the meltingly beautiful look of French actress Francoise Dorléac (Catherine Deneuve's sister), who was later tragically killed in a car accident at twenty-five? Amiable Southerner Sharon Kincaid ("Right here in front of God and everybody?") in Walker Percy's *The Moviegoer* has yellow eyes. The old vivacious prostitute in García Márquez's story "Maria Dos Prazeres," a mulatta, has "pitiless yellow eyes." And of Dashiell Hammett's great detective Sam Spade we read: "His yellow-grey eyes were horizontal . . . He looked rather pleasantly like a blond Satan." I've always thought the Colorado River toad, a warty greenish lump—its venom is volatile—had especially weird yellow eyes. But nothing on earth has eyes as dangerously memorable, as soft and unsleeping a steel yellow, as the Alaskan Gray Wolf, staring directly at you.

The infant sired by the devil in the novel *Rosemary's Baby* has yellow eyes as its most distinctive feature. "His eyes were golden-yellow, all golden-yellow, with neither whites nor irises; all golden-yellow with vertical black-slit pupils. She looked at him. He looked at her, golden-yellowly, and then

at the swaying upside-down Crucifix. She looked at them watching her and knife-in-hand screamed at them, 'What have you done to his eyes?' "

Georgiana Peacher in *Mary Stuart's Ravishment Descending Time* may well have given us the greatest passage on yellow eyes ever written, which I include here for, among other things, the edification of those undermedicated hacks, shameless book-a-year novelists, and jug-headed commercialist yahoos whose predictable prose comes cranking out of the trafila of their heads like streams of common pasta:

Bothwell lifted a red raspberry to balance in suspension by Mary's gold irides, striped with hazel rays, equals of golden eagle eyes, brother native in this Scottish realm. Her narial cartilage, soft ossa slope, tilted to catch aroma of the crimson scent. Pink tint buds on her gentle tongue swelled in claret glow. Ruby flesh of small berryballs blushed by candle flame. Yellow auburn threads alerted in her hirsute dwells, live fine fires, color swatch matched to earth sand stone, baked by volcanic arts, creations of masses and plasms erupted from seas of long ago, lava flashed hues, molten pigments painted to creatures, fluid fauna fish fowl, flowing with jaspery

cherts, precious ores processed in nature's deer marten hare owl hedgehog squirrel salmon heather thistle and seal. Mary's eyes syncopated spectrums; orange coppered yellowed pumpkined ambered lavafountained blued primrosed, rheostated golds in bolder flakes.

Bothwell thumbed the juju fruit to closer approximation before female pupils in black dilation. Irises thinned; gilded eminences embraced night jewels. Onyx breathed. Stars fainted.

I once saw in the Smithsonian Blue Room, reminding me somehow of eyes in its perfect cleavage (thus, the name), the largest euclase in the world, an extremely rare greenish yellow stone. And isn't jasper yellowish green in hue?

The "Tiffany Yellow," perhaps the largest and finest of yellow diamonds, was found at the Kimberly Mine in South Africa in 1878. It was cut in Paris to a double brilliant weighing 128.5 metric carats. It has 40 facets on the crown, 44 on the pavilion or lower side, and 17 on the girdle, a total of 101 facets. It is ironic to learn that this unprecedented number of facets was given the stone to make it not *more* brilliant, but rather less so, simply because, as the rare stone was of a yellow tint, it was thought better to

give it the effect of a smothered, smoldering fire than one of bold flashing radiance. The stone has the unusual feature in a yellow diamond of seeming to return its color by means of artificial light.

A very light straw color is a raw diamond's commonest tint, though yellow diamonds are considered inferior to the blue and white varieties, except of course for the classic stones. (Sir William Crookes once changed a pale yellow diamond to a bluish color by keeping it embedded in radium bromide for three months.) In the seventeenth century, Shah Jahan gave to his favorite wife, Arjumad Banū Begam, the Mumtaz Mahal of Taj Mahal fame, a formidable heart-shaped yellow diamond, which some say was as beautiful as the Great Mogul, discovered in 1650. There is also the "Austrian Yellow" (a.k.a. the "Florentine" or "Grand Duke of Tuscany"), one of the Austrian crown jewels. It is rose-cut in the form of a star with nine rays, weighs 137.25 metric carats, and tends somewhat to a citron color. The famous "Orlov," which weighs 194½ carats, also has somewhat of a yellow tinge. It was stolen by a French soldier from the eye of an idol in a Brahmin temple, stolen again from him by a ship's captain, then bought by Prince Orlov for $600,000 and given as a gift to the empress Catherine II of Russia. It remains one of the Russian crown jewels.

Beryls supposedly cure jaundice and bad livers. (Some odd jaundice cures? Yellow spiders rolled in

butter in England; turnips, gold coins, saffron in Germany; gold beads in Russia.) Yellow sapphires indicate charity. Wulfenite, a lead molybdate, is yellow. It can be scratched by a knife blade but not by a copper coin. Goethite, an iron oxide named after the German poet Goethe, who was a student and collector of minerals, is yellow. Like topazes, which vary from canary to deep orange. (Some are actually white!) Yellow topazes can be made pink or red by heating. There are also yellow sapphires, precious stones of great value. Realgar, arsenic sulfide in its simplest form, is also yellow. As is of course native sulfur, known to the ancients as brimstone. (When sulfur crystals are held close to the ear, they can be heard to crackle, on account of the warmth of your hand, because the outer layers expand away from the still-cool interior.) "In the Hall of Gems at the Museum of Natural History in New York, I once stood in front of a huge piece of sulfur so yellow," wrote poet Diane Ackerman, "I began to cry . . . The intensity of the color affected my nervous system." John Dryden referred to guineas as "yellow boys," and gold British coins known as sovereigns were commonly called "yellows" or "yellow mould." And then there's that other commodity, as the English poet Thomas Hood wrote,

> *Gold! gold! gold! gold!*
> *Bright and yellow, hard and cold*

In 1896, George Washington Carmack made his great discovery on Rabbit Creek, a tributary of the Throndiuck River—quickly changed to the more easily pronounceable Klondike River—in the Canadian Yukon. Something sparkled. He brushed away the loose gravel. "I could see the raw gold laying thick between flakey slabs like cheese sandwiches."

Precious gold. In Wat Traimit, a temple in Bangkok, stands a three-yard-tall, five-and-a-half-ton solid-gold Buddha, which gleams like no other gold artifact I have ever seen, except perhaps for the funerary mask of King Tut. Gold is also the hue of magnificence in Western Christian civilization, where it is used in the churches on monstrances, chalices and chasubles, pyxes, altar coverings, and in the form of gold-leaf backgrounds of paintings to signify light and divine glory. One remembers gold as the favorite metal, the definitive aura of Byzantium—think of that magic city's mosaics and W. B. Yeats' irresistibly rich imagery celebrating both—but it is also the color, as art critic Robert Hughes reminds us, discussing Andy Warhol's Marilyn Monroe, "patched like a gaudy stamp on a ground of gold leaf," of drag queens, too.

Eros is often thought of in yellow terms. The Yellow Cat was once a well-known brothel in the Strand in London. *Yellow Silk, A Journal of Erotic Arts* is a currently popular quarterly magazine. I can still remember the smoldering photograph of Nancy

Kwan, star of *The World of Suzie Wong,* in that tight dress of yellow silk on the cover of *Life* (October 24, 1960). Yellow has always been the color of debauchery, impure love, and trashiness. The basic color scheme of the sulfurous film *Last Tango in Paris* is yellow. A hint of degeneracy has always been associated with the color, a mood of enervation, corruption, a strange sort of involuted unhealthy languor, with as much a touch of the erotoexotic as the forbidding yellow hills of Macao. As a matter of fact, "The Yellow Trade" in China always means vice (pornography, brothels, etcetera). *The Yellow Book* was a decadent turn-of-the-century publication, filled with stories of preciosity and inversion. It was yellow, to flaunt the flaring "aesthetic" color, which was also the color of French novels, like the infamous *Aphrodite* of Pierre Louys, the book that invert Oscar Wilde was reading in the Cadogan Hotel when he was arrested and which, being reported as a "yellow book," immediately brought into disrepute the publication with that name and hastened its demise, though *The Yellow Book* was in and of itself indeed considered decadent. Somewhat presaging its louche and unwholesome reputation, the publisher's prospectus announced it would "have the courage of its modernness, and not tremble at the frown of Mrs. Grundy." "I'm reading a yellow" (*un giallo*) is slang in Italy, by the way, where all detective novels are called yellows because of their yellow

spine. And isn't it interesting that the *National Geographic* magazine with its yellow border, while generally high-minded, as Marina Warner recently pointed out, "often carried connotations of the forbidden for certain readers for whom the magazine was notorious as the first and perhaps only place they were permitted to look at nakedness"?

In Marcia Davenport's novel *Of Lena Geyer* (1936), drab Elsie de Haven, who harbors a deep crush on the soprano, sends diva Lena a huge box of yellow roses after each and every performance, with a note cagily disguising her gender (E. deH). Critic Wayne Koestenbaum notes, "Clearly this is queer behaviour: Elsie says, 'Call me freak if you like.' " The drug LSD was also called "yellow sunshine"; "yellow jackets" is slang for capsules of Nembutal, a barbiturate; a song by Mom's Boys from the album *Freakout USA,* a classic psychedelic compilation LP from the 1960s, is called "Yellow Pills"; and going back to that very same period, many people associated the Beatles song "Yellow Submarine"—were hazy, semi-surreal opium dreams suggested?—with the practice of "getting high." Does the same apply, with its kinky languorous connotations and almost hazy atonal sound, to the old song "Yellow Days"? Or the drum-beating and mantra-like pop song by the English group Sergei Adventuresov and His Wow Federation called "Yellow Telephone"?

Olden days. Long gone days. It is early August,

the first week or two, say, and the westering sun is lowering at eight, settling far away, beyond Webster Park, far past even the distant reaches of Toyland (where once you cross its borders you can never return again), as a low-pressure area moves eastward, and the godly evening skyline of the Medford, Massachusetts of my childhood takes on that mysteriously misty yellow-shrouded cyclorama effect that Walt Kelly warmly celebrated in the color installments of *Pogo* at Okefenokee. I have my dreams to remember, of what never fades.

But what did I see?

Was Socrates correct in Plato's *Theaetetus* when he asserted that what we call a color is neither the active nor the passive element, the seeing or the seen, but something which, passing between them, is peculiar to each percipient? And then if we are never the same, are therefore colors? Is all "process," as Whitehead put it?

Is motion the only reality?

Yellow was much in fashion during 1890 to 1900, the period often referred to as the Yellow Nineties. It was the favorite hue of Burne-Jones and of writers and painters like William Morris and Dante Gabriel Rossetti. Oscar Wilde popularized it. In the delicious "greenery-yallery, Grosvenor Gallery," celebrated by W. S. Gilbert in *Patience,* yellow was the predominant color. Evening gowns of yellow satin were the rage. During the same period in Paris,

Toulouse-Lautrec was making lavish use of sun-yellow in his now famous posters. Yvette Guilbert, who became famous for her risqué songs in *Les Bouffes du Nord* in Paris, in the leading cafés of Germany and England, and in vaudeville in the United States, was the subject of numerous Lautrec drawings and caricatures in which he pictured the tall emaciated French chanteuse in long black gloves and her habitual yellow dress. And of course many of the popular novels of the *fin de siècle* had covers of yellow, a carry-over that, today, makes it the identifying, naughty, somehow scholarly color of all French paperbacks.

As far as books go, all the wonderful novels written in the twenties by Louise Jordan Miln and set in China, *Mr. Wu* (1918), *It Happened in Peking* (1926), *In a Shantung Garden* (1924), etcetera, have appropriately yellow covers, a color that echoes in the titles of many of the strange and forbidding Fu Manchu novels by Sax Rohmer such as *The Yellow Claw* and *The Yellow Shadows,* where its antagonist on lurid dust jackets is portrayed menacing all onlookers with long, sinister fingers. How many Mr. Huangs (Mr. Yellows) in fable and film have peered sinisterly through how many beaded curtains in how many dock-wet Kowloons and Shanghais? The Chinese think of themselves as golden, however, not yellow. They often repeat the old fable that when God made the human race, cooking them in the

oven like dumplings, as it were, he found the first batch white and insufficiently cooked, the second overcooked, black, but the third batch, golden, was just right! It was a color, nevertheless, often linked to evil—thanks perhaps to people like Carolus Linnaeus, who, in his *Systema Naturae* (1758), left us records of classifications such as *"Asiaticus: luridus, melancholicus, rigidus"* (yellow, sad, inflexible) that lent their grim connotations to a racism as unhappily handy to Hollywood as it readily was to bigots in general everywhere. The war *was* good for Hollywood, and some of its memorable movie titles from the 1940s were *Yellow Peril, Slap the Jap Right off the Map,* and, among others, *When Those Little Yellow Bellies Meet the Cohens and the Kellys.*

The repulsive yellow face has long been a traditional bugbear and icon of fright in literature. A Chinese man "convulsively wrestles with one of his many Gods or Devils" and "snarls horribly" in *The Mystery of Edwin Drood.* Sir A. Conan Doyle relies heavily on the use of the yellow face in his stories to scare and intimidate us, even if its source may be, as in one case it is, the result of fatigue. In "The Yellow Face," a particular story in the Sherlock Holmes canon, a hideous mask the color of that strange livid tint disguises the face of a "little coal black negress, with all her white teeth flashing." And remember the awful Dr. Grimesby Roylott in Doyle's "The Speckled Band" having a "face burned yellow with

the sun and marked by every evil passion"? "She seemed to read in his small glittering eyes something fiendlike," we read in A. H. Fitch's *The Breath of the Dragon* (1916), a typically sinophobic line. Remember in Zack Mosley's comic strip, "Smilin Jack," the singular characters "Hong Kong Hatchet" and "The Head," two hideous Orientals? Daryl Klein in his graciously entitled *With the Chinks* (1919) refers several times to the Chinese face as "yellow skin stretched over puny bones." In his novel *War and Peace,* Tolstoy vilifies Napoleon, "the Latin tyrant," "the profaner of Russian soil," as being not only short, stout, a poor rider, and an awful tactician, and for having a "fat and hairy chest," but also, when sitting before his toilette, of having a "yellow bloated face." L. E. Sissman in his poem "Tras Os Mentes" writes,

> *My mother, with a skin of crepe de Chine*
> *Predominantly yellow-colored, sheer*
> *Enough to let the venous blue show through*
> *The secondary bluish carapace,*
> *Coughs, rasps, and rattles in her terminal*
> *Dream . . .*

And Queequeg's face in *Moby-Dick* is "of a dark, purplish yellow color, here and there stuck over with large, blackish looking squares" and is later described as "a mildewed skull," while shipmate Flask speaks of the "gamboge ghost of a Fedallah," that

mysterious Indian Zoroastrian with the Arabic name, and those eerie rowing companions of his, smuggled on board the *Pequod,* described all of them as being "of that vivid tiger-yellow complexion peculiar to some of the aboriginal natives of the Manillas; - a race notorious for a certain diabolism of subtilty." (The business of blacks and tattoos is aesthetically interesting. Ever hear of yellow tattoos? Among the Nandi, Lumbwa, Elkoyni, and Kalamega peoples of Africa, normal tattooing almost disappears in the darkness of their Semi-hamitic skin, but the corrosive strips of bast they plaster on, once removed, make the lines of the wound appear much lighter than the skin and so remain pale yellow.) May I mention here the frisson I had in Moscow in 1966 at the tomb of Lenin upon seeing skin, quite yellow, tightly drawn across the high cheekbones and domed forehead of the great revolutionary? Or in the low, dark crypts of St. Michin's Church in Dublin, finding the *real* leathern-yellow skin of ancient Crusaders still on their skeletons?

It all put me in mind of creepy Mrs. Danvers in du Maurier's *Rebecca* and that one hideously arresting detail I've never forgotten: "I could see how tightly the skin was stretched across her face, showing the cheek-bones. There were little patches of yellow"—shudder!—"beneath her ears."

Yellow is often taken to be the color of protection, as well. A sterilized second-hand mattress

always carries a yellow tag. Widows in Guatemala frequently paint their bodies yellow. Yellow on cream in Persian rugs signifies modesty. Diseases in Malaysia are symbolically driven away in a yellow ship. In India, brides often wear tattered yellow garments six days before the wedding to drive away evil spirits, and the wearing of yellow flowers in that country often accompanies the performance of *puja,* a traditional Vedic ceremony of thanksgiving, involving a brazier of live coals. Yellow—along with red—is also the marriage color in Egypt, the Orient, Russia, and the Balkans. It is the color of light and transformation throughout the world. "York Minster, with the sun new-washed for bed shining full on the west windows, looked lovelier than I had ever seen it. Yellow, crisp, and *eatable,* like the crust of an apple-pie," wrote James Agate in *Ego* (1935). And it is equally the color of comfort. One thinks of the welcoming yellow doors in Mexican villages. The most popular room at the Savile Club in London, founded in 1868, is the Sandpit, so called because of the yellow-beige decor of the sofas and armchairs around the fireplace. Comic book detective Dick Tracy's topcoat and fedora all through the film *Dick Tracy* are yellow and reflect a sunny benevolence. Some say the color brings luck. Champion swimmer Janet Evans' mother wore a yellow blouse for luck in the 1988

Olympic Games at Seoul, and her daughter won three gold medals.

It is also considered unlucky. Yellow in traveling carnivals is constantly avoided as an ill omen. Curtains as part of a stage or theatrical set, according to popular superstition, must never be yellow. In fact, theatrical designers are told to avoid yellow whenever they can, simply because it is considered to spell doom for many actors. Was it somehow infelicitous that the old Haymarket Dance Hall in New York, which opened in 1872, was painted yellow or that the original Metropolitan Opera House on Broadway in New York, since razed, was built in 1883 of yellow brick and was referred to familiarly as "the Yellow Brick Brewery"? It was in the old Craigie Mansion at 105 Brattle Street in Cambridge, Massachusetts, where Longfellow wrote "The Children's Hour," that a tragic fire on July 10, 1861, took the life of his wife, Frances, as she was sealing locks of their children's hair by candle. The building featured in H. P. Lovecraft's chilling story "The Shunned House"—it still stands at 135 Benefit Street in Providence, Rhode Island, built over a haunted graveyard—is of yellow clapboard.

Concerning structures, a famous Hollywood landmark was the DeMille barn, a two-story yellow affair, built originally in 1895 on the southeast corner of Selma Avenue and Vine Street. In 1913 Cecil

B. DeMille rented it from Jesse Lasky for $200 a week to make his first spectacle, *The Squaw Man*. When Paramount, the successor to the Lasky company, moved to a twenty-six-acre studio on Melrose Avenue in 1927, the sentimental executives took along the barn, which they used as a company library; then in a somewhat diminishing progression, as a gymnasium; then as a set for the "Bonanza" television series. In 1979 Paramount turned over the semidilapidated DeMille barn to the Hollywood Historic Trust and it was moved to a parking lot on Vine Street just north of Hollywood Boulevard. The old relic stood there unused for three years while various interests debated its future. It was finally moved to a "permanent" site across from the Hollywood Bowl, where it became a small movie museum. The lemon-bright shop of Poujauran, that matchless patisserie on 20 rue Jean-Nicot in Paris, is, I would endeavor to add, also one of the great yellow places in the civilized world.

Frogs will often turn yellow. The surface of their skin is translucent. It allows the light rays to pass through and forms a protective cover over the battery of chromatophores within the deeper layers of the skin. The lipophores lie directly under this translucent layer, under which are the guanophores, and under them the melanophores. A frog appears green because the chromatophores have absorbed all the light rays except green. The change from green to

yellow, for protection, takes place when the melanophores are so contracted that the guanophores are unable to reflect much blue or green. The yellow rays from the lipophores are now more numerous than the blue rays from the guanophores, and the frog's skin looks yellow. An iguana, also normally a green color, when trying to escape and fearful, literally turns yellow. And remember Xanthus? He is one of the immortal "golden-hued" horses of the wrathful Achilles (*Iliad*, XIX) who spoke to his master and told him of his approaching death when unjustly chidden by him.

As to creatures, polar bears of the Beaufort Sea in the Arctic Ocean, posing like monarchs on ice floes, are often stained a light gold—*civigniq* (yellow) in Yupik—from the oil of seals they have killed. (White polar bears actually have black *skin*, the better to absorb the sun's warmth.) And distinctions are made in the Yukon between clam-eating walruses, with tusks scratched from opening shells, and the more dangerous seal-eating walruses, whose tusks show yellow from kills.

A certain yellow spider supposedly securely protected as it lurks in the blossom of a yellow primrose, as it will, has been found to be distinctly visible to an eye sensitive to ultraviolet light, for it is only slightly ultraviolet but the primrose is strongly so.

Warnings attract attention, and must. Yellow has a burning, highly visible, almost unoverlookable

shine or sheen to it. Chrome yellow, as a matter of fact, can be seen farther than any other color on earth. Yellow is not surprisingly the color used for quarantine and prohibition—yellow flags were flown on quarantined ships and sometimes hospitals—as well as of course the general warning color code on highways. Christo's artistic display on a landscape in California in 1984 of hundreds and hundreds of standing umbrellas, *The Umbrellas of Japan,* was all sunlit-yellow but incredibly stark. On roads as well as on railroads, amber lights mean proceed with caution and at reduced speed. As to surf, it is the caution color for riptides. Yellow gas canisters fight acrid gases. Yellow indicates caution on the inner guards of planes and heavy machinery, and all passenger life-preservers on an aircraft are yellow; crew members wear orange. A solid yellow card in soccer is always raised by a referee to indicate that a player has committed a flagrant foul and is being cautioned. Cars in the United States are pro-hibited from parking in yellow zones, and cross-walks, which have been traditionally white, are now more commonly yellow. Small collapsible dinghies, used for rescue at sea, are called "yellow doughnuts." Yellow lettering on red means flammable liquid, while the color combination of yellow and purple always indicates a radiation hazard.

Emergency trucks at airports are yellow. So are gas main covers. Yellow is also the fatal warning

color on shipping labels for oxidizing agents and for organic peroxide in the Inter-Governmental Maritime Consultative Organization. And the firetrucks and general equipment of many fire departments throughout the United States are not red any longer but now a slightly eerie gamboge. In junior high school I thrilled at duplicating with relative success (and some parental apprehension) Sir Humphrey Davy's pyrotechnic electrolytic experiments with potassium and sodium, watching those tiny globules catch fire, burning with Walpurgisnachtian flames of yellow.

And you'll recall in Dickens' *Bleak House* (Chapter 32) how, when the cadaverous, gin-soaked old junk dealer, Mr. Krook, dies from spontaneous combustion, he leaves dripping all over the floors and walls a "thick yellow liquor"—a disgusting oil that stinks to high heaven. So impure, so vile, so unlike the smooth yellow waters, say, of Yeats' line "The yellow pool has overflowed high up on the Clooth-na-Bare"—or yellow antimony; or goldwater pounded by the alchemist for magic like a drench of yew; or those unearthly currents in García Márquez' fabulous story "Light Is Like Water" ("A jet of golden light as cool as water began to pour out of the broken bulb"), where the young boys happily sail their rowboat on deep currents of light that fill the enchanted room!

It is surely for its high visibility that it is the color

of tetracycline, rain slickers, legal pads, heavy machinery, the Yellow Pages, highway lines (many), the original Post-it notes, tape measures, the caution flags in motor racing, racetracks, yellow nylon rope, McDonald's golden arches (and the almost comic yellow roof-struts on each squat hut), New York taxicabs, the round lights on construction sawhorses, postboxes in France, direction signs (*segnalazioni turistiche*) in Rome, the police ribbons used to mark off a crime scene, and, because the better seen, presumably the more easily followed, the color of the long, winding Yellow Brick Road that Dorothy Gale takes in *The Wizard of Oz*. Bus stops are marked with yellow posts in Puerto Rico. As to yellow in Puerto Rico, El Morro, the historic fort and castle in Old San Juan, was originally a sort of stucco yellow. By the way, a certain Virgil, a fifty-year-old Oklahoman, who after regaining his sight after forty-five years of total blindness became the subject of a recent article by Dr. Oliver Sacks, more than any other thing he saw, most loved the bright yellow schoolbuses. Amelia Earhart's first plane, a Kinner "Canary," was also a lovely chrome yellow, which she liked to explain was a safety factor if she went down at sea—it could be spotted bobbing in the waves—and she carried a large yellow signal kite on the last flight of her Lockheed Electra in 1937 which could have been flown above the plane or life raft in an emergency. There is always the alertness of bright

efficiency to it. Colonel Charles A. Lindbergh turned out the 45,000 words of *We* about himself and the flight on legal-size sheets of yellow paper. (His wife, Anne, by the way, when young, was transported with delight by seeing sunlight in jars of marmalade.) And what student, whether in college or high school, hasn't spent time in a carrel Hi-liting lines in books with yellow felt-tip pens?

Perhaps that's for its energizing force—brightness implying brightness! According to Eric Danger in *How to Use Color to Sell,* customers who prefer yellow have an intellectual bent.

Frequently, it is taken to be the color of cowardice, of excessive timidity, of pusillanimity. Malvolio, the weak, sour, and censorious underling of *Twelfth Night,* appears in cross-gartered yellow stockings. By a "yellow belly" we mean a craven coward, or a person with a "yellow streak" up his back. A "Yellow Belly," something less widely known, is also a native of the fenlands of East Anglia and Lincolnshire, an allusion to the frogs caught there. Mexican soldiers almost always wore yellow uniforms, and some say this is the origin, the bigoted one, at least in North America, of the cowardly association with the color. William Wetmore Story in his short poem "Cleopatra," a masterpiece, refers to giraffes fleeing wildly "in a yellow cloud of fear"—and in the same poem, the scene where Cleo fights the passionate tiger ("he licked me and lay beside me"), whose

"yellow eyes flashed fiercely," is brilliant. Fear becomes a "yellow chirper" in Robert Lowell's poem "In the Cage." Jack London—novelist and quondam racist—grudgingly recorded for the San Francisco *Chronicle* on July 4, 1910, the bold headline following black heavyweight Jack Johnson's defeat of white Jim Jeffries, THE NEGRO SHOWED NO YELLOW. And as Philip Larkin noted in his poem "A Study of Reading Habits":

> *the dude*
> *Who lets the girl down before*
> *The hero arrives, the chap*
> *Who's yellow and keeps the store,*
> *Seem far too familiar*

"What's the matter, ya yella?" Ray "Mad Dog" Earle—Humphrey Bogart—defiantly shouts to the cops pursuing him up the rocky hills in the movie adventure *High Sierra*. Speaking of Bogart, Captain Queeg, whom he portrays in the film *The Caine Mutiny*, is pejoratively nicknamed "Old Yellow Stain" by the disgusted and eventually mutinous crew for the yellow dye-marker he had thrown to indicate retreat in a naval maneuver.

Many negative connotations adhere to yellow. It is the color of treachery, malevolence, often treason, deceit, and jealousy. (Shakespeare, Dekker, and Robert Burton all use the color yellow frequently in

this sense.) In her poem "The Plaid Dress," Edna St. Vincent Millay apostrophizes the sun with the wish that it bleach from the offensive dress she has come to dislike, among other colors, "the yellow stripe / Of thin but valid treacheries." A "yellow-dog contract" is pejorative slang for an employee's work contract that forbids membership in a union. A single yellow rose is the symbol of infidelity (or jealousy, decrease of love, etcetera) in the language of flowers. To have a "yellow sheet" is to have a criminal record. The term "yellow press" originated in the late eighteenth century when papers began printing sensational articles about the "Yellow Peril," the constantly increasing Chinese and Japanese population, which was ludicrously said to threaten the safety of the white race. Yellow-backs were cheap novels, of the sensational kind, so called because of the yellow board bindings so well known in railway bookstalls in the early nineties of the last century. Yellow is the enervating color in All-Star Comics that takes away the Green Lantern's power. It is the color of mourning in Egypt and in Burma, where it is also the color of the monastic order. Anne Boleyn, incidentally, wore yellow mourning for Catharine of Aragon. And in Brittany, widows' caps among the *paysannes* are yellow. Jo Mielzener's famous set design for Arthur Miller's *Death of a Salesman*, almost exclusively yellow, was surely a visual quotation of that tragic portrayal of loss, failure, and eerie betrayal. James

Caesar Petrillo, president of the American Federation of Musicians in the 1940s, was so fearless that his classmates, with the reverse logic of childhood nomenclature, gave him the nickname "Yellow." It is a deadly and so to be avoided color in poisonous snakes. Remember the old childhood rhyme that went:

> *Red next to yellow*
> *will kill a fellow.*
> *Red next to black*
> *is a friend of Jack.*

It is the color of early bruises, unpopular cats, potato wart, old paper, chloroflavedo in plants, forbidding skies, dead leaves, xanthoderma, purulent conjunctivitis, dental plaque, gimp lace, foul curtains, infection and pus ("yellow matter custard, dripping from a dead dog's eye," sings John Lennon in "I Am the Walrus"), speed bumps, calloused feet, and ugly deposits of nicotine on fingers and teeth. (According to Dr. Li Tao in *How to Read Faces,* yellow teeth can indicate not only a heavy smoker but may mean in a person excessive commitment to work.) And of course a choleric man, in whom the "humor" (fluid) of yellow bile predominates, was for centuries found to be yellow-faced, lean, proud, ambitious, shrewd, and quick to anger. Lawns in Alaska

at "break-up" are a sad, swampy yellow. Ringworm starts with small yellow specks, which then spread out circularly. There is the nicotine yellow-gray of older people's hair. To act yellowly—a legitimate adverb—is often to fail. According to legend, the first butterfly seen in spring, if yellow, predicts illness—if white, health and happiness. It is also the shade of exposed dentine, the universal hue in the ranks of starving men, and the color of various explosives like nitroglycerine, picric acid, and TNT (trinitrotoluene), by dint of the graduated action of strong nitric acid upon toluol in the form of yellow prismatic crystals.

On the V-1 rocket or "Buzz Bomb"—Hitler's *"Vergeltungsnaffe eines"* (or Vengeance Weapon No. 1)—the warheads, containing nearly a ton of high explosives, were yellow.

There is in Poe's gory story "The Facts in the Case of M. Valdemar" a "profuse out-flowing of a yellowish ichor (from beneath the lids) of a pungent and highly offensive odor" as the grotesque, spine-chilling protagonist (*"I say to you that I am dead!"*) actually corrodes in his bed before gaping witnesses and deliquesces into a puddle of loathsome putrescence. And do you recall Dona Flor's first husband, in Jorge Amado's *Dona Flor and Her Two Husbands,* "emerging from a bout with her crab dish"—which in cooking she flavored with palm oil—"his teeth dripping yellow from *dendê*"?

Xanthocyanopsy is a particular aspect of color blindness in which the ability to distinguish only yellow and blue is present (vision for red being wanting), the *summum bonum* for Swedish nationalists, Notre Dame fans, the perfect Vermeerite, etcetera. Yellow point is that point at which a wire or rod of metal goes on stretching without any increase in the force acting on it. The dismal flour on Magellan's ships on those interminable voyages was always stained yellow by the urine of rats. And "yellow grease" is a low-quality refuse fat obtained from those parts of a hog not used in making lard but used in manufacturing. "Yellow Admirals" are merely post-captains in the British navy promoted to rear admiral on retirement but who have never served in that rank. And from the early seventeenth century until 1836, *dayvours*—the old name in Scotland for bankrupts—were compelled by law to wear an upper garment, half yellow, half brown, with parti-colored cap and hose. Oh, it is the color of debilitation, indeed.

One can feel knife-like despair in the westering winter sun in Emily Dickinson's poem:

> *There's a certain Slant of light,*
> *Winter afternoons—*
> *That oppresses, like the Heft*
> *Of Cathedral Tunes—*
> *When it comes, the Landscape listens*

Shadows—hold their breath—
When it goes, 'tis like the Distance
On the look of Death—

When Pharaohs ruled the valley of the Nile, which Rome coveted as the granary of the empire, precious wheat was ground between stones we would consider of rude design; only the most expert millers could grind exceedingly fine, as is said of the mills of the gods, and they vied to eliminate every trace of yellow from the flour, for the flavic in flour was almost close to weevily. Their pure white bread became a symbol of advanced civilization. But doesn't rue itself have yellow flowers and decompound leaves and a bitter taste?

In tenth-century France, the doors and abodes of criminals, felons, and traitors were painted yellow, and in medieval Spain, yellow as part of the executioner's costume stood for the accused victim's treachery. During the Inquisition in Spain, at an *auto-da-fé*, victims were robed in yellow, to denote heresy and treason. This was the sanbenito, or *Sacco Benedetto* ("sack of Benedict"), the yellow linen robe with two crosses on it, painted over with flames and devils, in which condemned persons were arrayed when they went to the stake. Japanese soldiers killed by flame-throwers at Iwo Jima, Okinawa, Leyte, Saipan, etcetera, when not burned black, were scorched a terrible brilliant yellow. It was always the color in medieval

times worn by the devil and his acolytes. Judas in medieval pictures is almost always arrayed in yellow. And wasn't poor Iphigenia, with mute violence sacrificed by Agamemnon on top of an altar like a goat, wearing a saffron-dyed tunic? Yellow dyes were produced in the ancient world, Palestine for instance, from the ground rind of pomegranates, and we know the Phoenicians used safflower and turmeric. Yellow circles made of cord an inch thick had to be worn, to single them out, on the chests of Venetian Jews by a general order in the year 1430. The city of Pisa, a century earlier, had required an *O* of red cloth. Ancient Rome insisted male Jews wear red tabards and Jewish women red-and-yellow doublets. Red or yellow clothing continued to be required of "vile and perfidious" Jews who lived in the old Italian city-states throughout the Renaissance, prefiguring the yellow cloth armbands marked with the Star of David imposed on Jews by Nazi law in the thirties and forties. Curiously, in mystic Kabbalism, yellow symbolizes severity.

Yellow often carries the connotation of oleaginousness, as well. It is the color of sweaty need, cringing obsequiousness, and guileful flattery. Eunuchs, famous for their hand-washing subservience—and who are reputed historically to *love* the color yellow—are extremely unctuous. Putting me in mind of the ingratiating Reverend Mr. Chadband in Dickens' *Bleak House,* for one, who is rather vividly described as a large yellow man with a

fat smile and the general appearance of having "a good deal of train-oil in his system."

And then there is the infective tropical fever known as yellow fever, transmitted by a domestic mosquito, where the skin of the victim becomes cold and takes on an unhealthy yellow tint. (In Rio de Janeiro in 1898 mortalities actually reached the appalling rate of 94.5 percent.) Yellow fever was also a smirking British term in the thirties for the spy mania in Singapore. In homosexual parlance, incidentally, "yellow fever" indicates a sexual fondness for Orientals. (Asians actually tend to have a soft yellow-ocher skin.) Speaking of yellow skin, a pill called atabrin, originally a dye but also given as a medicine to U.S. servicemen in the South Pacific to fight malaria, actually turned a lot of the men yellow—but the natives in places like Bougainville and Munda and Guadalcanal were happy to get boxes of them on the black market to dye clothes, food, etcetera. And a term for punishment at Greenwich College, from about 1820 to 1860, was "to be yellowed." Dermatologically speaking, yellowness of skin tone is not a good sign. Jaundice is a morbid condition characterized by yellowness of the skin and eyes and deep yellow color of the urine, due to the presence of bile pigments in the blood and tissues. (Critic Alexander Woollcott, whose cruelty was as casual as his humor was often inaccessible, once insultingly told a young lady that her brains were

"made of popcorn soaked in urine.") Chronic hepatitis, with its high bilirubin count, is dangerous, incorporating its distinct xanthodermic signs. Hepatic necrosis, or acute yellow atrophy, with its rapid decrease in liver size and overt bleeding, is often fatal. Did you know that although red cells give the blood its color, plasma—the fluid part of the blood which is a little thicker than water and in which many substances are dissolved, such as proteins, antibodies that fight disease, fibrinogen that helps the blood to clot, carbohydrates, fats, salts, etcetera—is light *yellow*?

And let me add, in passing, that the blood of insects is not like that of vertebrates, red in color; it is in fact almost colorless, slightly stained with yellow.

"Keen lemon-yellow hurts the eye as does a prolonged and shrill bugle note the ear," Kandinsky wrote in *Concerning the Spiritual in Art, and Painting in Particular* (1912), "and one turns away for relief to blue or green." Yellow, though a typically earthy color, never acquires much depth in spite of its brightness and waving unavoidability. When cooled by blue, it assumes, as I have pointed out, a sickly, unappetizing tone. If one were to compare it to certain human states of mind, it might be said to represent not the depressive but rather the manic aspect of madness. The madman attacks people and

disperses his force in all directions, aimlessly, desperately, until it completely dwindles and is gone.

Is that why Pablo Neruda in his poem "El Buen Sentido" ("The Right Meaning") is surrealistically able to capture the essence of loose madness or sorrow in this line:

Y desfila por el color amarillo a llorar
porque me halla envejecido, en la hoja de la
espada, en la desembocadura de mi rostro.

(And she walks firmly through the color
yellow to cry, because I seem to her to be
getting old, on the blade of the sword,
in the delta of my face.)

tr. Robert Bly

Yellow wallpaper has been used as both symbol and metaphor for women's madness and the condition of forced confinement in a so-called patriarchal society. It has its origins in a polemical short story written by Charlotte Perkins Gilman and published in 1892. A woman in this story, suffering from an unstated "condition," is taken by her physician husband to a lonely and isolated country estate for a "rest cure." The woman is confined to a claustrophobic single room which contains little more than a bed and is covered over with yellow wallpaper that

she perceives as hideous and eventually finds unbearable. She ultimately goes mad. According to Paula A. Treichler and Cheris Kramarae in *A Feminist Dictionary* (1985), "Gilman intended the story as an attack on the rest-cure treatment for neurasthenia developed by the neurologist S. Weir Mitchell"—an infantilizing regime for morbid or nervous women (including, by the way, Edith Wharton, a patient of Mitchell after suffering a mental and physical breakdown in 1898) who have lapsed from their feminine duties into invalidism— "and as a more general critique of the patriarchal treatment of women which makes it difficult or impossible for them to carry out active, useful creative work and instead enforces passive domesticity."

In Willa Cather's story "Paul's Case," the hometown rooms of protagonist (and invert?) Paul, a feminized overaesthetic music freak and "opera queen," later a suicide, have yellow wallpaper. As to the leaden oppressiveness of the color, finally, it may be added here that at North Alberta Institute of Technology it was recently concluded, "Hospital patients require more painkillers if they stay in rooms painted yellow."

Elms, willows, gingkos all grow radiant yellow, along with hickories, aspens, cottonwoods, bottlebrush buckeyes, which turn yellow in the fall. There are yellow birches ("Bank of yellow birch and yellow / Twig of willow," wrote Edna St. Vincent

Millay), and first-growth white pine has yellow wood ("the clear yellowish grain of the pumpkin pine," observed Thoreau). Canola, also known as rapeseed, has brilliant yellow flowers, and in the cultivated fields of them in and around Dawson Creek, British Columbia, they are positively breathtaking. As are the gorse and the broom and the wattle, a native bush or tree of Australia, with its bright, inspiring clouds of yellow blooms. Yellow Arctic poppies in summer stretch into infinite dreamy distances. What of the enduring power of yellow in flowers? There are winter flowers, like late guests in a deserted ballroom, that flourish in cold, particularly winter aconite, whose delicate golden blossoms flower undaunted even under sheets of ice, like elegant Victorian posies poised in a glass boscage. And the memorable tansy, a yellow-flowered perennial herb, derives its name from *athanasia* (Gr.), because it is everlasting. Our Lady's Bedstraw (*Galium verum*), which, according to legend, was used as the actual bedding for Christ's manger in Bethlehem, is or was commonly used to curd cheeses, to which it gives a good yellow color, and, as a yellow dye belonging to all the madder family, it has often been used to produce that golden color so much in request as a hair dye. Crottle from weathered rocks, by the way, a kind of lichen rather commonly found, produces a rather warm yellow that is often used in dyeing raffia. And who can forget the

lovely primrose, lost on Wordsworth's wistfully un-
poetic character, Peter Bell:

> *A primrose by a river's brim*
> *A yellow primrose was to him,*
> *And it was nothing more*

And remember the *genêt* (gorse) spread over the belt
plateau, or Cengle, of Mont Sainte-Victoire near the
village of Le Tholonet that Cézanne loved so much?

Marigolds, laburnums, jonquils, dandelions ("If
it were possible to count on yellow / Dandelions
would constitute discovery," wrote Fairfield Porter),
primroses, forsythia, sunflowers, allamanda with its
trumpet flowers, and many orchids and hibiscus are
all bursts of yellow. There is Hawaii's vibrant Yellow
Plumerias. Palo Verde in the desert. Clumps of pale
yellow and lavender wachendorfia in South Africa.
The sunny yellow-blossoming *kowhai* tree of New
Zealand. And hopeful goldenrod, with its small
heads of yellow ("And we are glad in this bright
metal season / Even the dead laugh among the gold-
enrod," noted Sylvia Plath). And what of the gay
yellow calendula? The Chrysalora tulip? The Bou-
ton d'Or? The Mark Graaf, striped with scarlet?
There are of course the classic Hybrid Tea roses—
the King's Ransom, Peace, and the explosively full
Golden Giant—and also the Lawrence Johnston
(*Foetida*), with its clusters of large, semi-double

buttercup-yellow blooms. Among rosarians, nomen-clature can vary. Fortune's Double Yellow, for exam-ple, a rose spirited out of China in 1845 by Robert Fortune, a Scot sent there by Great Britain's Royal Horticultural Society on a plant-collecting mission, is also called "Gold of Ophir" and "Beauty of Glazenwood." The "Tequila Sunrise" rose, found in New Zealand, is magnificent. A hybrid yellow rose-giant buff dahlia was also named after Amelia Ear-hart. Are yellow roses from the past century? Is there something slightly out-of-date and overly nostalgic about them? In Anne Stevenson's melancholy poem "A Tricksy June," we read,

> *I'm missing those old-fashioned yellow roses*
> *hugging my gate,*
> *already losing their frowsy, blowsy furbelows.*
> *Who lets them yawn*
> *and disintegrate, petal by lazy petal,*
> *without complaint?*

Ylang-ylang, a yellow oil distilled from the flowers of *Cananga odorata,* indigenous to the Malay archi-pelago and cultivated in the Philippines, is quite frequently used in perfumery. And the flowers of melilot, often used to flavor beer—and also cheese—are bright yellow, like scorzonera, a peren-nial plant with a root not unlike a carrot, which is, by the way, highly delectable when fried in butter.

Did you know that Linnaeus once dropped to his knees and wept for pure joy when he saw a hillside of English heather burning with the yellow flame of furze in blossom? Yellow tint is everywhere! Yellow saxifrage, or "gold dust," is quite lovely, as is yellow broom, a sprig of which was worn by Geoffrey of Anjou, conqueror of Normandy, as he rode into battle in 1144. There is also the shrub benzoin, or gum Benjamin, with its flowers of yellow that grow in umbelliferous clusters and are often found in the painted vases of still lifes. In 1947, Vladimir Nabokov wrote "yellow blue vase" on the board in one of his classes at Wellesley and told his students that it was almost "I love you" in Russian: *ya lyublyu vas.*

And of course buttercups.

The prevailing idea, by the way, held for years, that cows feeding in a field of buttercups produce milk which gives cream and butter of a richer yellow is entirely erroneous. Cows actually show great discrimination in avoiding buttercups, for if they should make a mistake and munch some of it, they can badly suffer in consequence from blistered mouths, as simple yellow buttercups hold a vile acrid juice in their stems which burns and raises blisters, a fluid, curiously enough, sometimes used in folk medicine as a *counter*irritant for sciatica and rheumatic pains. And is there not a flow in the streaming tresses of willow trees, in the sweep of their thin

xiphoidal leaves blowing in the wind, as delicate as Veronica Lake's aureoline hair?

Few had a beauty that exceeded Persephone's, that winsome girl carried off by Hades as, about to pluck it, she gazed at the yellow narcissus. "But what is it that makes this yellow flower, used at once for garlands of Eros and of the dead, so marvelous?" asks Roberto Calasso in *The Marriage of Cadmus and Harmony*. "What sets it apart from the violets, the crocuses, and the hyacinths that make the meadow near Henna so colorful?" One answer perhaps, bound up with that flower, surely lies in that ambivalent love we need to bear for ourselves in order to cope, in a sense in order to survive, a love that nevertheless can so easily seduce us to vanity.

There is a spider, the tropical orb weaver, the silk of whose webs is yellow—and may stretch as far as fifteen feet across. The neat, taut spirals of the webs are often densely strung from tree to tree in forest and jungle, and the strong, elastic spider silk can be pulled to twice its length before it breaks. Small animals have little chance in such a sticky trap, and even humans find it hard going to shove through one tough, springy web after another. Natives actually use its threads to fashion fishing nets and hats.

Of yellow saltwater fish, there are many: the Common Clown; the Butterfly fish; Yellow Tang—a marine fish, quite rare, of a single color—the seahorse (*Hippocampus kuda*); the Badgerfish; and

the long-horned Cowfish. I have always thought that, along with blue, yellow aquarium fish are the most irresistibly radiant.

No, the color yellow in nature is complex in beauty and as various in its modality as the fierce yellow tiger, emblem of power, is from the fleet yellowhammer or male golden oriole—if upon which, Pliny relates, a jaundiced person looks, he recovers but the bird dies—or hooded warbler, emblem of grace, in the transcendent skies overhead, a color registering solidity and speed, light and labor in its facets all at once. (The natural color of canaries, by the way, is not yellow, but bottle green, just as the feathers of a male goldfinch, olive drab, turn yellow at mating time.) "The first summer yellowbirds on the willow causeway," observed Henry David Thoreau in May 1852, greeting the yellow warbler with that beautiful line. "Now I remember the yellowbird comes when the willows begin to leave out," he reminds himself. "So yellow. They bring summer with them and the sun, *tche-tche-tche-tcha-tcha-tchar*." The bright yellow of the basal wings of a sulfur-winged locust—wings of locusts are pitched tentlike over the back of the body, whereas those of crickets lie flat—is as wonderful as its music, short sharp clicks heard in early summer. To the American Indian, the rich yellow leaves on autumn trees indicate flames from the cooking fires of the Spirits.

Why do leaves turn yellow in autumn? A yellow substance called xanthophyll, consisting of carbon, hydrogen, and oxygen, can be found in all leaves and makes up 23 percent of their pigmentation. Carotene, the substance which, for instance, colors carrots, is also present, along with anthocyanin, which is red and gives the sugar maple and scarlet oak their particular color. And chlorophyll, the dominant green color in leaves, gives them two-thirds of their pigmentation. A marcesant leaf—they can endure in Massachusetts throughout winter—is almost always yellow, or rigorously fuscofulviate.

Oh, the magisterial impact of trees and leaves. Who can ever forget the lines of Joseph Brodsky's poem "Eclogue V: Summer," when he speaks of summer people trying in vain to sleep "while outdoors the invisible, rustling quantum"—an absolute forest of leaves—"airs its China-like, powerful yellow anthem"? I have always felt it significant, incidentally, that the enchanting autumnal forest in Robert Frost's poem "The Road Not Taken" *be* autumnal, making the line "Two roads diverged in a yellow wood" a prefigurement of a time when the speaker, though now young, will see how, when he gets older, choosing one road over another crucially matters.

There is an abundance of lovely yellow vegetables: corn, butternut squash, yellow onions, wax beans, as well as fruits: yellow pears, peaches ("Florida" is the name of a large yellow one), figs, bananas,

grapefruit, lemons, citrons, quinces, pineapples, the musky-flavored flesh of jackfruit, native to Southeast Asia (also the world's largest tree fruit), as well as the exotic ceriman from the American tropics and carambola from Malaysia, a fruit whose yellow sides are so deeply indented that slicing one at any point miraculously produces a five-pointed star—and even raspberries. Oscar Wilde once plaintively inquired of writer Beverley Nichols' grandmother if he might perhaps have a few raspberries—"pale *yellow* raspberries," writes Nichols, "a request which in snow-bound Yorkshire, a week before Christmas, she was unable to satisfy." Disraeli loved pyramids of strawberries on golden dishes. Many Asian and Greek food shops stock sheets of concentrated apricot, pulp-packed in neon-yellow cellophane paper, which is known as amardine. Ripe nutmeg fruit, including the nut, is yellow, as are ground asafetida, the lentils Mator, Channa dal, and Moong dal peas, and many grains. (Did you know that the original name for Cheerios, those miniature oat "doughnuts" in the exuberant yellow box—each one, by the way, specifically measuring $\frac{1}{2}''$ x $\frac{1}{8}''$ x $\frac{3}{16}''$ in size—was Cheeri*oats*, which was shortened to Cheerios in July 1945 when Quaker Oats claimed that they had exclusive rights to use the word "oats" as a trademark name?) In Alaska, among the Inuit, natives commonly enjoy eating the inner "meats" of willow branches (never eat the green stuff on willows), and

on the inside of birchbark is a yellow tree-marrow that is delicious with sugar and seal oil.

Our tables shimmer and shine with vegetable oil, noodles, egg yolks, and various sun-bright, gold-light mustards and butters and margarines. (Are you aware that butter fluoresces yellow but margarine blue-green under fluorescent light?) A French omelette, which should be a perfect oval pointed at both ends, is a mandala of pure yellow (if it is brown, the pan was too hot), mellow and creamy inside—what the French call *baveuse*. Soups are often yellow, pleasing everyone perhaps but William Trevor, who in his memoir *Excursions in the Real World* complained of the stomach-turning school dinners forced on him in England in the early 1940s, especially the "greasy yellowish soup." Pasta with its content of semolina is yellow; so are yellow beans and most common cheeses. Cheeses that are bright yellow in color, incidentally, are usually made that way by means of a specific coloring substance known as annatto that has been stirred into the curd. In olden times, this rich color was usually supplied by the use of marigold juice or carrot juice. There are as many different colored cheeses, of course, as there are beers.

Beer, incidentally, in the 1840s was often referred to as "a pint of yell," an abbreviation given to it, of course, for its golden color. Galleano is yellow, and Benedictine ("that thick yellow disgustingly sweet

monks' liquor," as George Grosz complained in his
autobiography), as is the aperitif Pernod, along with
mescal, tequila, and most of our strong burnished
brandies, though they can appear very light. And
Beverley Nichols (q.v.), in his excoriating and unre-
lenting memoir, *Father Figure* (1972), writes of his
first intoxication on yellow chartreuse: "I was exqui-
sitely drunk . . . I leant back and apostrophized the
gleaming fluid in my glass. It was gold, it was daffo-
dils, it was the skin of tigers; it was the sands on
which I had lain naked, it was sun-flowers, it was the
hair of golden girls." Grenadilla, also known as pas-
sion fruit and found in Haiti—big as balloons—has
a heavy but fragrant yellow juice. As to yellow wine,
are we not adjured in Proverbs 23:31–32 of the
Vulgate to avoid it completely for its harmful effects?

Ne intuearis vinum quando flavescit,
Cum splenduerit in vitro color eius
Ingreditur blande; sed in novissimo mordebit
ut coluber, Et sicut regulus venena diffundet.

(Look not upon wine when it is yellow,
when the color therein sparkles in the glass.
It is drunk harmlessly; but in the end
it will bite like a snake and will spread
within you like poison from a basilisk.)
My translation

And isn't there a wonderfully paradoxical phenomenon to cherish in the fact that *orange* juice is yellow?

Many new varieties of potatoes, especially "fingerlings," have yellow or orange-yellow flesh which leads people to describe them as buttery. Then there are the Yellow Finn and Yukon Gold, other yellow-fleshed potatoes, along with the Banana potato, named for both its shape and yellow flesh. It may be ironically noted that *Sclerotina sclerotiorum,* a severe potato blight, is also yellow. Pine nuts are yellow. So is ground fenugreek. Saffron, the dried stigmas of violet flowers, is orange-yellow. (And were you aware that it takes a staggering 200,000 to 400,000 stigmas to make two pounds of saffron? That each flower has only three stigmas which must be picked by hand at dawn before the sun becomes too hot? That the Romans used to strew paths and roads with it, creating with mad extravagance a golden carpet for emperors and princes? That the clothes of Levites in biblical days were dyed with the yellow of the saffron crocus?) And turmeric (*Curcuma longa*), native to tropical Asia, is often called Indian saffron and yellow ginger in the Far East. Healthy chicken (skin on) is yellow, which is doubtless why Perdue chicken containers found in supermarkets are uniformly bright yellow. What about the center cavity of a popover? A superb

yellow hollow! Yellow is also the color, as well, of Mary Janes, B-B Bats, lemon-flavored Fruit Slices, and butterscotch humbugs, among my favorite candies as a youth. And how about that super-energized, high-tech, neatly boxed, caramelized space-age popcorn of the seventies, Screaming Yellow Zonkers?

Acacia honey from Hungary, believed by many to be the finest honey in the world, is as famously golden, like most honeys, as it is viscous. Many honeys are not yellow at all, however. There are snow-white honeys from Siberia, Cyprus, and Mount Hymettus, where the gods found it, and there is even a black honey from Brazil.

I remember being amazed when visiting the Dahlem Museum in Berlin back in the summer of 1966 and seeing for the first time the impasto of yellow oil paint, lathered on, it seemed, almost as thick as honey, built up on Rembrandt's *Man with the Golden Helmet.* And look at the great yellow ottoman in Degas's *Woman Having Her Hair Combed.* Pieter Breughel's *The Harvesters,* one of the few Breughels found in the United States, as a composition is almost all yellow. And Vermeer? In his work, yellow is by far the crowning color—"a color," as van Gogh once remarked, "capable of charming God." It was, along with blue, clearly Vermeer's favorite color, metonymically bonded to ambiguities of light and exposure. It demystifies. It is an open

and radiant color, almost always the singular color, energizing its wearer, of the sulfur-bright jackets, doublets, and blouses of pretty girls and fetching, exquisite women in various of his canvases, such as *Woman Pouring Milk* and *The Procuress* and *Soldier and Young Girl Smiling* and *Girl Reading a Letter at an Open Window* and Martha in *Christ in the House of Martha and Mary* and *Diana and Her Companions.*

Consider the blinding, almost lurid suns in J.M.W. Turner's *The Decline of the Carthaginian Empire* (1817), his *Ulysses Deriding Polyphemus* (1829), and especially *Regulus* (1828), the last glimpse, presumably, of the historical Roman general punished by the Carthaginians, whose prisoner he was, whose eyelids were cut off, and who was then exposed to the sun, thereby blinded, and then killed by being rolled in a spiked barrel. No suns ever painted, no prismatic splitting of pure white light— the terrible forces couched in yellow, the aerial orbs of shimmering power, virtually, *acts* of light—were ever done better or more fully grasped.

Piero della Francesca's masterpiece *The Baptism of Christ* is a painting not only suffused with golden light but one that is also geometrically precise, balanced on the basis of Euclid's Proposition 16, according to art critic Marilyn Lavin, a formula for constructing a fifteen-sided figure by superimposing a pentagon on an equilateral triangle. Angles and

measurements in the painting recapitulate the number of degrees of the sun in relation to winter and summer solstices, Christ's baptism having taken place on what was once thought to be the winter solstice, the beginning of the new year and the moment of the Descent of Holy Light. And so della Francesca found, Lavin points out, a mathematical way to identify Christ with the sun, and hence with Divine Illumination.

In May 1921, Marcel Proust, mortally ill, in the terminal stages of tuberculosis, set forth to see the Vermeer exhibition at the Jeu de Paume, specifically the *View of Delft,* a painting he judged "the most beautiful in the world," and he was so mesmerized by the exquisite touch of yellow on a tiny wall in that painting that he suffered a near-fatal stroke. (He later thought it was indigestion from potatoes.) In his masterpiece, *À la recherche du temps perdu,* on which he had been putting the final touches at the time, Proust immediately fictionalized this scene. His character Bergotte, against the advice of his doctors, goes out to see the Vermeer and contemplates the same *"petit pan de mur si bien peint en jaune."* "His giddiness increased; he fixed his eyes, like a child upon a yellow butterfly . . . upon the precious little patch of wall. 'That is how I ought to have written . . . My last books are too dry, I ought to have gone over them with several coats of paint,

made my language exquisite in itself, like this little patch of yellow wall . . .' " And then Bergotte dies.

Curiously, the name *Jaunet* (Yellowboy) was a term of endearment and condolence used by Proust's mother during his childhood—it is echoed in later letters to her—and, notice, also by the narrator's mother in the *François le Champi* episode at Combray in *Du Côté de chez Swann*.

Claude Monet found light for all times and seasons, from the shimmering *Poplars (Autumn)* to the gold in *Grainstacks (Sunset)* and *Rouen Cathedral Façade (Sunset)* to the *Cliffs at Pourville (Morning)*, an almost benedictive celebration of the high cliffs and beaches of Normandy he so loved, so beautiful they seem not so much painted as the emanation of one's own bright and golden dreams. And the way he put sun into his *Ice Floes*. Enchantment itself.

Oh, the glory of yellow paint! I love Renoir's *Woman's Torso in Sunlight with the Fauves*, with its luminosity of foliage, hair, and drapery. (Sunlight must almost always be painted by tints slightly prismatic, composed of red, yellow, and blue, that obviate coldness and realize aerial effects.) We have the chromatically brilliant yellows, found, for example, in Matthew Smith's *Nude, Fitzroy Street, No. 2.* Manet's *Nude* has a much lighter skin. Then there is the magic iridescence of Braque's *Landscape at La Ciotat*, a painting that, for me at least, virtually

defines summer. In American painting, Joseph Albers' *Homage to the Square: "Ascending,"* although a formal structure, is almost chewable in its richness. As to the Hudson River School, there are all those airy golden skies, filled with supernatural light, of Frederic Church's *Oil Sketch: View of the Catskills from Olana* (a picture which, I think, uses Dutch pink, which is not pink, but yellow) and David Johnson's *Foundry at Cold Spring.* Frederick Carl Frieseke's *The Yellow Room,* with its oriental influence, shows a yellow with a hint of green that is an almost perfect celandine. And in Mexican paintings, as indeed in that unself-conscious and colorful country, so many courtyards are the color of yellow cake. For such yellows, what a plethora of paints and pigments and palettes!

There are many yellow pigments. Yellow ocher in oil paintings is essential. It is permanent with the advantage of not affecting any other color with which it may be mixed. It is also a yellow that is quite safe for any highlights, whereas lemon yellow and chrome are often too pungent and too powerful. Chrome yellows, introduced in 1797, which tend to turn dark or greenish, are perfectly replaced by cadmiums. Chrome yellow, used by Matisse, by the way, in his *Portrait of André Derain,* covers and dries well but tends to change tone with time. Cobalt yellow (aureolin) is rarely used in opaque or body-color painting because its mass tone is a dull and undis-

tinguished mustard hue that can easily be duplicated by less expensive pigments, but it is invaluable for transparent glazes and for the precise matching of delicate or very pale colors and off-whites. Cobalt yellow dries extremely fast. As to the instability of colors, yellowing in particular, egg tempera paintings, paradoxically, do not yellow, when it might seem logically they would—yolk becomes clearer as it dries and never darkens—but linseed oil will always darken to yellow.

Ochers occur in all parts of the world, but the finest ones are mined in France. Mars yellow is much more brilliant and powerful than are many ochers and raw siennas; theoretically, it should supplant them, but most artists continue to prefer the more delicate, subtle tones of the native earths. At the Bronze Age excavation site Akrotiri on the island of Thera in Greece can be found frescoes in houses 3,500 years old of yellows and reds that are so bright they look as though they had been drawn yesterday. Cennino used a yellow brighter than ocher, called *giallorino,* but exactly what was it? Massicot, a yellow oxide of lead? Yellow glass or frit? Whatever it was, he said it could be used in fresco. There was quercitron, a yellow lake made from the rasped inner bark of the black oak. An orange-red gum resin called gamboge (i.e., from Cambodia) becomes bright yellow when powdered and was often used as a yellow pigment, as well as a dye and a violent

cathartic. Indian yellow was made from the urine of cows—from plain camel urine, I've also heard—fed on mango leaves, a pigment no longer used.

It is probably correct to say that Naples yellow, that old standby, made of lead and antimony, was the one reliable yellow available to Old Masters, a heavy, dense color, with excellent covering properties, though it had little tinting strength. The Old Masters also had at their disposal vegetable substances, including curuma, saffron, aloes, and the inner rinds of various trees.

But above all they had orpiment, also called King's Yellow, a yellow sulfide of arsenic, usually mined in Asia, and extremely poisonous, fugitive, and, unless used with great care, ruinous to all other colors. Orpiment, whose name comes from a sort of bastardized Latin and means "golden paint," was called *auripigmentum* in the old days, because it was believed in fact to contain gold, which attests to its vivid lemon-yellow color. (It is the distinction of the primary colors, remember, that, pure, they cannot be made by mixing other colors together.) Orpiment was often used to illuminate manuscripts, and in the seventh grade I once composed a lurid story, set in a monastery, where one monk killed another by stabbing his victim with a long bristling quill dipped in orpiment. Cadmium yellow has since come to replace this pigment.

Cadmium yellow is a splendid glowing yellow,

invaluable for such subjects as gorgeous sunsets. Pale cadmium varies from a straw color to a lemon or primrose hue. Van Gogh's famous *Chair with Pipe*—"Blunt yellow in such a room," as Wallace Stevens said (in "Floral Decorations for Bananas") in another context—is a masterpiece of cadmium yellow. Van Gogh knew many color tricks, especially with his kinetic yellows. Any yellow article, for example, placed in a red light will look red to us, and in a green light, green. This is because yellow can reflect both the red and the green light, and when both are reflected together it looks yellow, but if we place it in a violet light, it will also look black because yellow cannot reflect anything but red and green, or yellow, which of course is a combination of the red and green light together.

Manufactured colors in their pure state seldom correspond exactly to the colors of natural objects. Painters are obliged to mix them for desired tones. Mixing pigments reduces a color's intensity, however. Pissarro, Monet, and Cézanne wanted to reproduce on their canvases the mixed colors of nature—that is, of reflected daylight—without badly reducing the intensity of those colors. So they developed a new method of applying their particular colors. Instead of mixing two pigments (say, red and green) on a palette, they placed small strokes or dots of pure red and pure green close together directly on the canvas. When seen from a certain distance these contiguous

spots of pure color would blend without appreciable loss of intensity to produce on the retina the effect of a single spot of brilliant yellow. Pigments were not mixed. Simply, the separate rays of colored light reflected from the canvas were automatically fused by the eye of the observer. Such was the daring of the Impressionists' stroke. What colors they gave us! What luminous intensity!

Vincent van Gogh's pictures dripped with golden light. Consider the rich and buttery yellow ochers of his *Starry Night*. And *Portrait of Armand Roulin* (1888). What about *The Sunflowers*? And *Yellow Wheat* (1889). ("Moving fields of amber grain," in Don McLean's song "Vincent.") The yellows of his famous sunflowers are chrome—he almost always used three tones of chrome yellow—and were once undoubtedly much cruder and brighter than their now subdued and harmonious gold. There are certain critics who ascribe the penchant for yellow of van Gogh, an incipient xanthopsiac, as the possible result of his having been poisoned by digitalis, which at the time was given as a treatment for epilepsy. Vincent wrote to his brother Theo from Arles in 1890: "All the colors that the Impressionists have brought into fashion are unstable. So there is all the more reason to use them boldly . . . time will tone them down only too well." And he was right. The billiard table in his well-known *Night Café* was once a bright green, as he refers to it in one of his

letters. It is now tan, with no trace of green what-soever. Contemporary artist Robert Moskowitz has recently done a series of engaging pictures entitled *Vincent* (1989), where he explores, in various tints and symbols, the varying shades of van Gogh's famous yellows.

Gauguin loved primitive yellow. We find it in lavish use in the lush background of *Woman with a Flower;* in the background of both his *Les Misérables* self-portrait and his bird's-eye-view portrait of Vincent painting sunflowers; and, among other pictures, on the bed covering of the rich *Te Tamari No Atua,* which depicts his young mistress Pahura, who died after giving birth to his daughter.

In Gauguin's *Yellow Christ* (1889), a crucifixion made contemporary—and autobiographical, for the painting is a self-portrait, as well—set in the golden fields of Brittany, a group of Breton women kneel in a curve about the cross with lowered eyes and clasped hands. The painter fashioned his Christ, a frail, suffering, passive figure in the painting, after a polychrome wooden crucifix which still hangs suspended from the nave in the chapel of Trémalo, near Pont-Aven. The yellow pallor of the corpse, a yellow with the almost drained greenish tint of celadon, recalls the yellow sunflowers in Gauguin's portrait of Vincent, the color almost serving as the bloodless shroud of fatality. One eye of Christ is completely closed, the lids of the other slightly

parted, with the eye cast upon the viewer. (Notice sometime that a similar eye occurs in the sunflower in Gauguin's portrait of van Gogh at his easel.) In a blend of the real and the imaginary, the crucified Christ is set against a yellow—and red-treed—landscape, while the Three Marys of Calvary are transformed into Breton women wearing head-dresses. Gauguin curiously quotes this painting, an example of Synthetism, in his famous self-portrait (1889–90), where one side of the painter as a mirror-image, reversed, is balanced on the other with the painting of a piece of pottery, which is also in the form of a self-portrait.

Those, incidentally, who have always thought Gauguin to have been a strong standard-bearer of anticolonialism and closer cultural ecumenism (which of course he proved to be in the Marquesas) might recall with some disquietude that memorable speech of his on September 23, 1900, in behalf of the Catholic Party, where, defending "poor whites" against the Chinese lobby in Tahiti, he alluded, spitefully and vehemently, to "this yellow blot on our country's flag."

Yellow is, and has been, loosely applied to count-less hues, tints, and shades, ranging from the clear and brilliant cadmium and lemon yellows, to the ochers and bilious greenish yellows. Strangely, al-most inexplicably, while it is the brightest, most

luminous of all colors, it is considered the least popular among adults, particularly the darker shades, a remaining tocsin—who can explain it?—to whatever mystery awaits within ourselves to be solved. Surely color presents itself, in the rhetoric of image, to the reading of several different people who can coexist in a single image. As Roland Barthes points out in *Image Music Text,* "One lexia mobilizes different lexicons."

There is a significant moment in Conrad's *Heart of Darkness* when the protagonist, Charlie Marlow, a man of sunken cheeks, described as having a "yellow complexion," looks at a map of the Belgian Congo, marked with all the colors of the rainbow. "There was a vast amount of red—good to see at any time, because one knows that some real work is done in there, a deuce of a lot of blue, a little green, smears of orange, and, on the East Coast, a purple patch, to show where the jolly pioneers of progress drink the jolly-lager beer. However," reports Marlow portentously, "I wasn't going in to any of these. I was going into the yellow. Dead in the centre. And the river was there—fascinating—deadly—like a snake."

I was going into the yellow.

So few colors give the viewer such a feeling of ambivalence or leave in one such powerful, viscerally enforced connotations and contradictions. Desire and renunciation. Dreams and decadence. Shining

light and shallowness. Gold here. Grief there. An intimate mirroring in its emblematic significance of glory in one instance and, in yet another, painful, disturbing estrangement. An opposing duality seems mysteriously constant. The Yellow Brick Road. The Heart of Darkness. We go into the yellow, I suppose, each in our own way, with values attuned, no doubt, to whatever mode of empathy our particular vision aspires. Nevertheless, how enigmatic a color it seems, being so ready to oblige.

Red

RED IS THE boldest of all colors. It stands for charity and martyrdom, hell, love, youth, fervor, boasting, sin, and atonement. It is the most popular color, particularly with women. It is the first color of the newly born and the last seen on the deathbed. It is the color for sulfur in alchemy, strength in the Kabbalah, and the Hebrew color of God. Mohammed swore oaths by the "redness of the sky at sunset." It symbolizes day to the American Indian, East to the Chippewa, the direction West in Tibet, and Mars ruling Aries and Scorpio in the early zodiac. It is the color of Christmas, blood, Irish setters, meat, exit signs, Saint John, Tabasco sauce, rubies, old theater seats and carpets, road flares, zeal, London buses, hot anvils (red in metals is represented by iron, the metal of war), strawberry blondes, fezes, the apocalyptic dragon, cheap whiskey, Virginia creepers, valen-

tines, boxing gloves, the horses of Zechariah, a glow-
ing fire, spots on the planet Jupiter, paprika, bridal
torches, a child's rubber ball, chorizo, birthmarks,
and the cardinals of the Roman Catholic Church. It
is, nevertheless, for all its vividness, a color of great
ambivalence. Eugene Field wrote of the effects of red,

> *There's that in red that warmeth the blood*
> *And quickeneth a man within,*
> *And bringeth to speedy and perfect bud*
> *The germs of original sin.*

Love is red. So is death, its counterpart. It is the
color of fire and flame. A bride's gown in China is red.
So is the button on a mandarin's cap. Red means
happiness in China, where people under roofs tiled
that color prosper. At new births in old China, red-
colored eggs were often sent by messenger from
neighbors to the new parents in the ritual of *pao-hsi*,
"Reporting Happiness," and in marriage rites the
Chinese bride formerly wore red and processed to the
wedding in a red sedan chair, where, walking on a red
carpet to the ceremony, she found the groom, who,
greeting her, lifted up her red silk veil. Red-letter days
are holidays, festal, not ferial, and in almanacs are
printed in red ink. In celebrating we "paint the town
red," and no other color. Upon merely seeing the
color red, the metabolic rate of a human being sup-
posedly increases by 13.4 percent. When subjects in a

test viewed a red light—hand-grip strength was being measured—their strength increased by almost 20 percent. Giorgio's exotic perfume, Red, has such a powerful scent that it has been reported in places to kill people's appetite for food, and there are certain restaurants in the Los Angeles area which actually prohibit entrance to women wearing it. Its passion as a color is arguably matchless. One of my favorite jazz records, which I own on an old RCA 78 r.p.m. (No. 26141-8), by Larry Clinton and his Orchestra, is called "A Study in Red." Wasn't it Kandinsky himself who said that red calls up the sound of trumpets?

It is generally agreed that of all the colors, red has the strongest chroma and the greatest power of attraction. It is at once positive, aggressive, and exciting. It is strong, simple, primary. Red was the very first color to be designated by name in virtually all primitive languages—the name of Adam, the first man, means, according to ancient Hebrew tradition, both "alive" and "red"—and the color most used in primitive and classical art. There has been much speculation as to the reason for this particular phenomenon, though for me it is most cogently explained by Maitland Graves in *The Art of Color and Design* (1941), where he writes:

> Primitive art as well as classical was essentially an outdoor art; that is, it dealt chiefly with the decoration of facades, painted statues, and

totem poles, war galleys, chariots, and the like. The background for this art was the blue sky and green vegetation. Therefore, the use of the warm colors, particularly red, would result in the most effective contrast against such a background, whereas blue and green would be overwhelmed and lost . . . The same predominance of reds and yellows may be noted in outdoor decorations of today, exemplified in such things as beach and garden furniture and billboard advertising.

There is in nature a hidden palate of reds—clay, plants, berries, bark, flowers, grasses, minerals. It is found in soils everywhere, from the reddish clay of western Connecticut to the Ultisols of the northeast coast of Australia to the ferruginous earth of southern Brazil to the dark red dust blown up by the khamsin in the Sudan. Red for the cave paintings at Lascaux, in southern France, came from rich iron ore that was ground to powder with stones or with bone mortar and pestle, then mixed with animal blood, or fat, and plant juice. In the cave of Altamira, in Spain, you can see the shaggy red bison, the horse, and the wild deer, painted in these dusky colors on the ceiling by Cro-Magnon man, 15,000 to 8,000 years ago. In Jericho, in the neolithic pre-pottery levels which date to about 6,000 B.C., were

found a number of lime marl masks, wearing sea-shells for eyes, touched with red paint. And in the earliest wall paintings, unearthed in the ruins of Teleilat el Ghassul, a village of Chalcolithic mud-brick huts (circa 3,500 B.C.), artists left designs in mineral pigments of red and yellow ocher. During those remote ages, a certain kind of clay containing iron oxide was found to turn a rich brick-red color when baked. Redware, a craft which was eventually mastered in Egypt and Asia Minor, was soon being peddled all over the Near East.

Redware pottery, incidentally, is made from the same run-of-the-mill clay that went into making common bricks. Today, flowerpots are about the only objects still made of redware, but in the eighteenth and early nineteenth centuries it was used for many things, including pie plates, massive jugs, marbles, etcetera. It was with earth the color of iron oxide, in fact, that the Kikuyu, the Nardi, and many other primitive tribes down through the ages used to rub over themselves in order to shine red as copper. The Semi-hamitic Nardi are actually called "Reds," and use with dismissive disdain the word "black" for any such persons undyed or untreated their color. Color can be a subjective thing. While blacks in the United States derisively call whites "grays," strangely enough the expression "He is red" in Trinidad means that a man is either part Chinese or part Portuguese.

Hot, dry weather, by the way, favors the growth of lichens, whose excrement, says German geo-microbiologist Wolfgang Krumbein, produces a reddish patina, and, curiously, almost all the mid-nineteenth-century paintings and "views" of the ancient Acropolis in Athens, pinkish red, reflect this, whereas, later, algae and fungi growing rapidly in our damper, cooler climate are presently turning this historic monument a weird blackish green.

American Indians valued red for skin garments and especially men's moccasins, a sort of brownish red, the shade of which is still worn. The Crow and Shoshone usually beaded on red trade or blanket cloth, however, using the cloth itself for a background, and so they tended to avoid using red beads simply because they blended with the color of the cloth and could not be seen. To dye buckskin, they cut up and boiled the roots of a type of mountain mahogany (*Cercocarpus montanus*) and spread the liquid over the skin. Dry pieces of alder bark were then usually scattered on it, to help it soak through, after which the skin was folded up, and in the morning the treated side held a fast red dye. The Ojibwa Indians of the Great Lakes region of Canada and the United States used the inner bark of the red cedar to make a red dye, used mostly to color mats. Cochineal, the brilliant crimson dye used in medicines, cosmetics, and candy, is obtained from the dried, pulverized bodies of the scale insect *Dac-*

tylopius coccus, which lives on cactus plants in places like Mexico and Peru but is also found in oak trees. The scale of the insect is a body covering that somehow protects its eggs after the insect dies.

I believe that the skies and curtains of the Tabernacle (Exodus 26:1–35, 36:1–38) were also dyed scarlet by the juice of crushed cochineal insects. And we know that those expensive purple and red garments of Tyrian or imperial dyes, worn by the wealthy and the noble of biblical times (Judges 8:26, Proverbs 31:32, Luke 16:19, Revelations 18:12), were prepared from mollusks (murex, *mollusca purpura*, etcetera) found on the east Mediterranean coasts—clearly the same dyes used by the renowned artisan of Scripture Huram of Tyre, whose "skill in purple, crimson, and blue fabrics" (2 Chronicles 2:7) King Solomon himself not only greatly admired but coveted.

On the totem poles of the Haida and Tlingit Indians of northern British Columbia and southeast Alaska, the color red—obtained from hematite pulverized with masticated salmon eggs and saliva used as a binder—is used, iconographically, on the lips, nostrils, and sometimes bodies of the pole creatures and as a secondary form line element in two-dimensional areas. Blue is used in eye sockets and in two-dimensional design areas.

It may be noted in passing that red is, at least generally, the preferred description—WARN

(Women of All Red Nations) is one example—for themselves of the natives of North America. "Oklahoma," from the Choctaw *okla homma*, in fact, means "red people." Remember the opening line of John Steinbeck's *The Grapes of Wrath*? "To the red country and part of the grey country of Oklahoma the last rains came gently, and they did not cut the scarred earth." And it is interesting to know that Sacajawea, the Shoshone Indian woman who accompanied the Lewis and Clark expedition from the Missouri River over the Continental Divide and on to the Pacific Coast in 1805, instructed those explorers to carry red paint with them to paint the cheeks of people they met—a sign of peaceful intention.

It has always been a popular color in southwestern Indian weaving and pots. Pueblo people often recognize a garment embroidered at Acoma, for instance, by the quantity of red which its women like to use. To get red yarn, Zunis usually soak the yarn for three days in alunogen and native lime (calcium carbonate), remove it, wash it in yucca suds, then boil it with mothlana, a plant, to which are added blossoms of coreopsis. As to pottery, the deposits of sedimentary clay in the Southwest are usually coarse red. In San Juan, Santa Clara, and San Ildefonso "polished red" pottery, the "slip" is usually red ocher, though it can be turned black if the fire is smothered while the pot is baking. And to dye

woven baskets a vegetable red, twigs are dipped in a boiled solution of alder bark, sumac berries, and cockscomb flowers. To set the dye, the twigs are sometimes held in the smoke of burning wool, white for light colors, black for darker ones. In Africa both the nut and the red wood of the *nkula* tree are scraped to give a red powder, which makes a stain when mixed with water. It is used for both body and bark-cloth decoration among the four-foot-high Mbuti pygmies of Zaire's Ituri Forest. And in Peru achiote is a tree whose pod yields red dye.

There are many shades of red. Vermilion is a light cadmium red. Adrianople red, also known as Turkey red, is a bright, intense color made from the madder plant. Fire-engine red is unsubdued, like the translucent red-plastic Fresnel lenses of automotive lights. Dog food, which is presently being extruded and puffed and dyed in multicolors, is a sort of of hideous matt liver-red. There is the deep red of Red Seal labels on old opera 78 r.p.m. records. Fox-red *tenné* in the language of chivalry shows a somewhat burnt tone. And garnet red with its low brilliance and medium saturation is a sort of "pigeon blood" or "Spanish wine." Cranberry red has a saucy sharpness to it, with a hint of yellow. Bluish red, popular in lipsticks, cardigans, and the aura of dramatic personalities, always puts me in mind of Sir William Rothenstein's arch remark, "One should always listen to Weber in mauve." In

the color trade, the impure native oxide with a bluish tone is known as Spanish red, the brighter, more scarlet shade of which, really an earth red, is called Venetian red, a color mixed with ocher, making a kind of *sobresada* stain that Raphael, Velázquez, and Goya all had on their rich palettes. The famous Red Fort in Old Delhi in India, with its carved marble walls, is of a strange, chalky, powdery, reddish rust. There is also a special rust-red peculiar to the house walls of old Pompeii. *Sang-de-boeuf* is the deep red with which ancient Chinese porcelain is often colored. Fuchsia is a pink-blue-red. (Elsa Schiaparelli's famous "shocking pink" was really a Tyrian purple.) Red Cell, a brand of horse vitamin, is a livid liver-red. Red-orange is a crayon that Crayola has, unfortunately if you ask me—it was my favorite color for gunfire in my early drawings—discontinued. And don't chicken pox, rubella, and erysipelas have their own quaint tints, the clawed hues of inflammation?

The living room of Dorothy Parker's Bucks County, Pennsylvania, farm, bought in 1934 with Alan Campbell, her second husband, was painted in (count them) *nine* shades of red: pink, vermilion, scarlet, crimson, maroon, raspberry, rose, russet, and magenta. She used strawberry wallpaper in the hall and dining room, I suspect, to keep everything germane.

Magenta, the brilliant red aniline dye derived

from coal tar, was named in commemoration of the bloody Battle of Magenta, when the Austrians were defeated by the French and Sardinians on June 4, 1859 (and forced to evacuate Lombardy), not long before the dye was discovered. Murrey or sanguine in English heraldry is a dark crimson red, and gules a sort of orange vermilion with a touch of Chinese white. Coral is a happy variation of red. So is Harvard crimson. And cerise. Red clothing in catalogs is variously (and often inexplicably) called flame, cardinal, claret, berry, heliotrope, bittersweet, mistletoe, cinnabar, pimento, geranium, watermelon, rose pink, candy, and—yes—love-philter!

The letter *V* for Vladimir Nabokov, something of a synesthete, was, at least to him, the color of rose quartz. (C major to Scriabin was red.) The almost uncanny red of the enchanting Sangre de Cristo mountains of New Mexico, in the words of Willa Cather in her novel *Death Comes for the Archbishop,* "never become vermilion, but a more intense rose-carnelian; not the color of living blood . . . the dried blood of the saints and martyrs preserved in old churches in Rome, which liquefies upon occasion."

So many shades, so many variations, so many words and phrases. The Maori have hundreds of words for the color red. So do the Inuit. In even barely inflected Yupik, for instance, the predominant language of native Alaskans, where specific usage changes, word to word, phrase to phrase, in

different contexts, the word "red," the basic root of which is *kavir,* is a good example of the rather rich multiple linguistic possibilities it holds: red fox (*kaviaq*); a willow tree with red bark (*kavingkuksaq*); an egg yolk (*kavingupagtaq*); he blushed (*kavinguq*); she put cranberries into the ice cream (*atsiliraa akutaq kavirlinek*); when he hunts birds, he never wears red (*yaqulegcuraqami atuyuitaq kavirlinek*); any red thing at all (*kavirpak*); and so on and so forth. Striving for exactness, Vergil maintained delicate distinctions in his poetry for particular shades of red he saw: *ruber, sanguineus, roseus, cruentus, rutilus,* and *sandyx.* Ovid liked *cruor* (blood) and *mavors* (poetic for Mars).

I would love to have seen the great ancient temple dedicated to Bast, protector of cats, mistress of love and of matters feminine, and glimpsed the strange red cat coffins, fashioned of red obsidian, on that island in the Nile, in Lower Egypt, north of Bilbeis, where the city of Bubastis once lay and the remains of which can still be seen. I wonder if Jesus as a boy ever played with cats there. Herodotus has left a vivid description of that temple in its glory: a building of the finest red granite, five hundred feet long, with a frontage adorned with carved figures no less than nine feet high. Along these lines, I once came across a wonderful poem written by a fourteen-year-old English schoolgirl named Cathy

Thomas; it was entitled "Femina et Felis," and it went in part:

> *"Ah, Cat, you are Woman.*
> *You are the first and last breath of Love;*
> *You filter off my red today . . ."*

In Egyptian mythology, where all stones, both non-precious and semiprecious, possessed sacred, eternal qualities, carnelian and other red stones represented the blood of Isis, the great goddess. In the Great Pyramid of Egypt, the huge sarcophagus of Khufu, cradled in balks of timber and buoyed up by the water level in the King's Chamber, was hewn out of red granite. Lenin's tomb, constructed in the years 1929–1930 and designed by the architect Alexei Shchusev, incidentally, is made of red granite, as is the old Moscow Hotel.

A factory-candy red can be found in the shockingly bright, wildly artificial maraschino cherry, probably the most singularly garish red food on earth, thanks to Red Dye No. 3. Nothing in nature flares so red, I'm sure, with the possible exception of a burning bush (*Euonymus atropurpureus*) in New England in late October or a fresh red Baldwin apple in autumn rubbed on a flannel shirt or a red lobster steamed by boiling water, which does somewhere flare, alas, but then it is not a natural red. Neither is

the holiday brightness of grenadine, although I find myself constantly fascinated with the bold wonderful red—and exotic taste, which Oscar Wilde also admired—of Campari. And do you remember Za-Rex? My favorite red is the almost preternatural, swirling, frisson-making, black-currant red of the true French concoction crème de cassis, like liquefied martyr's blood. And I remember the red Cocilana cough syrup given me by my sweet, patient mother in great spoonfuls being of a similar color, when as a schoolboy I was bedridden with a sore throat. There is no red Necco wafer.

Pedantic distinctions are made of the color red, simply because, so vast are its hues and shades, they can be. Jewesses, following the treatise of Niddah which according to marriage laws forbids sexual intercourse for twelve days just before, during, and just after their period, must inspect themselves before lovemaking to avoid surprises. Upon seeing a spot, no matter how microscopic, they must still desist. The required color for the spot, according to rabbis and elders, was that of "wine from the plain of Sharon, or the juice from roast meat," that is, red tending to dark. And what of the seamless robe worn by Jesus Christ? According to Mark (15:17) and John (19:2), the soldiers put a *purple* garment on Jesus. But Matthew (27:28) called it "a *scarlet* cloak," emphasizing its redness. But since purple is any color having components of both red and blue,

all the evangelists agree the robe had a red—and distinguished—hue.

Many houses in Egypt, the houses of the faithful, are painted with simple red and blue designs to indicate that the residents have gone on *hajj*, the pilgrimage to holy Mecca.

As regards blood, is the redness of a woman's blood somehow different than a man's? The great French naturalist Georges-Louis Buffon thought that the physical evidence of virginity, the intact hymen, was often lost in the very search for it. "And the indignity," he wrote, "which causes the pure and modest girl to blush [*rougir*] with shame is the true defloration of her purity." Woman's blood was often strictly taboo. There was a centuries-old caveat that it should never be shed. The Old Testament, which specifies stoning as the proper punishment for adulteresses, doubtless set the pattern. Smother her, poison her, drown her, burn her, or boil her in oil, but shed not a single drop of her blood! In medieval Christian Europe, when men no longer understood the atavistic reason for the ban on woman's blood, women were never beheaded or drawn and quartered as were men. Burning alive was the accepted form of execution for women. Paracelsus, the famous sixteenth-century physician, perpetuated the ancient belief in the mysterious sanctity of woman's blood when he wrote in his book on diseases: "Only a common boor thinks that the blood of a woman is

the same as that of a man. It is of a different sub-
stance, a spiritual substance, more refined than
man's."

And with woman it becomes an eidolon of her
sex. Louise, a character in Tom Drury's short story
"Strong," is trying to choose between pregnancy test
kits: "Most of the kits were three dollars, but some
were eleven, and she ruled out the less expensive
ones on the theory that something must account for
the price difference, and after all she wasn't going to
be buying a pregnancy test every day of the week.
Beyond these judgements, she went by the design of
the packaging. Almost all the boxes had red lines or
red words, as if invoking some kind of nostalgia for
the menstrual cycle. The brand she chose suggested
urgency and yet not outright panic."

There are many stories relating to the mysteries
of blood, the color and opacity of which is due to the
large number of solid particles, the blood corpuscles,
having a higher refractive index than that of the
liquid in which they float. It is in its telltale redness
the mysterious barometer of health, fuel, illness,
disease, shock, shame, embarrassment, stress, choler,
and pain. Robin Redbreast, according to legend,
had its breast dyed red by picking a thorn out of
Christ's crown on His way to Calvary. The rarest
blood type in the world is Bombay subtype A-h,
discovered so far only in a Czechoslovakian nurse in

1961 and in a brother and sister in New Jersey in 1968. After many grueling dance routines with Fred Astaire, Ginger Rogers' shoes were often filled with blood. Is there less of a frisson for you to know that the blood in the shower scene in Hitchcock's *Psycho* was actually *chocolate sauce*? And Cuvier's last few words, softly spoken in May 1832 as he was dying to an attendant who was applying leeches, were: "Nurse, it was I who discovered leeches have red blood."

Red cars statistically are given more tickets than any other color car on the road. Cops spot the color immediately. Psychologists make heavy weather of the exhibitionism behind "Arrest-Me Red" cars. Vance Packard found the compulsion men have in yearning for red convertibles strictly sexual. (Wasn't the classic 1957 Chevy, even the steering wheel and dashboard of which were a bright cherry, the quintessential red car?) The Red Flag, *Hung Chi*, is the brand name for their limousine in the People's Republic of China. It is the color of triumph, fortitude, intrepid daring. Red appears in more flags than any other color. The Red Baron, who had eighty victories, flew, and died in, a red Fokker triplane. And Amelia Earhart's fast little favorite was a vivid red Lockwood Vega NC 7952, powered with a supercharged Wasp S1D1 that had a cruising speed of 160 m.p.h. The color of all British territory on all

official maps is red, and an "all red route" in cartography meant a trip wholly within the British Commonwealth. On ships in the eighteenth-century British navy the decks were painted red, lest when blood was spilled on them it frighten the British seaman. There is a place named Bousbir, also called "the Red City," built southeast of Casablanca near the Porte de Marrakesh, a suburb where prostitutes are kept locked in their brothels all night. The Alhambra (Arabic: *kal'-at al hamra*, "the red castle") in Granada, Spain, is surrounded by a reddish brick wall. The Nazis signed the fateful surrender document on May 7, 1945, at the "red schoolhouse," the Collège Moderne et Technique in Rheims.

Hitler loved red marble floors. It was also Marx's favorite color. British "redcoats" furnished the radicals and revolutionaries of eighteenth-century Boston a series of highly visible hate-figures. Conspicuous soldiers wearing red were easy targets for riflemen. "The redcoats are coming" speaks for itself. ("The quintessential camouflage color, khaki," wrote biologist Michael H. Robinson, "probably first arose when British troops, fighting in Afghanistan in the nineteenth-century, dyed their white uniforms with tea.") Fishermen in Brittany by tradition wear red trousers, which however usually fade to orange, then murky pink. And in England, red bags are reserved for Queen's Counsel in the common law, but a "stuffgownsman"—a junior barrister—may carry

one "if presented with it by a silk" (gownsman, that is). And so convention has it that only red bags may be taken into common-law courts. Blue must be carried no farther than the robing room. In Chancery courts the etiquette is not so strict. Nearsighted people see red much more distinctly, while people with cataracts tend to see things redder and more blurry. Monet, after his operation, was amazed at how much blue he could see. Kodachrome has a red bias, Ektachrome a blue one. Red is a unique color, in many ways an ambiguous one. Infrared, like ultraviolet, is outside the visible spectrum. White light is the source of all color because it is a uniform mixture of all colored light wavelengths. Deep red at the very end of the spectrum is visible at 700 nanometers, billionths of a meter.

David Friedman's film *Color Me Blood Red,* with its huge appeal to drive-in audiences traditionally lustful for blood and guts—seldom has Eastmancolor been exploited to better effect—is probably the locus classicus of visual gore, although Sam Peckinpah's *The Wild Bunch,* among other violent films, could easily be a suitable runner-up. Jean-Luc Godard once pointed out that there was no blood in *Pierrot le Fou,* just red paint—an artificial ploy, as were many things in his films. He was proud of it, feeling that American cinema, with its violent brainlessness, wallows in rivers of blood. Were you aware, by way of gruesome footnote, that at the showing of

one particular Italian creature-feature called *The Night Evelyn Came Out of the Grave,* theaters actually advertised "bloodcorn," which was ordinary popcorn with a red food dye added? The silent film *The Lost World,* directed by Harry Hoyt, which opened at the Astor on Broadway in 1925 on a two-day basis, owed much of its success to the technical wizardry of a certain Willis O'Brien, not only for the savage fights he staged between pterodactyl and brontosaurus, all very lifelike in their movements, but for the wild stampede of monsters during a volcanic eruption which in the actual film he managed to *tint* red!

But could someone straighten me out here? The Thing—a "super carrot" of a vegetable—in the movie of that name has no blood ("no arterial structure"), yet it needs it in order to live, or so it's explained, and so it goes about its mad plasmatic way, killing. Why?

The 1991 eruption of Mount Pinatubo in the Philippines produced spectacular red sunsets around the world for more than a year thereafter, after having blasted dust into the upper atmosphere which, gathering ice crystals, refracted the rays of the setting sun in early noctilucent clouds.

Rubrics, those directions found in breviaries and huge Psalters for divine service, are written in red—by definition. It is a term taken from the civil code of ancient Rome. Juvenal writes, *"per lege rubros ma-*

joram leges" (*Satires*, XIV, 193). Church Psalters are invariably bound in flame-red covers. So are the *Missa Romanum* and the *Annuario Pontificio*, that fat red-bound pontifical yearbook published every February in Italian. The Church loves red. The Pope's close-fitting red velvet cap is called the *camauro,* and of course he wears red slippers. Some old-style churchmen still terminate letters or petitions to the pontiff with the archaic phrase "humbly kissing the sacred slipper" before their signature. Oddly, the felt, broad-rimmed, tasseled red hat of a cardinal, the *galero,* pictured in his coat of arms, placed on his coffin, and symbolic of him and his office, is in fact—queerly, don't you think?—never *worn.* The long scarlet mantle of a cardinal is called a *caudatorio.* As to the peculiarity of certain sacramentals, what is prefigured in the oddly unliturgical and surprisingly non-Calvinistic rope ladder attached to Father Mapple's lofty, stairless pulpit in *Moby-Dick* and the "handsome pair of red worsted manropes for this ladder, being itself nicely leaded and stained with mahogany color"?

It was not always a color easily available. Irish monks putting together the exquisite Book of Kells would have imported kermes, the dead bodies of insects of the genus Kermes, which themselves constitute the dyestuffs, to make carmine, and used folium, derived from metamorphic rocks, to create the book's pinks, purples, and blues. Red was gener-

ally used by scribes in ancient and medieval times when they wished to decorate their manuscripts. The word "miniature" comes from the word *minium,* the Latin name for "red lead." (Minium is now a red lead paint used for painting bridges.) The pictures that they incorporated with this red lead were quite small, and so the word "miniature" got somehow mixed up in people's minds with the Low Latin word *minutum,* meaning "a small portion." Hence "miniature" is now used to signify a little painting, and by extension, anything on a reduced scale. Along with black ink, red ink, manufactured from red ocher or red iron oxide—usually dried into cakes, then moistened with water—was used not only by the ancient Egyptians, particularly for headings, but also in biblical times (Jeremiah 36:18). A Victorian recipe (ca. 1857) for red writing ink goes as follows:

> *4 ounces ground Brazil wood*
> *1 pint diluted acetic acid*
> *½ pint alum*
> Boil slowly for an hour, strain, add 1 ounce gum.

Passionate letters are written in red. And of course minatory ones, as well. (Blue ink on a red valentine envelope appears as black.) Don't teenage girls favor red ink in writing? Young Nancy Clutter,

murdered in 1959 by Smith and Hickock—which became the subject of Truman Capote's novel *In Cold Blood*—keeping a diary in different colors, made all of her 1957 entries inked in red. Alexandre Dumas *père,* who, as we have seen, wrote his fiction on blue and his poetry on yellow, wrote his nonfiction on rose-colored paper. The Chicago *American,* a Hearst paper, to take full advantage of the lurid interests of its readers, liked to print headlines in red ink. The line "Is God Dead?" that appeared on the cover of *Time* in April 1966—posed dramatically in red type against a severe black background without illustration—generated a deluge of more letters and telephone calls than any other of their covers (except for Ayatullah Khomeini as "Man of the Year" in 1979). The message was of course red in its alarm, but the color served it well. And of course the Faber-Castell col-erase Carmine Red pencil is the choice of editors everywhere. (Proofreaders use blue.) Finally, in 1849, in Cologne, Karl Marx was arrested, tried twice, first for violating press censorship, then for inciting to armed insurrection—although he was acquitted both times—and then expelled from Prussia by the government. After his paper the *Neue Rheinische Zeitung* was suppressed, Marx saw to it that the last issue, as a specific protest, appeared in print that was stop-light red.

A certain fraternity has always existed between white and red. As Emily Dickinson wrote in a poem

of 1863, " . . . by power / Of opposite—to balance odd— / If White—a Red—must be!" Cornell University, Santa Claus, Coca-Cola products, Hitler's ensigns, Campbell's soups, etcetera. The colors not only look good together, but in very real terms of visual relief almost need each other, with the possible exception of the late, poor, pale, poached Andy Warhol, who once confessed, "At one time the way my nose looked really bothered me—it's always red—and I decided that I wanted to have it sanded. Even the people in my family called me 'Andy the Red-Nosed Warhola.'" Couldn't one fashion a creature, by the way, of composite red parts? I mean, the Florentines themselves, Kenneth Clark assures us, loved the "knobs of form"—noses, knees, etcetera. Along with Warhol, Mr. Micawber had a red nose. So did Martin Luther, Emmett Kelly, W. C. Fields ("ruby rose" is Cockney slang for the nose), the Scarecrow of Oz, Shelley's Beelzebub in "The Devil's Walk," Hart Crane, and Clarence the Angel in *It's a Wonderful Life*. Teddy Roosevelt had a red neck. So did Randall McMurphy, whose neck in *One Flew Over the Cuckoo's Nest* "comes out of his T-shirt like a rusty wedge." (He also had "thick red arms.") Beethoven, it was remarked by several contemporaries, had thick wide red *hands*. Bashful, one of Walt Disney's Seven Dwarfs, had red ears. And there's Kali with her flaming red tongue. And who in Dickens *didn't* have red cheeks—Mr. Fledgeby, the

Cheeryble Brothers, Dawes, Mr. Turveydrop, Fezziwig, of course, Samuel Pickwick, Little Swills, Septimus Crisparkle, Mrs. Lupin, Clara Peggotty, etcetera. Aldous Huxley in *Antic Hay* said Nancy Cunard, with her white skin, blue eyes, and red lips, looked like the French flag. A woman in Huysmans' novel *Là Bas* has red teeth. And P.L.O. leader Yasser Arafat has a protruding red lower lip "so thick it looks like he has been stung by a bee, so red," observed journalist Amos Elon, who once interviewed him, "you might think he uses lipstick." So many characters in literature have faces as red as baboons! In Valerii Briusov's novel *The Fiery Angel,* which Prokofiev would later turn into his most powerful opera, the hero Rupprecht at one point, having rubbed witches' ointment all over himself, visits a sabbath and sees the Devil with "his face human, red, sunburnt like an Apache." I have always thought, walking through Baghdad or Basra or Kufa, how the faces of Iraqi soldiers have the color of red leather. There are even red laughs. David Plante, writing of artist Francis Bacon and his group, spoke of Isabel Rawsthorne, a friend whom Bacon often painted, "laughing a wide, wet red laugh."

Of course, we have the paradigm of the red character in Diggory Venn, the reddleman in Hardy's *The Return of the Native* (1878), who provides farmers with redding for their sheep, a fellow "singular in colour," for "like his van, he was completely

red. One dye of that tincture covered his clothes, the cap upon his head, his boots, his face, and his hands. He was not temporarily overlaid with the colour: it permeated him."

As to red and white, we should not overlook Mendel. By experimentally crossing red peas with white, this Moravian monk discovered the principle of alternation of color. New Hampshire barns were once painted with blood and milk. There is the three-hundred-year-old Rauchbier establishment in northern Bavaria, famous for its smoked meats and smoked beer, the old walls of which are still regularly painted with pure ox blood. And the pschent, the high conical cap or crown worn in ancient Egypt, united Upper (white) and Lower (red) Egypt with its two colors. The colors are found even in nature, as well, in trees, lichen, even stone. The Gypsum Hills, near Medicine Lodge, Kansas, are red stone mesas capped with white gypsum that looks like whipped cream on strawberries.

Red-and-white is also the predominant color scheme of Shinto. The annual *Kohaku* (Red-White) year-end song contest held in Japan is a serious competition between male and female. (Red symbolizes the female in Japan.) Red and white girdles in Japan are a protection during pregnancy, furthermore. And on the stark white Japanese flag the *Hinomaru*—that hot-red central circle—mythically

evokes the powerful sun goddess, Amaterasu, as an orb rising.

Henry Wadsworth Longfellow apparently loved the image of the late afternoon sun on windowpanes:

> *Through clouds like ashes,*
> *The red sun flashes*
> *On village windows*
> *That glimmer red.*
> ("Afternoon in February")

and

> *Lo! in the painted oriel of the West*
> *Whose pains the sunken sun incarnadines*
> ("The Evening Star")

and

> *The windows of the wayside inn*
> *Gleamed red with fire-light through the leaves . . .*
> ("Tales of a Wayside Inn")

Many culinary gadgets and inexpensive kitchen wall clocks from the thirties—brands like Westclox, Telechron, National, etcetera—were made in traditional red and white, "kitchen colors." There was

even a "Red, White, and You" Coca-Cola campaign in the 1980s, and while the company's color is essentially red (the actual drink *itself* is rubious, no?)—in fact, Mark Pendergrast in his book *For God, Country, and Coca-Cola* notes that the Color Research Institute "discovered that red was 'hypnotic,' and particularly attractive to female shoppers"—after experiments in various test markets, Coca-Cola came up with New Coke, a.k.a. Coke II, simultaneously (and almost blasphemously!) before sheepishly bringing back the compromise of Classic Coke, adding a blue line to the can (forgetting, apparently, an old Jimmy Clanton pop-tune titled "Red Don't Go with Blue"), an explicit nod, and no doubt lamentable capitulation, to Pepsi. I mean, a blue line on a can of *Coca-Cola*? Sacrilegious!

Coca-Cola is the world's most famous product with this color combination. Its red is of course very red. To duplicate it, Centari-77968 AM is probably closest to the color, and for its white, which is mighty white, I would try Dupont Iceberg white. And there is that memorable passage of the ship in Garland Roark's novel *Wake of the Red Witch* (1946): "And she fell beautifully into title, for she gracefully towered into the wind hand and swept through the water like a fleet swan done in Chinese lacquer . . . Her decks were long and scrubbed white, her hull glistened of red."

Red and white as juxtaposed colors in many

cultures are also thought to be bad luck. But not in Nazi Germany. Hitler himself planned the design of the Nazi flag, a red background with a white disk in its center bearing the black swastika—he chose the *female* form of the ancient emblem, a cross with equal-sized arms bent at right angles to the right, instead of to the left, as in the male form of the swastika—echoed in the blood-red banners of Nuremberg, generating roars of *"Sieg Heil! Sieg Heil!"* "Not a soul had seen this flag before," noted Hitler. "Its effect at that time was something of a burning torch . . . The red expressed the social (not *socialist*) thought underlying the movement. White the national thought. And the swastika signified the mission allotted to us—the struggle for the victory of Aryan mankind . . ."

And the ancient Greeks, according to Roberto Calasso in *The Marriage of Cadmus and Harmony,* usually celebrated feast days, victories, and so forth with fluttering strips of wool, red and white for the most part, which they tied around their heads or arms, or to a branch, the prow of a ship, a statue, an ax, a stone, or a cooking pot.

Persian weavers to dye rugs red have found that the best and most lasting color is the rich carmine, again, known as kermes, those dried insects which live in a species of oak tree. Collected in June, they are killed by exposure to the vapors of acetic acid, evolved by heating vinegar. Kermes was known to

have been used in Syria in the time of Moses, by the way, and remains to this day the most lasting and most preservative of dyestuffs. It was later supplanted by cochineal, which is more brilliant, and which combined with chrome mordant on wool will leave a rusty, salmonlike red. Madder root, ground and boiled, is also the basis of a multitude of reds in weaving. Persians today combine madder with alum and grape juice. A Turkey-red field is probably common to most rugs. The red in a Saraband rug has a sort of orange cast to it. Deep terra-cotta red is a favorite color with Shiraz weavers. In the center of many Persian rugs is set a small touch of red yarn, purposely introduced to bring good luck and to overcome the evil eye.

When large quantities of wool are spun in the high reaches of Tibet, the thick ropes are almost always dyed a warm reddish brown obtained not only from the bark of trees, earth, and plants, but from a wild rhubarb which grows in the mountains and represents an extra source of income to the peasant women there. It is not only the color that is highly prized, but also the acid which the special rhubarb contains, which can be mixed with other colors. This is of course also the color of the famous red-brown dagam, the wide garment of the Tibetan Buddhist monks, which is worn like a toga and in which, when you sit down, you can completely muffle yourself.

Speaking of dyes, Red Dye No. 2, which had been used for years in breakfast cereals, packaged mixes, jams and jellies, imitation fruit juices, gravies, ice cream, lunch meats, candy, lipstick, cake mixes, and even pet food, was determined by the FDA in 1976 to be carcinogenic. (Red M&M's disappeared for over a decade.) Red Dye No. 40 was then used, followed by Red Dye No. 3, which since 1984 has created an even more enormous brouhaha due to the rising cases of thyroid cancer appearing in rats when they ingest the equivalent of hundreds of bottles of dyed cherries a day.

Red intrigued the Maya. A rich hematite was the basis of their much-used red paint. The red in the mural paintings of Uaxactun, Chichen Itza, and the brilliant small temple at Bonampak in the forests of Chiapas was a pigment made from red ocher. Iron pyrite in fact served as mirrors for them. With the Maya, colors are associated with directions. The Maya, like the Mexicans, believed that the world rested on the back of a huge alligator or crocodile, which, in turn, floated in a vast pond. Red is the color of the east. Their high priests, dressing in red, symbolized the red rain god of the east. In one ritual of the four world directions in the Book of Chilam Balam of Chumayel, we read, "The red flint is the stone of the red Muzencab [the sky bearer, who also functioned as a bee god]. The red ceiba [the wild cotton tree] of the dragon monster is his arbor which

is set in the east. The red bullet tree is their tree. The red sapodilla, the red vine ... Reddish are their yellow turkeys. Red toasted corn is their maize."

The early Greeks got red from lead monoxide and lead peroxide, in the same way red ocher, or iron oxide red, became the red paint of the American Indian, and of course red earth can be found everywhere in this country from Santa Fe to western Connecticut to the red volcanic soil of the Pribilof Islands in the Bering Sea. Red ocher and the sinopia of classical antiquity, used by the painter Apelles, are virtually the same thing. (Parenthetically, I know an old salt on Cape Cod who always uses red lead to waterproof the hulls of his boats.) What ochers the Egyptians used on walls! And the red semiprecious stones elaborated on their coffins, such as those on the cover of the coffin of Tutankhamen! The great temple of Abu Simbel, before the sand and weather of centuries erased the hue—the four colossi of the god-king Rameses (and the smaller family figures)— was painted over in its vast entirety, face and bodies, with red ocher. Pharaoh's engineers also lined up the axis of the temple, so that twice yearly, in mid-February and mid-October, when the sun shone into the innermost chamber 180 feet from the entrance to glorify the statues within of Rameses and of Amun, god of Thebes, a red line could be drawn along the rock paralleling the penetrating rays.

It was a color whose aura of grandeur—and

perhaps, by extension, of vanity—was invoked as well all through Scripture. In Jeremiah 22:14, for example, we read of the Lord implicitly condemning Shallum, son of Josiah, for having overreachingly beautified his palace by "painting it with vermilion." And in Wisdom 13:14, Solomon speaks of the guile in those who would, in trying to hide a defect, make a false image by "giving it a coat of red paint and coloring its surface red." In Ezekiel 23:14, the harlot Oholibah looks with lust on wall images of Chaldean men made even more handsome, it is implied, by being "portrayed in vermilion." And the grave attack predicted for Nineveh in Nahum 2:3 seems more terrible for the imperious red shields and soldiers "clothed in scarlet" of the invading Medes and Persians.

Red, being so bold, was a color sought out for that reason from the beginning. Ancient and medieval crimson lakes, as we have seen, had animal or vegetable origins: kermes, grain, madder, dragon's blood, brazilwood, and later, cochineal or carmine. Alizarin red, a synthetic coal-tar lake which is considerably more permanent, has replaced them all. Vermilion, mercuric sulfide, found in the form of a native mineral called cinnabar in Spain, China, and Austria, is usually replaced today by cadmium reds. As to Roman wall-painting, red was a popular color at Herculaneum and Pompeii. And in Rome, the faces of the gods—in temples, on statues, and on

wall paintings and frescoes—were often painted scarlet red, which however tended to fade over time.

Sir Joshua Reynolds for one never really mastered the technique of preparing his colors, so, consequently, the carmine in the cheeks of his portraits began to fade almost before the paint was dry. And how common were red cheeks, red as Remoulade, in that beef-loving, meat-eating, fat-chewing, wine-swilling century, where virtually everybody had gout. Look at the eighteenth-century portraits in any museum, and you'll see on most of the sitters faces like summer sunsets.

What strange insistent reds there are to be found in painting, like the shocking skies in Edvard Munch's *The Scream* and *Anxiety*. What of the glow in the rubescent cheeks of Frans Hals' *The Jolly Toper*? Or the stained-glass red in the trousers of Manet's young *Fifer* (who, notice, is a woman)? Then what are Hogarth's paintings without his reds? Or Boucher's? Or Cézanne's, whose apples, you may recall, stand for one of the few things, announced in his famous list in the film *Manhattan,* that made life worth living for Woody Allen? (D. H. Lawrence said that Cézanne's apples were more important than Plato's ideas.) Or Chagall's, who especially loved red for its barbaric richness of color? I think of his *Maternity* (1913) in this regard. It was part of what he called his "primordial palette." His *Obsession,* with its war motifs, is dominated by flaming colors

of scarlet, as are his *Bouquet* and vivid *Red Circus* and *Listening to the Cock.* As to barbaric richness of color, Francis Bacon, who wanted, among other things, to make the human scream into something "which would have the intensity and beauty of a Monet sunset," liked the color of blood, whether Antioch-red or paintbox bright or cherry: "It's nothing to do with mortality, but it's to do with the great beauty of the color of the meat." Rembrandt and Soutine and Kienholz shared this attraction to images of the abattoir, flesh and hanging carcasses. Gauguin's *Vision after the Sermon* shows Jacob wrestling with an angel in what could be, so bright is the background, a cranberry bog! In Henri Rousseau's *Dream,* which shows the irresistible Yadwigha, imaginatively in the middle of a virgin forest, seductively outstretched on a splendid red sofa, it may well be argued that we have the masterpiece and the touchstone of surrealism. (As a matter of fact, Tristan Tzara himself wrote the preface to two strange dramas written by Rousseau, his vaudeville *Voyage à l'Exposition de 1889* and *La Vengeance d'une Orpheline Russe.*) The high-gloss red shoes and handbags in acrylics of Don Eddy's unique *New Shoes for H* are astonishing. And try to count the various shades of red in Alexei von Jawlensky's *Still-Life* (I count ten) or the strategically laid-out reds (you could connect the dots with them)—four jackets, six hats, one skirt, one sleeve, and one striped red crown—in Breughel's *Peasant*

Wedding. Incidentally, da Vinci in his drawings consistently favored red chalk, not chalk as we know it, but hard pieces of red mineral, like silver-point, which he used on suitably treated paper. Red was of course used down through the centuries for drawing, but it was the wonderful French artist Watteau who began to use red crayon in such marvelous ways that with it he opened up a whole new field of art.

I am sure nothing is redder than Saint Peter's gilt-edged scarlet robe (it seems even to tint his facial complexion) in Albrecht Dürer's *The Four Apostles.* Or Jesus' robe in Emil Nolde's *Last Supper.* Red is the color of the bed in van Eyck's famous *Giovanni Arnolfini and His Bride,* and also creates the fullness in the folds and color of his *Man in a Red Turban* (1433). The use of vermilion by Rubens on flesh has often been considered to be one of the great painter's bold peculiarities. (Was the gout he badly suffered, inflaming his own body, a possible source?) In any case, for good bright reds seventeenth- and eighteenth-century painters used vermilion— considered today unreliable—and got their transparent reds from madder and grain, that is, grana or kermes, that little red bug, like the cochineal insect, which we have already cited as a source of paint. I saw in the Hermitage in St. Petersburg Matisse's *Harmony in Red,* mostly in luscious pink with wine-red apples, flowers, and a red chair. (Matisse personally loved that delicate transparent pink of baked

shrimp shells, which tinges so much of his work.) And as Gulley Jimson said in Joyce Cary's novel *The Horse's Mouth*, "Old Renoir painting his red girls with the brushes strapped to his wrists. Best things he ever did. Monuments." There is also that barreta and tunic, both a deep royal red, in the portrait of Piero della Francesca's patron, Duke Federigo da Montefeltro, he of the odd-shaped nose and cultured beneficence.

What flourishes in Goya's painting of the infant Don Manuel de Zuniga, known as *The Red Boy*! I am also struck with Kandinsky's *Two Sides Red, No. 437*, with its scarlet geometric shapes. (Isn't every possible angle included there?) Cézanne's spectacular *Boy in a Red Waistcoat*, owned by Paul and Bunny Mellon, is hung over the chimneypiece in their Washington, D.C., house. Red in detail alone has power. In Velázquez's *Philip IV Hunting Wild Boar*, the single courtier in red in the foreground centers the entire scene. A mere dab of red in Cézanne's *Avenue at Chantilly* suffices for a house. Cézanne was badly myopic. Patrick Trevor-Roper in his classic *The World Through Blunted Sight* points out that instances of shortsightedness, or an elongated eye, affect perception of color, as well—reds, for example, will appear more starkly defined. Was that waistcoat dependent on Cézanne's infirmity? Cataracts, especially, may affect color, blurring and reddening simultaneously. There is the paradigmatic

case of Turner, whose later painting Mark Twain once described, not flatteringly, as "like a ginger cat having a fit in a bowl of tomatoes."

It is a color that can go from the hard electric red, almost centrally fixing the painting, of the woman in the scarlet dress in Edward Hopper's famous *Nighthawks,* that theatrical box set in a starkly lighted diner, to the soft natural scintillating reds of Arshile Gorky's *The Liver Is the Cock's Comb.* Matisse's *Red Room* (1911), an arrangement in an airy brownish red with delicate webs of line and color, of all his artistic achievements, especially his Fauve work from five years earlier, sums up his art and philosophy. René Magritte's bizarrely named *Tomb of the Wrestlers* (1960) has a unique origin. Challenged to produce an all-white composition, he chose instead to paint a red rose—an American Beauty, technically perfect, in full bloom, in a vivid red room! ("Surrealism," he wrote, "is the knowledge of absolute thought.") Van Gogh, who did not begin to paint, people forget, until the last decade of his life, sadly made the only sale of a painting, for four hundred francs, the year he killed himself, when he sold the negligible *Red Vineyard.* Is there a more beautiful red in existence than that rich red in the background of the famous *Lady and the Unicorn,* which has endured since the sixteenth century? And what list regarding the color could be complete without mentioning Sargent's *The Sulphur Match*—

isn't a somewhat sordid tale being told solely by the touch of that red foulard worn around the woman's neck?—or his bravura portrait of suave Dr. Pozzi, society gynecologist, with his fiercely burning eyes and beard, giving him the look of a wealthy hidalgo, resplendent in elegant slippers and that red dressing gown, described by John Updike as having the "cozy crimson aura of satanic drag"?

Speaking of Dr. Pozzi's gown, fourteenth-century Florence was the leading cloth-finisher of Europe, and in that city red silken garments (*"vermiglio"* or *"scarlatto"*) were generally worn by doctors and lawyers. In Boccaccio's *Decameron* (VIII), Lauretta bemoans: *"Tutto il dì, i nostri cittadini da Bologna ci tornano qual giudice e qual medico e qual notaio, co' panni lunghi e larghi e con gli scarlatti e co' vai e con altre assai apparenze grandissime."* ("Every day our fellow citizens return to us from Bologna, some as judges, some as physicians, and some as notaries, with long wide gowns and robes, of scarlet and ermine, and many other decorations of distinction.") May I note here that Pier-Francesco Florentino's beautiful *Madonna*, blonde-headed, contemplating a reclining Christ child, in the Palazzo dei Consoli in Gubbio, Italy, is actually wearing—uniquely—a red gown? I am convinced that the red fez—its sole and distinct color—is of judicial or magisterial origin. And in Boccaccio's *Corbaccio* the Spirit's garment as he comes from

Purgatory, also scarlet, is a convention in the dream or vision tradition.

Is red a soft paint? In roulette, because red and black paint differ in chemical properties, many gamblers will, cautiously—you might want to say half-wittedly—bet on no number not on the color red, figuring rather conceptually that red paint, having safely soaked into wooden fibers of the wheel, makes the slot more congenial to "housing" the ball, whereas black paint, having hardened the wooden fibers of the slot, can only make the ball bounce out!

There are red writers. Havelock Ellis wrote, "When we have ascertained a writer's colour-formula and his colours of predilection, we can tell at a glance, simply and reliably, something about his view of the world which pages of description could only tell us with uncertainty." Is he correct? Homer, surely, with all his Greek and Trojan battle scenes was such a writer (or singer, if you will). Shakespeare is charged with red imagery. As are Tennyson, Dumas, and Spenser with his Red Crosse Knight and all his dragons and slayings. I think of Dostoyevsky as being among this vivid group. And the Tolstoy of *War and Peace,* that uncompromising panorama of human passion, blood, slaughter, fire, flying flags, uniforms. I'd also include the Jacobeans. Among other such poets might be mentioned Andrew Marvell, for whom flowers, especially his red, red roses, represented the sexuality of women. (His

work is also filled with apple imagery.) Roses prolif-
erate in the work of Antoine de Saint-Exupéry. Then
there is Yukio Mishima. "I have a red rug in my
room. Wherever I've lived in life, I've carried my red
rug with me. I keep it in excellent shape. I have it
vacuumed; I have it dry-cleaned. It's part of my life,"
wrote Sylvia Plath, a distinctly red poet, who in
"Tulips" ("The tulips are too red in the first place,
they hurt me") is writing of her appendectomy.
"Dickinson relishes blood and is lavish with her red
palette," notes populist critic Camille Paglia, who
goes on to add with her characteristically hysterical
hyperbole, "The poet is a self-maiming pelican, tear-
ing clots of flesh from her breast to feed her song,
whose notes and bars float through the air in a red
trail, a bloody skywriting."

> *Say from the Heart, Sire*
> *Dipped my Beak in it*
> *If the Tune drip too much*
> *Have a Tint too Red*
> *Pardon the Cochineal—*
> *Suffer the Vermilion—*
> (1059)

Edgar Allan Poe was a red writer. It was the color,
to him, of ghoulishness, living horror, lust, murder,
and anxious foreboding—the ungovernable and
tempestuous flames that destroy the Palace of

Metzengerstein; the oppressive scarlet of the dungeon ("a richer tint of crimson diffused itself over the pictured horrors of blood") in "The Pit and the Pendulum"; and in "The Conqueror Worm," who can forget that "blood-red thing that writhes from out the scenic solitude"? He refers to red waves in "The City in the Sea," to red winds in *Al Aaraaf,* to the comets of fallen angels with the "red fire of their hearts"—think of all the hellish hearts in his stories and poems—as well as in "The Fall of the House of Usher," terrifyingly, to the "blood-red moon."

Rimbaud confessed "a flight of scarlet pigeons thunders round and round my thoughts" and in *Vowels*—was it from ghoulishness or a sense of his own violence?—actually sees *himself* as the color red, writing, "I, crimson, blood hawked up, sweet lips smiling anew in wrath or in the rapture of a penitent." Leonid Andreyev's *The Red Laugh* (1904) is a soldier's diary at the time of the Russo-Japanese war. The "red laugh" is the symbol expressing the torn, wounded, mutilated bodies of the suffering. James Fenimore Cooper's Red Rover was a pirate, Anatole France's Red Lily in *Le Lys rouge* (1894) a roundheel. "Please God, we're all right here. Please leave us alone," wrote Anne Sexton in her poem "May 30th." "Don't send death in his fat red suit and his ho-ho baritone." Then what is maybe the perfect line on the color, written by Dean Burgon in

1845, goes: "A rose-red city—'half as old as time.' "
And what about the bloody *Ivanhoe* of Scott?

And who can ever forget Paul Éluard's lines from "La Victoire de Guernica," as fully memorable as Picasso's excoriating painting?

> *Les femmes les enfants ont les mêmes roses rouges*
> *Dans les yeux*
> *Chacun montre sang*

> (Women and children have the same red roses
> In their eyes
> They show each other their blood)

Wouldn't we be delinquent, finally, if we excluded mention in this context of Hilaire Belloc, he of the famous couplet "When I am dead, I hope it may be said / His sins were scarlet, but his books were read"?

"Red is the color of magic in every country, and has been so from the earliest times," observed Yeats in *Fairy and Folk Tales of the Irish Peasantry*. "The caps of fairies and musicians are well-nigh always red." Gypsies used to wear red at funerals to symbolize physical life and energy, and in the dark ages rubiginous toads, simmered in oil, were supposed to cure leprosy. But red was almost always a color that meant death in the Celtic world. It foretold disaster.

Witches, it seems, dislike the color red, a fact that might have saved rather than condemned poor Bridget Bishop, who, married three times, owned an inn in Salem Village, "entertained" travelers, and strode around in a bright red bodice before she was hanged as a witch in 1692. Her accusers spoke of blood-red cats and stark red rats running about and strange red signatures in prohibited books. In Korea, it is considered bad luck to sign one's name in red. A red meditation belt is often worn in Tibet, and Milarepa, a greatly revered saint throughout that country, wears such a belt. In Tibetan Tantric mysticism, while one is slowly chanting the mantra *Om Mani Padme Hum,* thoughts held at the syllable *me*—symbolized by the color red—should be directed to comfort the existence of pretas, or tantalized ghosts.

In England rowanberries, the fruit of the mountain ash, are commonly said to act as a charm against the powers of darkness. And in that country, ruby water, any water in which a ruby had been washed, was given for stomach trouble. And in medieval Germany, mistletoe was hung around children's necks for the same reason. Not that those red berries don't also have the connotation of venery. Anything to do with Venus is red. "Red is the characteristic color of sexuality," wrote Oswald Spengler in *The Decline of the West*, "hence it is the only color that works upon the beasts."

Regarding ghosts, years ago when the first tele-
graph lines were strung across rural China, they
became a source of alarm—their purpose un-
fathomable, their appearance forbidding—not only
for the piteous moans heard as the wind blew
through them but because as the wires rusted, the
rainwater dripping from them acquired a gruesome
tinge of red and convinced the terrified peasants that
dead spirits were being tortured by these alien con-
traptions.

Red in a magic way has also reached the aura of
mythical worlds. The Tottentots in L. Frank Baum's
The Patchwork Girl of Oz (1913) are tiny dark-
skinned mischievous people whose scarlet hair
stands straight up on their head, like Wishniks. In
Peer Gynt, trolls wear silken bows on their tails, and
to receive a flame-colored bow is an honor. The sun
is red on Mondays in Richard Brautigan's *In Water-
melon Sugar* (1968). The Land of Wonder in the
stories of Isaac Leib Peretz is inhabited solely by red-
haired Jews, and the mythical half-wild savages who
hate strangers in William Morris' *The Wood Beyond
the World* (1894) have long red hair. In Basilisk
Country, which we know today as southern Africa,
near the coast, according to both Pliny and Lucan,
lived manticores, gigantic red lions with human
faces and triple rows of teeth which fit into each
other like combs. On stormy nights, that mysterious
red light seen crossing the great Grombolian Plain in

Edward Lear's fable belongs to none other than the Dong With The Luminous Nose.

There is a Red King who lies dreaming in the Looking-Glass Forest in Lewis Carroll's *Through the Looking-Glass, and What Alice Found There* (1871), whose dream consists of those visitors who come across him. Travelers must be careful not to wake him, for if they do, they will be blown out, just like candles. And children from Luggnagg in Swift's *Gulliver's Travels* are occasionally born with a red circular spot just above their left eyebrow. According to Luggnaggians, this is a sign that they will never die. But we find references to real worlds, as well, like red Ethiopians, a tribe of unknown origin living in the Pacific Ocean, mentioned in Mikhail Bulgakov's *The Purple Island* (1928), so called because of the color of their skin. And one of the most striking frescoes at the prehistoric city of Catal Huyuk, a 6,000-year-old Turkish settlement, is the great red bull, a fifteen-by-fifteen painting of a huge creature, dwarfing the armed hunters surrounding it, painted stark red.

We also of course associate red with beauty. A beautiful Red Room can be found in The Breakers at Newport. The Red Room in the White House—I own a postcard of it from 1910—takes its name from the red velvet wall-covering and window draperies. And the Red Room is the inner sanctum of the old Caledonian Club (1897) in London. It is the warm

and attractive color of most theaters. The box at Ford's Theater where Lincoln was assassinated, with its red damask wallpaper, red upholstered chairs, and red carpet, is in fact a red room. Red Square in Moscow got its name, not from the 1917 Revolution—it has been identified by that name ever since the Middle Ages—but from the Russian word *krasnaya,* which means "red and beautiful." Russian peasant women are described in *Hakluyt's Voyages* as habitually painting large red spots on their cheeks as beauty marks. In Russia red is supposed to be the beautiful color. *Krasota* is beauty; *krasnyi* is red. This may account for its adoption by the Bolsheviks in 1917, but red has always been regarded far and wide as the color of liberty. I know a beautiful Navajo girl in Santa Fe named A'zah Che'e, meaning "Red Woman."

A red rose symbolizes love. There is the celebrated comparison by Ariosto of a rose with a young girl, and the Blessed Virgin Mary, according to one legend, was born when Saint Anne inhaled a rose. Red roses have virtually always been synonymous with beauty ("My love is like a red, red rose"). It has always been the flower of Venus. In China, brides popularly wore red and were carried in a red marriage chair with a red parasol overhead; a red card tied the caps of the bride and groom together, and red firecrackers were exploded in their honor. I have always been surprised at the diverse group of pas-

sionate *rosiéristes* there have been, among whom can be numbered Albert Camus; the actor Charles Laughton; Empress Josephine of France; Rudolph Valentino (an expert gardener); Claude Monet, whose lovely gardens at Giverny prove, to a certain degree, that he considered gardening, not painting, his best creation; hoodlum Bugsy Siegel; Emily Dickinson (especially "globe roses," whose bright crimson "ill becometh," she wrote in 1862 in one of the "Master Letters," probably to Samuel Bowles, the "desperate sadness" she felt in losing him); Audrey Hepburn; screen actor Glenn Ford; and, may one add, Gertrude Stein, obfuscatrix, or was it that she merely wrote idiotic tautologies about roses? Perhaps we should add to the list that semi-mad English poet (and gardener) Christopher Smart, who once prayerfully wrote, "The Lord succeed my pink borders." Rumor had it that Bugsy in his secret rose garden in the back courtyard of the Flamingo in Las Vegas competitively used a secret formula to keep his roses so beautiful and richly red. The red rose is of course not always the cause of happy associations. It is also a leprous dermal mandala; the kitsch symbol of vulgarian / pop singer Bette Midler; and the shape of terrible cankers. And surely Norma Desmond's out-of-date perfume of hothouse tuberoses in the film *Sunset Boulevard* represents her own decay, does it not? The spy Mata Hari, shot for treason after World War I, faced the firing squad

with a smile on her lips and a bouquet of roses in her arms.

Did you know that roses are used in cooking? Chez Panisse in Berkeley, California, offers, among other rose dishes, "Wild Strawberry Tartlets with Pastry Cream," which calls for "3 fragrant freshly picked garden roses (pesticide free)." And "Quail in Rose Petal Sauce," a recipe in Laura Esquivel's *Like Water for Chocolate,* calls for twelve roses, preferably red. ("Remove the petals carefully from the roses," we are advised, "trying not to prick your fingers for . . . the petals could soak up the blood that might alter the flavor of the dish . . . ")

We should mention, along with firecrackers, that color hearing is a form of synesthesia that manifests itself by the appearance in the mind of colors or shades whenever certain sounds are heard. According to Albert Lavignac in *Music and Musicians,* "Each instrument really has its own color, which may be defined as its special character." He goes on to point out that the whole "family of trumpets, clarions, and trombones, presents all the gradations of crimson . . . while the cornet, trivial and braggart, utters a note of very ordinary red, ox-blood, or lees of wine." He adds that the "warm sound of the clarinet, at once rough and velvety, brilliant in the high notes, sombre but rich in the chalumeau registers, calls up the idea of red brown, the Van Dyke red, garnet."

Chestkin and Masten, an American design consulting firm, disapproves of red, and black, for marketing financial services. While red implies safety and strength, it also carries with it a connotation of vulnerability, of being "in the red." It is the color of alarm and volatility. You'll never find a bank or brokerage house with a red brochure. Is there also something of a pall in its inherent theatricality? In its forwardness? Eccentric Canadian pianist Glenn Gould, whose favorite color was battleship gray, once proclaimed while interviewing himself ("Glenn Gould Interviews Glenn Gould about Glenn Gould") that anyone who wanted to paint his house red should be prevented from doing so, not only for aesthetic reasons but because such a change "would . . . foreshadow an outbreak of manic activity," and, ultimately, "a climate of competition and, as a corollary, of violence." Red is bold and paradoxical, pleading and attention-getting, and yet, somehow for all that, dangerous.

At the red end of the spectrum, light waves are of course longer, and at the violet end, shorter. The planet Mars is swirling in iron oxide dust. Antares, the eye of the Scorpion, a red "supergiant twenty-seven million times bigger than the sun, is the reddest of all the first-magnitude stars, and there is the rose-red star of Aldebaran in Taurus. Betelgeuse, in Orion, is reddish. Mars is the red planet. There are immutable laws of a ruling planet. Fire, iron, hema-

tite, jasper, the taste of bitterness, the male sex, the liver, gall, kidneys, veins, and the left ear—all belong to the planet Mars, which, according to astrologists, also dominates the years of life from forty-two to fifty-seven, Tuesdays, and the night from Thursday to Friday. Children of Mars are considered hot-tempered, bold, bellicose, impulsive, destined for evil deeds. If, by the way, in the morning ancient Homer had his "rosy-fingered dawn," at dusk Dante in the *Purgatorio* (II, 13–15) noted how *"per li grossi vapor Marte rosseggia giù nel ponente sopra il suol marino"* ("through the dense mists Mars burns red, low in the West o'er the ocean floor"). My favorite line about sunset—the rhythm alone is hauntingly beautiful—is Jorge Luis Borges' "I saw a sunset in Querétaro that seemed to reflect the color of a rose in Bengal."

A "red giant" occurs, strangely enough, among stars when the hydrogen supply runs *low*. Stars swell, as nuclear reactions begin, and get hotter and denser at the core, while paradoxically getting cooler at the surface. Temperature also often indicates the age of a star. White stars are young, red ones old. Interferometers confirm that red, highly luminous stars are also the biggest. Everyone has seen blood-red sunsets. They are caused by the layers of dust in the atmosphere absorbing light of short wavelengths, so that only the long wavelengths of red light reach the eye.

Incidentally, the notion that beauty is in the eye of the beholder may be true in more ways than one. Most eyes contain three pigments—red, green, and blue—which absorb different wavelengths of light and send signals to the brain, so that it can calculate precisely which colors we see. But according to recent research led by geneticist Jeremy Nathans at Johns Hopkins University, the eyes of some women may have two different red pigments, uniquely enabling them to see subtle color differences that are at the same time imperceptible to other women and men. The gene for each of the red-sensitive pigments, Nathans observes, is found on the X chromosome, which means that men, who have only one X chromosome, can have only one or the other red pigment, while women, who have two X chromosomes, may possibly have genes for both.

Many people do not know that red light promotes and maintains dark adaption—the ability of the eyes to see faint objects out-of-doors after leaving a brightly lit house. In using, say, maps outside to read the constellations in the heavens above, a flashlight with two or three layers of red cellophane over the lens can be used, to be sure that the stars on the maps can be seen, while at the same time the stars in the sky will be plainly visible. There is even the lunar phenomenon of a red moon. At least so goes a song from the Comstock and Gest musical comedy of

1922, *Polly Preferred,* where ingenue Genevieve Tobin sang,

> *Just another waltz beneath the red moon*
> *Just another kiss before we part*
> *Let me tell my love beneath the red moon*
> *Dancing with you, sweetheart*

Nor should one forget flags flying the red half-moon of Turkey. Red, incidentally, doesn't photocopy. Fred Smith, CEO of Federal Express, at one time, according to gossip, always handed out to his flight crews letters of an anti-union nature on red paper, the better to avoid duplication.

It often does seem the color of the "feebly real," as George McFadden puts it, "red, the long, low-frequency wavelength of the light of the dying stars. Red and its shades stand for the dying or dead past." Red in a star means of course it's losing heat. And that eerie light of redness emanating from a celestial body, when light waves become longer, indicates that it is receding from the earth.

There are many negative connotations to the color. It is the color of war, spilled blood, burning fire, anarchy, excessive bureaucracy, danger, and welts. Singer Sophie Tucker, whose mother once inadvertently sat her on a hot poker, had a severe red welt across her buttocks all her life. Ahab wears a livid scar. And remember the red gash across Ethan

Frome's forehead in that novel? What are we to make in *Jane Eyre* of that eerie, unprepossessing red room with its "terrible red glare"—remote, seldom entered, haunted by a ghost—in which the beleaguered heroine at the very beginning of the novel finds herself captive? And Tennyson in *Maud* opens the poem ("I hate the dreadful hollow . . . ") with a revulsion of red. It is also of course the color of the devil. Satan has almost always been depicted as red as boiled crabs. Adultery wears a scarlet letter. Captain America's foe is the menacing Red Skull. It is the color of anger, debt, diamonds and hearts, prostitution, attack, gout victims, the second horse of the Apocalypse, a mandrill's buttocks, and the red necks of country churls in the American South. *Rooinek,* "red neck," in Afrikaans, was also a derisive name given to the British during the South African War. The liturgical color for martyrs is red, which is usually associated with pain, wounds, suffering, trauma, surging, ripping, and tearing emotions. It is the color of embarrassment and humiliation. ("A cheek is always redder / Just where the Hectic stings," wrote Emily Dickinson.) In Africa it is the color of mourning. It is the color of rust, rashes, sunburn, fever, measles, cuts, and poison in snakes. Wily foxes are red. In Hades, Phlegethon is the circular river of blood. It is always the color of raging fire. Remember how when Dante's shadow is thrown over the flames in the *Purgatorio* the flames

begin to burn more savagely red? (*"Ed io facea con l'ombra più rovente parer la fiamma," Purg.* XXVI, 7–8.) Red is even a disguise. The French expression to wear the *bonnet rouge* means to be savage. Even the procedure of dying pistachio shells red—which are normally white—originating in Iran, was not to add beauty, as is often thought, but to cover up imperfections in the shells of broken or poor-quality nuts.

Caliban in *The Tempest,* in fact, uses the color in a curse: "The red plague rid you for learning me your language!" At Irish weddings a knotted red handkerchief also indicates a curse has been placed on the couple. In Malaysia wild buffalo are painted with red pigment, then harried out of town, taking the town's diseases with them. Red is also envy in China; covetousness is "red-eye disease" (*Hon yen bin is*). And who can forget the ghastly scarlet plague which eventually—and fatally—comes hideously to hold "illimitable dominion over all" in Edgar Allan Poe's phantasmagorical story "The Masque of the Red Death" or those portentous opening lines: "The 'Red Death' had long devastated the country. No pestilence had ever been so fatal, or so hideous. Blood was its Avatar and its seal—the redness and the horror of blood. There were sharp pains, and sudden dizziness, and then profuse bleeding at the pores, with dissolution. The scarlet stains upon the body and especially upon the face of the victim were the pest ban which shut him out from the aid and

from the sympathy of his fellow-men. And the whole seizure, progress and termination of the disease, were the incidents of half an hour." Red, like white, horrified Poe.

War is red. Soldiers in India habitually carry red amulets as preparation for death, and Fiji Islanders paint themselves red after killing a man. The combat uniforms of the Spartan army—right down to their leather shoes—were red, their rough tunics of wool dyed with madder. Joyce Carol Oates in *On Boxing* (1987) writes of the moment "when fighting suddenly emerges out of boxing—when, for instance, a boxer's face begins to bleed and the fight seems to enter a new and more dangerous phase. A flash of red is the visible sign of the fight's authenticity in the eyes of many spectators, and boxers are justified in being proud, as many are, of their facial scars." It has ever been the unremitting color of Mars. American army patches were originally red. In 1862, during the Civil War, General Philip Kearny mistook some officers for stragglers from his command. Embarrassed, he decided to do something about it. The result was an immediate order passed down that officers of his command should thereafter wear "on the front of their caps a round piece of red cloth to designate them." Thus came into being the famed "Kearny Patch." Kearny even donated his own red blanket to be cut up by his officers, and some sol-

diers covered their entire caps with red. "The practice is said to have reduced straggling," observed Civil War historian Colonel Ralph R. Burr, "and even the Confederates are reported to have given special attention to wounded and dead wearing the patch because they recognized the valor of Kearny's troops."

But what terrible rider in red, an offense against what military beatitude—the blood the martyred soldier shed?—makes the sight of red ritualistically wrong in the officially folded triangular American flag handed to his widow and children?

Dr. Jekyll's evil potion in Robert Louis Stevenson's tale is "a blood-red liquor." It was "highly pungent to the sense of smell and seemed . . . to contain phosphorus and some volatile ether." The name Holly Golightly used for hyperanxiety in Truman Capote's novel *Breakfast at Tiffany's* was the "mean reds" ("when you're afraid and don't know what you're afraid of"). The Santa Ana winds—red wind, some people call it—blow in hot from the desert. The *pika,* that blinding flash of atomic light in Hiroshima on August 6, 1945, brighter than a thousand suns, its searing heat 300,000 degrees centigrade at the hypocenter, was red. Red tape is the pejorative term for official formality, or rigid adherence to rules and regulations, carried to excessive lengths; so called because lawyers and government officials often tie their papers together with red tape.

Dickens is said to have introduced the expression, but it was the cold scorn continually poured upon this evil of officialdom by Carlyle that brought the phrase into popular use. And "red-lighting" was a circus custom, old and dishonorable, which consisted in opening the side door of a moving car near the red lights of a railroad yard and booting out undesirables. It is ironic that cultivated roses and Japanese cherry blossoms, so red, so beautiful, yield no nectar and are valueless to bees. As to further negativity, experts also insist red is too angry and too violent a color for children, a color rather too insistently aggravating. Take a moment sometime to notice, Fisher-Price toys are mostly yellow.

Isn't there, by the way, a hideous symmetry in the fact that the ravenous scheming wolf in *Little Red Riding Hood* has red eyes? Judah had red eyes (Genesis 49:12). In Edith Wharton's story "The Eyes," those blazing orbs of horror with their hateful stare, diabolically plaguing the narrator, are "red-lined lids hung over the eyeballs like blinds of which the cords are broken." Scrooge had red eyes. Captain Ahab in *Moby-Dick* has "eyes of red murder." "And my eyes, like the Sherry in the Glass, that the Guest leaves," a line Emily Dickinson wrote to T. W. Higginson in July 1862, is wonderfully memorable. And *The Dragon with the Red Eyes,* by Astrid Lindgren, is one of my favorite children's stories. Rarely do red eyes

seem pleasant, however. It is the eye color of loons, albinos, insomniacs, comic-book futuroids, bunnies, long-distance motorcyclists, droolies, and breathing idiolects of the midnight phone call. The eyes of cocaine freaks are often frayed red. Lobsters' beady little eyes seem to be affected by agitation. When shaken or flung about in crates or barrels, their eyes turn so ruby red that they glow. Monsters in comic books and science fiction novels always seem to have red eyes. And remember the celestial ghost herd in Vaughan Monroe's "Riders in the Sky"? ("Then all at once a mighty herd of red-eyed cows he saw.") Crows are said to bleed from their eyes during coition. And, according to legend, all vampires weep red tears.

Confucius disliked the color red. Medieval magicians wore red on Tuesday, the day set aside for operations of vengeance. Red cats in Japan are considered very bad luck. It was a color worn by the Aztec high priests during human sacrifices and by the Greeks when reciting the *Iliad* to signify bloody encounters. In the Tarot, rubeus as a geomantic sign, meaning passion, is a bad symbol corresponding to Mars, Fire, Gemini, and to the number 13. It is the fate of Cincinnatus in Nabokov's *Invitation to a Beheading* "to don the red tophat," that is, to be beheaded. And do you remember that mad line in Brautigan's *Trout Fishing in America,* "The old shack had a tin roof colored reddish by years of wear, like a

hat worn under the guillotine"? Red-eye is cheap whiskey, and Red Biddy a noisome and highly intoxicating concoction of which cheap port is the basis, much favored by old crones in low-class English life. In old military slang, a "red-laced jacket" indicates a flogging. The "signature" on the crudely written ransom note left by the Lindbergh baby kidnapper, to be used as code, was two red circles, partly overlapped, the secanted area filled in blue, and in each of the three separate areas a square hole punched through the paper. In 1888, Jack the Ripper penned in red ink the only authentic three letters we are certain he wrote, the last one of which, by the way, was indited with a piece of victim Catherine Eddowes' kidney and went as follows: "From Hell, Mr. Lusk sir [George, head of the Whitechapel Vigilance Committee] I send you half the kidne I took from a woman, prasarved it for you, tother piece I fried and ate it; was very nice. I may send you the bloody knif that took it out if you only wate while longer. Catch me when you can, Mr. Lusk."

In nineteenth-century whaling, the men habitually cried "Flurry! Flurry!" when the poor stricken beast's blood, running from its blowhole into the sea, turned the water red around the boat. And the special rocker Abraham Lincoln sat in at Ford's Theater on April 14, 1865, made redder by his blood, was upholstered in red damask.

A savage red power mower, which seems to run of

its own volition, tears through the house and devours hapless Harold Parkette in Stephen King's ghoulish story "The Lawnmower Man." Revelation 6:4 shows us war mounted on a fiery red horse, its rider wielding a great sword, and in that same mysterious book there is the scarlet-colored beast (chapter 17), the enigmatic "eighth king." The Chinese shawl Isadora Duncan was wearing which caught in the wheel of her Bugatti, instantly throttling her, was red. It is not only the masculine, active principle, of ferocity, strength, calamity, but has long been a color connected with the rage of revolution. Anarchy is red. It has long stood as an emblem of defiance and violence—the blood-red flag flying above the Kremlin, the high red wall, the dark red granite of Lenin's Tomb. We even have the term "Red-Diaper Babies," denoting young people whose parents had been at one time in or associated with the Communist Party. ("The children born of thee are sword and fire / Red ruin, and the breaking up of laws," Tennyson wrote in "Guinevere.") Frank Fay, an alcoholic vaudevillian who had recently made a comeback in a play called *Harvey,* attracted attention in the fall of 1947, when in front of the House Un-American Activities Committee he told an interviewer that Orson Welles was "red as a firecracker." The red flag was not only adopted by the Bolsheviks, it signified war and a call to arms during the Roman Empire—Roman battle flags were red—and was of course used during the

French Revolution as the symbol of terrorism by "Red Republicans," the extremist Jacobins who, like China's Red Guard or Cambodia's Khmer Rouge, never hesitated to steep their hands in blood in order to insure their political goals.

Nostradamus, the sixteenth-century French prophet, wrote in his *Centuries*, *"Les rouges rouges le rouges assommeront"*—"the red 'reds' will destroy the reds"—a prediction, to many, of how the Jacobin madness during the French Revolution of 1789 would come, as it did, to destroy itself. Now, it can also apply to the former Soviet Union. As far as the redundancy of *rouges rouges* goes, country singer Randy Travis owns a horse, I believe I once read somewhere, named "Red Rouge," a beautiful Appaloosa—and tautology.

And in 1898, the Chinese Boxers—the Buddhist Patriotic League, which grew out of the earlier Righteous and Harmonious Fist societies—wore their hair tied up in red cloth, red ribbons around their wrists and ankles, and a flaming red girdle around their loose tunics, as they tore through foreign legations of Peking, screaming *"Sha! Sha!"* ("Kill! Kill!"). "The Red Flag" is the Italian socialist chant, calling to mind the red-shirted thousands Garibaldi led to the conquest of Sicily and South Italy in 1860. Bruce Chatwin once told my brother Paul that he had worked out a connection between the fact that when Garibaldi was helping liberate Uruguay he adopted

the color red from butchers' aprons (presumably red for the same reason that matadors' capes are red: to hide spilled blood) and brought it back to Italy, and that afterward it stood for European revolution generally. And the fasces, a bundle of elm rods coupled with an axe, symbolizing in ancient Rome a consul's powers of life and death, as well as in the 1930s uncompromising dictator Benito Mussolini's totalitarian government, is always bound by a red cord. At the time Italian Fascists who also pompously wore red stripes on their right sleeves habitually—and ostentatiously—swigged cherry brandy.

Perhaps Yves Bonnefoy was right in his poem *"Le Lieu des Morts,"* when he wrote

> *Le lieu des morts*
> *C'est peut-être le pli de l'étoffe rouge*

> (The place of the dead
> May be a fold in red cloth)

An octopus turns red when angry, as do humans. A red dog is the personification of anger in China. The fire-bellied toad, if discovered and threatened, arches its back in such an extreme contortion that it suddenly exposes its underside, which is a vivid scarlet, a spectacular warning that its skin contains a burning poison. The most lethal amphibian venom of all—one ten-thousandth of a gram can kill a

man—is secreted by tiny reddish-pink frogs in South American rain forests. Red is produced by lipophores, pigment cells in the skin in certain species of frogs, chameleons, salamanders, and toads. Smallmouth and largemouth bass constantly strike lures of red. And of course the lethal black widow spider has a telltale red (or yellow) "hourglass" marking on the underside of its belly. Red is the color of danger and explosiveness, from the Red Queen in *Alice in Wonderland* (1865), forceful and dogmatic unlike the rumpled, sweet-tempered White Queen, to the tips of matches. (In 1847, an Austrian chemist named Schrötter discovered that red phosphorus, which is inert and gives off no fumes, explodes when touched with chlorate of potash.) The color is supposed to infuriate cattle. Veterinarians believe in the so-called sport of modern bullfighting that the raging bull does not distinguish colors as such but that his senses are stimulated by the wavelengths colors emit. As John McCormick observes in *The Complete Aficionado,* "The cape, accordingly, is magenta on one side and yellow on the other, and the muleta scarlet, because these colors of the spectrum have the longest wavelengths and consequently are those most likely to attract and excite the animal." Within the field of vision, it is therefore color and movement in dynamic activity that, producing the bull's irritability, make him charge.

Anger is always a link to protection. Throughout

eighteenth-century Europe, red, symbol of blood and good health, was believed to protect the wearer against the evil eye. Italian brides covered their heads with a large red veil. In Rumania, oxen had red rags tied to their horns. And Scottish tenant farmers tied red ribbons to the tails of their livestock or bound crosses of wood from the sacred rowan tree with strands of red thread. It is mentioned in the Talmud to equip one's horse or ass with a red rag or a fox's tail, hung between the eyes, to prevent a fall. (The Greeks of today provide their mounts with blue beads.) A skein of red wool wound about the arms and legs was thought, among old Russians, to ward off agues and fevers; and nine skeins, fastened round a child's neck, were thought of as a preservative against scarlatina. Red cakes were eaten in ancient Egypt to fight constipation. In Macedonia, red yarn was worn as a guarantee for a safe childbirth. Red rice was sprinkled over the bridegroom to keep his soul from flying away in the Dutch East Indies, where if the names of a boy and girl were written on paper with the blood of a red hen, the girl would become utterly infatuated when she touched it. And doesn't the red of sealing-wax have a caveat in it? The color red has also had a benevolent if volatile connotation. To Saint John of the Cross red stood for charity. A lutin or *nain rouge* (Fr. "red dwarf") in Normandy is said to protect fishermen. And in the face-painting of Chinese opera, the color symbol-

ically indicates loyalty. According to many legends, the ruby is believed to have special powers and properties, soothing tempers, protecting against seduction, helping its possessor acquire valuable lands and titles. Curiously, a strange phenomenon happens when two rubies are placed side by side; they stain each other, and their singular beauty is immediately lost.

As regards rubies, in *The Travels of Marco Polo,* that world-famous traveler tells of a king in Ceylon (chapter 19) who reportedly possessed the largest ruby that was ever seen, a jewel, being a span in length and the thickness of a man's arm, that had the "appearance of glowing fire." According to legend, Kubla Khan upon seeing it offered, unsuccessfully, the value of an entire city for it.

Ants don't see red at all. Bees are insensitive to red (it appears black to them), though they can see a color called "bee purple," a combination of ultraviolet and yellow. They are most sensitive to the short wavelength end of the spectrum, particularly to ultraviolet light—red is of course at the other end. Red-blind bees can make distinctions between different kinds of red blossoms if they reflect ultraviolet in different amounts. All hummingbird feeders are red. So is their artificial nectar. Wild ducks have red feet, tame ones yellow. Red-bellied piranha in the Amazon River, which can grow as large as two feet, will tear you apart. Red wood ants, like Argentine

ants and fire ants, are fierce killers, slaughtering creatures much larger than themselves with their sicklelike jaws. The small redback spider of Australia is also extremely deadly, usually fatal in its bite. And in Panama, little red ticks in the grass called *coloradillas* can, when they bite, cause terrible irritation.

Did you know that, deeply underwater, going down fathoms of darkness toward the abyssal benthic ooze, the colors of fish gradually disappear? Red is always the first to go; blue is the last.

Warnings are almost always red. Stop signs, brake lights, rail crossings. It is invariably the color of prohibition, signifying Turn Back, Don't Touch, Danger, and Halt. All flammable gases or liquids are labeled red in intergovernmental maritime shipping. The whipping post in Colonial Boston, located in Old State House Square, was painted red. A "red hand" painted on dwellings in places as divergent as Mexico, Turkey, India, and Ireland shields inhabitants from harm. It is the color code for heavy surf. A storm or hurricane warning in the Coast Guard is a red flag with a black center. In Japan to get a draft notice is to get the "red paper," because the form sent to young men is blood red. And in aviation, when the head fills with blood, say, during an outside loop, that light-headed fainting disorientation is called a "red out." All exit lights are red, as are fire extinguishers. And of course hospital emergencies are generally called a "code-red," a phrase also used

for an illegal hazing that Marines mete out to soldiers who fail to live up to Corps standards or the leatherneck code of "Unit! Corps! God! Country!"

Red lights appear on the left of airplanes (green on the right), which is the same as on boats, and there's the rule of "red right returning," where moving boats must always keep the red buoys to their right. The rotating lights or flashing red lights on planes, which with their high-intensity beams can be seen for miles away in daylight—even by planes coming out of the sun toward you—are now left on by good pilots even in sunlight. And in aviation, runway-remaining lights use the following colors to indicate how much runway is left: at 3,000 feet, white and red; at 2,000 feet, amber; the final 1,000, all red.

Red is a hygiene marking in Sweden for unsterile and dirty, the signal for a score in ice hockey, and an almost worldwide color for fire apparatus. Yellow is in fact a more eye-catching color, but Americans, except in certain cities, have refused because of tradition to allow the change. There is an odd and continuing intermorphology of the two colors. The Golden Gate Bridge in San Francisco is not yellow or golden at all, but rust red. Red and yellow paper is displayed in China to ward off demons. The colors of the posh Marylebone Cricket Club in England are red and yellow, as are those of the Washington Redskins. Native Americans from the beginning have always used the two colors in harmony. (Remember

the famous tongue twister, "red leather, yellow leather"?) The walls of the Forbidden City are red. Red-skinned man has often been seen as a threat. People in what is now the Roquefort region of France were known in Roman times as *Rutenes,* "the red ones," a hardy race known for its fierce independence. In North America white people habitually called Indians "redskins" ("The only good Indian is a dead Indian" became proverbial), and as intruders proceeded to butcher them and appropriate their land.

The arbitrariness of assigning a negative connotation to skin color long precedes but certainly includes Carolus Linnaeus' description in *System Naturae* (1758) of the habitating species of native America: *"Americanus: rufus, cholericus, rectus"* (red, irascible, upright). With Linnaeus, Africans don't have any better luck: *"Afer: niger, phlegmaticus, laxus"* (black, calm, lazy).

On the other hand, an Indian peasant named Juan Diego (so called after his conversion) passed a hill called Tepayac in December 1531 and saw the vision of Our Lady of Guadalupe, whom Mexicans privately, affectionately, still call *La Morenita* ("Little Darkling"), for with the Virgin Mary's imprint on his cloak he found

> *Her complexion as red as cinnamon bark,*
> *Cheeks as brown as persimmon*

The French say that a Red Man commands the elements and shipwrecks off the coast of Brittany those whom he has doomed to death. Did he come from the old alchemical term "red man" used in conjunction with "white woman" to express the affinity and interaction of chemicals? In the long list of terms that Surly scoffingly gives in Ben Jonson's *The Alchemist* (II, iii), "your red man and your white woman" are mentioned. Another story affirms that this very same Red Man appeared to Napoleon and foretold his downfall.

Are we to look for the same admonition in the flaming hair of women "hellcats" like Lillie Langtry, Maureen O'Hara, Arlene Dahl, Rhonda Fleming, Katharine Hepburn (known to her friends as "Red"), Lotte Lenya, Lady Ottoline Morrell with her red-gold hair, or other would-be redheads who rub their hair with henna to entice? (Women in biblical times not only dyed their hair but painted their toenails, fingernails, and even their *hands and feet* with henna juice, which left that red-orange stain mentioned in the Song of Solomon 1:14, 5:10, and 4:13.) It has often been the hair shade of the vixen, the siren, "that sizzling color," as Roberta Luttrell observed in a recent article, "Red Alert," "of the Other Woman's hair." Jean Harlow was an unscrupulous vamp in the film *Red-Headed Woman,* based on Katherine Bush's best-seller. And who can ever forget the lurid description of contor-

tionate Delilah in Leopold von Sacher-Masoch's scandalous novel *Venus in Furs*: "an opulent woman with flaming red hair lay extended, half-disrobed, in a dark fur-cloak, upon a red ottoman, and bent smiling over Samson who had been overthrown and bound by the Philistines." Red is a chameleon. There are so many different gradations of what we commonly call that color, cinnamon, sherry, chestnut, auburn, copper, fiery russet, and that unique reddish gold tinct of women's hair in Titian's paintings has made of his name a byword in the English language to describe that rich voluptuous shade today. But there is a downside, as well. Red hair tends toward dryness, is rarely an all-over shade, and in terms of fragility is easily the most difficult hair color to maintain. And it tends to lose luster. Luttrell is realistically quick to point out, "Bright red hair rarely survives childhood; eventually it fades into brown or tan. A redhead past her teens, therefore, will likely have to revitalize the color if she wants to remain a true red."

There was also Susan Hayward, Hollywood's tempestuous "Titianette Queen," a gorgeous redhead who was cast when a young woman as the tragic ingenue, Drucilla Alston, in the epic sea drama *Reap the Wild Wind*, a movie where even the giant squid—whose network of insides and thirty-foot tentacles were operated by electric motors and a complex set of hydraulic, piston-operated cables—

was bright red! Of equally complicated Susan, who claimed redheads always had to be the center of attention, her producer Walter Wanger observed, "Susie suffers from one of the strangest and most startling guilt complexes you can imagine. She's embarrassed that she's a beautiful woman. She doesn't think she deserves it. She knows that it's a priceless gift, but she's afraid that on the inside she isn't so beautiful. It causes her to avoid other women on her own level. It's responsible for her fits of temperament. Actually, her beauty makes her miserable. Ironic, isn't it?"

The key to the structure of a personal perfume is supposedly hair color, which is closely related to skin color. According to Paul Jellinek's hair color–odor diagram in *The Practice of Modern Perfumery,* the suitable perfume for redheads should not be a narcotic or soothing one but a stimulating, exalting erogenous one like lavender or blue lilac. What of this need for extra allure?

"There is always something wrong with redheads," wrote Truman Capote in his novel *Answered Prayers.* "The hair is kinky, or it's gone the wrong color, too dark and tough, or too pale and sickly. And the skin—it rejects the elements: wind, sun, everything discolors it. A really beautiful redhead is rarer than a forty-carat pigeon-blood ruby—or a flawed one, for that matter."

Red-haired persons have for centuries had the

reputation of being angry and hot-tempered, unreliable and deceitful, probably owing to the tradition that Judas Iscariot had red hair. It is said to indicate irascibility, personalities like the mesomorphic Esau ("red all over like a hair garment"); General George A. Custer; Swinburne (the "Red Dwarf of Balliol"); van Gogh; Benjamin Constant (whose confessions were published as *Le Cahier Rouge*); Red Barber, voice of the old Brooklyn Dodgers; the mythic wild man Iron John; Thomas Jefferson—who kept a sewn crimson mantle counterpane over his bed at Monticello—Boston eccentric Isabella Stewart Gardner; and "Carroty Bess," Elizabeth I. Cleopatra— by the way, a Macedonian, not an Egyptian—had red hair. Thomas Chatterton was a redhead. So were Boadicea, Oliver Cromwell, George Bernard Shaw, Salomé, Malcolm X, Robert Penn Warren, Li'l Orphan Annie, and Civil War general William T. Sherman, who as a boy so hated his apple-red hair that he tried to dye it, but unfortunately his hair turned green in the experiment and so he decided to learn to live with its natural color. Emily Dickinson's hair, tending to auburn, had reddish tints. "And I am the Cow Lily," said the poet in her twenties, comparing herself to a flower, to her friend Miss Emily Fowler (Noah Webster's granddaughter), who asserted it was "because of the orange lights in her hair and eyes." And Thomas Wentworth Higginson, after a visit to Amherst,

wrote home to his wife in August 1870 with this brief description of the reclusive and eccentric forty-year-old: "A step like a pattering child's in entry and in glided a little plain woman with two smooth bands of reddish hair."

There have been many notable redheaded murderers, as well: Nero, Lizzie Borden, Henri Landru, mobster Dion O'Banion, Mahmud ("The Red") Abouhalima, the terrorist bomber of the World Trade Center in New York in 1993, and Charles Starkweather. Explorer William Clark of the Lewis and Clark expedition was called "Red Hair" by various Indians. (Lewis was called "Long Knife.") Eric the Red, who set out about 1000 A.D. and reputedly discovered North America, which he called Markland and Vinland (New England?), had roilrust hair and was legendarily irascible. Rob Roy, the Scottish outlaw, had a flaming crop of red hair. So had Virginia Hill, Bugsy Siegel's tough moll of a girlfriend. And then there was the angry young bricktop Van Morrison of the early rock group Them, who thought nothing, in the middle of a concert, of castigating and vilifying whole audiences of fans.

"Three of the most famous traitors in history—Judas Iscariot, Benedict Arnold, and Teddy Glynn [only one of thousands in the history of corrupt Boston Irish politicians]—had another thing in common," said nest-feathering, money-grubbing,

vote-snatching Mayor James Michael Curley in 1925, "they were all redheads."

Redheads are not only volatile, they are prone to break limbs, hold grudges, bristle, talk too much, badly boast about being Irish (when they are), and tend to fall in love with the wrong people. They also get skin cancer. Their pale skin is freckled and poaches in the sun. They have white eyelashes, and when you take their picture, their eyes come out red. (I have read that albinos, whose bodies are often pale rose-red, somewhat along the line of redheads, are more sensitive to the bites of insects.) Incidentally, people with so-called red hair—it is, more often than not, usually a sort of rust or piss-burnt auburn or wiry orange—actually have *more* hair than people with black, brown, or blond hair. The only truly real red hair on earth, I suppose, belongs to that goofball of the hamburger chain, Ronald McDonald. Or Woody Woodpecker. Or "Crackle," the Kellogg's Rice Krispies elf. ("Snap" and "Pop" have orange hair.) There is always a slight incongruity, a clown-ishness, to red hair. It can look almost black when combed wet. It is often cowlickishly unruly. We may recall even Yeats' aristocratic friend, Mabel Beardssley, with her dolls, dying at forty-two: "She lies, her lovely piteous head amid dull red hair propped upon pillows, rage on the pallor of her face"—lines that always remind me of the Gaelic word for red (of hair), *rua,* so close to rue. "We account red hair an

abomination," we read in *Salad for the Social* (1856)—curiously, a nineteenth-century American guide to etiquette and human manners.

The loathsome Uriah Heep, who appears in Dickens' *David Copperfield*—whose weirdly sallow complexion and obsessive emotional handwashing to Victorian readers, critics insist, characterized a compulsive masturbator—is a redhead. Copperfield's first meeting with him is described thus: "I saw a cadaverous face appear at a small window on the ground-floor . . . in the grain of it, there was that tinge of red which is sometimes to be observed in the skins of red-haired people. It belonged to a red-haired person—a youth of fifteen, as I take it now, but looking much older—whose hair was cropped as close as the closest stubble; who had hardly any eyebrows, and no eyelashes, and eyes of a red-brown, so unsheltered and unshaded, that I remember wondering how he went to sleep."

And of course the irrepressible R. P. McMurphy with his "broad white devilish grin" in Ken Kesey's *One Flew Over the Cuckoo's Nest* (1962) "is redheaded with long red sideburns and a tangle of curls out from under his cap, been needing cut a long time . . ."

It is the first color of the spectrum and the last seen by the eyes of the dying, according to Tom Robbins in his novel *Still Life with Woodpecker,* a redhead himself, who observes, "Sugar, like lust,

accentuates the reddish pigment in the hair and on freckles of lunar-oriented people, especially when they're exposed to direct sunlight." The third marquis of Hertford, Francis Charles, art collector, eccentric, and rake, who was mockingly nicknamed "Red Herrings" and "Bloaters" on account of his bright red hair and scarlet skin, nevertheless quite amazingly managed to make notable appearances in William Thackeray's *Vanity Fair* as the Marquis of Steyne, in the works of Balzac under the name of Lord Dudley, and in Disraeli's under that of Lord Monmouth. And in the maleficent "Hugh Boone," the disguised Neville St. Clair in Sir Arthur Conan Doyle's story "The Man with the Twisted Lip"—"A shock of orange hair, a pale face disfigured by a horrible scar, which by its contraction has turned up the outer edge of his upper lip, a bull-dog chin, and a pair of very penetrating dark eyes"—isn't a baboon in fact being suggested? In Holland, men and women with red hair are said to bring misfortune, though not, it seems, in France, where the red-headed milk girl at the train halt in Proust's *A L'Ombre Des Jeunes Filles En Fleurs* becomes for young Marcel in a sudden epiphany a creature of immeasurable importance: ". . . that handsome girl whom I still could see, while the train gathered speed, was like part of a life other than the life that I know, separated from it by a clear boundary, in which the sensation that things produced in me were

no longer the same, from which to return now to my old life would be almost suicide." But negative associations to the phenomenon more often prevail. The fat of a dead red-haired person was commonly requested as an ingredient for poisons (see Middleton's *The Witch,* V, ii), and George Chapman asserts that flattery, like a destructive plague,

> *Strikes into the brain of man,*
> *And rageth in his entrails when he can,*
> *Worse than the poison of a red-hair'd man.*
> (*Bussy d'Ambois*, III, ii)

Incidentally, the redbud, sometimes called the Judas tree, is supposedly in its crookedness the kind that the infamous traitor used to hang himself. Some say it was the carob, for its blossoms, originally white, now blush with shame. Others disagree and would have it the Elder. In *Piers Plowman,* for example, we read,

> *Judas he japed*
> *With Jewen silver*
> *And sithen on an Eller*
> *Hanged himselve.*

History has given Antonio Vivaldi the soubriquet of "red priest" (*il prete rosso*), an allusion either to the color of his hair or to the loud semi-clerical

suit he often wore, not to his political radicalism. In the movie *Red River,* Harry ("Dobie") Carey, Jr., the actor who played the young cowboy who gets killed during a cattle stampede, got his nickname because his hair was the color of an adobe building. Thomas Jefferson, who was extremely good-looking, was said to be handsomer and even more distinguished for his red hair. It was a fashion to have red hair in Tudor England. Mary, Queen of Scots, though she had exquisite hair of her own, wore red fronts, and Bess of Hardwick Hall seduced many husbands with it. Clara Bow, a redhead—she was the unabashed gold digger in *Red Hair* (1928)—kept a limousine to match her hair, and she often drove down the street in her flaming red Kissel convertible with seven red chows, all dyed to match the color of her hair. When Miss Margarita Carmen Dolores Cansino became known as Rita Hayworth, specifically to star in her first major film production, *Strawberry Blonde,* she dyed her hair a luscious flowing red. And fifties singer Sonny Burgess, who had red hair, when he performed wore a red suit, red shoes, and, yes, indeed, played a red *guitar.* But a bias against the color always remains. Singer Peggy Lee told me she once upon a whim dyed her platinum-blond hair red for a day or so, and everybody, especially women, was put off by an aura she insisted she herself felt she gave off as being "the wrong kind of sexy" and "too smoldering." "Look at that foreign devil's hair, will

you? It's on fire," cry the Chinese children following a redheaded American boy in Margaret Rau's novel *The Band of the Red Hand* (1938). The Arab women are amazed by Khalil's inexplicable red beard—a Nasrani's—in Doughty's *Arabia Deserta*. And Vladimir Nabokov even implies in *Invitation to a Beheading* that redheads, like his Rodion the jailer, have stiff, rusty joints.

So many Russians as we find them in novels and plays and stories have red hair, as for instance almost all the characters of Chekhov and Dostoyevsky (even the cows in the fields have red coats), flaming hair with sky-blue eyes, and "noses in the shape of an onion," like Tolstoy, who points it out about himself, in a letter. But what about Jews? When Sam Goldwyn hired Danny Kaye (né Daniel Kaminsky) to star in *Up in Arms* in 1940, he was dismayed by the first screen tests because Kaye looked—as he was—too Jewish. ("Let's face it," said Goldwyn, "Jews are funny-looking.") He solved his problem by having Danny Kaye's red hair dyed blond, thus, at least in the mind of Goldwyn (born Shmuel Gelbfisz, a former glove salesman from Lodz), de-Semitizing him, as he had himself (aren't all such jejune changes a form of anti-Semitism?), a man who once when working on a motion picture of the life of Christ said, "Why only twelve disciples? Go and get *thousands!*"

With regard to the ancient Egyptians, a dark-

haired Mediterranean race, they scoured Europe and Asia for redheads to serve their goddess temples—it is the belief of many historians that red hair appeared *only* among the Celts of Europe—and we have it on the authority of Manetho, priest and keeper of the sacred archives at Heliopolis, that they used to burn red-haired men, who incarnated for them the spirit of the ruddy grain (corn was seen in antiquity to have red hair), and scatter the victim's ashes with winnowing fans, a deeply symbolic if barbaric sacrifice offered by kings at the sacred grave of Osiris, who was annually slain, dismembered, and buried that he might quicken the seed in the earth. Red and only red oxen were also sacrificed in Egypt. A single black or white hair in one would have disqualified it for the sacrifice.

Romans sacrificed red-haired puppies in spring to avert the supposed blighting influence of the Dog Star, believing that the crops would grow ripe and ruddy. According to James Frazer in *The Golden Bough,* "The heathen of Harran offered to the sun, moon, and planets human victims who were chosen on the ground of their supposed resemblance to the heavenly bodies to which they were sacrificed; for example, the priests, clothed in red and smeared with blood, offered a red-haired, red-cheeked man to 'the red planet Mars' in a temple which was painted red and draped with red hangings."

Speaking of red hair, painter Oskar Kokoschka,

dumped by Alma Mahler, eccentrically had a Munich doll-maker construct a soft, life-size red-haired effigy of his former lover, complete in every last anatomical detail. The doll shared his bed, and during the day he'd dress it up and trundle it out. In *Self-Portrait with Doll* (1921), Kokoschka is seen, wearing a wistful expression, pointing toward its private parts, presumably to indicate his frustration and despair. One night, after a bout of drinking, he "murdered" the doll and flung it onto a garbage truck in Dresden. It has long been a superstition, finally, that if you rub dice on a redheaded person, it will bring you good luck. Is it for the color? Oil? Possibly the smell? Colette has one of her characters—Julie, I believe, in *Julie de Carneilhan*—somewhere say, "She makes a good thing out of smelling like a red-head." And of course J. K. Huysmans in *Croquis Parisiens* (1905) makes detailed distinctions between the odors of redheads, brunettes, and blondes.

Vasari, who gave vestments in painting symbolic colors, said red meant fire. Martyrs are recalled by a priest's red chasuble. (Pope Innocent III says of martyrs and apostles, *"Hi et illi sunt flores rosarum et lilia convallium,"* *De Sacri Alto Myst.*, I, 64.) It is a color in clothes that has always enticed, promised excitement, shone. It has spotlighted everyone from the Canadian Mounties to innocent Little Red Riding Hood to the Scarlet Pimpernel. "Her clothing is of

linen and wool dyed reddish purple," is one of the
thirty-one characterizations from Proverbs 31:10–31
of "The Woman That Fears Jehovah." When Dante
first saw Beatrice she was only eight years old and
wearing a crimson dress. Dorothy's slippers in *The
Wizard of Oz* are ruby. But there is often something
shocking in the color. Exaggerated. Even shameless.
"Please don't wear red tonight," sing the Beatles in
"Yes It Is," apparently finding too much passionate
pain in the color. The libido is all mixed up with red,
and, all things considered, it is not surprising to
learn that Priapus was known as the Red God. For-
ties hearthrob Van Johnson always wore red socks—
his trademark. Tallulah Bankhead as Regina in *The
Little Foxes* made her entrance in a red dress, red
picture hat, and red umbrella held like a rapier in her
gloved hand. In James M. Cain's novel *Double In-
demnity,* the original ending—changed in the
film—had the villainess, turning into a thing of evil,
dressed all in scarlet and viciously trying to destroy
the corrupted salesman. And it is the color of the
gown that Julie Marsden (Bette Davis) wears to
the Olympus Ball in New Orleans in the 1938
movie *Jezebel,* scandalizing society (even filmed in
black-and-white). Unmarried women of course
traditionally wore white. In her video "Material
Girl," Madonna, finally, sashays around in a high-
saturation strapless shocking pink gown and coquet-
tishly flashes her fan at a group of men in tuxedos.

Doris Day as Ruth Etting in her first big number in the film *Love Me or Leave Me* wears a red dress. Gene Tierney's gown of American Beauty red velvet in *Where the Sidewalk Ends,* a film in which she plays a Seventh Avenue fashion model, is so risqué, off-the-shoulder and figure-hugging, that Otto Preminger called it "dangerous." In 1923, when the picture *The Spanish Dancer* was being shot, the popular but imperious Pola Negri stopped production and left thousands of extras in the film waiting because the red of her satin dress ruffles failed to match the red of her slippers. (It was a black-and-white film.) And in *The Woman in Red,* seductress Kelly LeBrock blinds Gene Wilder with that color. Poor dipsomaniacal Ava Gardner as Julie in *Showboat* wears the characteristic red dress of the fallen woman in several scenes, and in *One-Eyed Jacks* Karl Malden's Mexican stepdaughter, Luisa, first appears in a red dress, almost a signal, as she is quickly seduced and—only temporarily—abandoned, of the fate awaiting her at the hands of handsome but vengeful Marlon Brando. And lovely Michelle Pfeiffer in *The Fabulous Baker Boys* sings "Makin' Whoopee" enticingly, atop a piano, in a sexy red dress.

Rhett makes Scarlett wear a red dress to Ashley Wilkes' birthday party, to which Scarlett does not want to go, only because earlier she had been caught in an embrace with Ashley—her name, like the

color of her dress, becomes almost an objective cor-relative of what she symbolizes—but Rhett insists that she go and "look her part." Rita Hayworth dances lasciviously in *Miss Sadie Thompson* wearing a tight sequined red dress. Betty Anderson (Terry Moore), the "local tramp," wears a scandalous red dress to Alison MacKenzie's party in the film *Peyton Place.* And in the film *Niagara* (1953), Marilyn Monroe as Rose, an adulteress and borderline hys-teric deceiving her husband (Joseph Cotten), wears a dress—a red one—in the words of the script, "cut so low you can see her knees." At the London premiere of Arthur Miller's *A View from the Bridge,* Marilyn wore a skin-tight Jezebel-red dress which later evoked criticism as being tawdry and in poor taste. Marilyn replied, "Red is my husband's favorite color!" It is a fashion commonplace that blondes, wearing red, look washed out, a fact difficult to believe with the voluptuous Monroe (whose natural hair, by the way, was actually reddish brown). The woman in red in Edvard Munch's *The Dance of Life* (1899), enviously watched by two women in black and white dresses, is given pride of place as she dances about. And in Munch's *Jealousy* (1895) three figures are connected by red—the bold brazen red of the woman's voluminous gown links up with the red contours around the two male figures. The scene records the libidinous power of a certain Dagny Juell, a blond Norwegian music student in real life

who broke up a circle of friends in Berlin in 1893 when all seven of the men involved, including August Strindberg and Munch himself, fell in love with her. Picasso's *Seated Woman with Necklace* wears a vivid red dress. The subject in Chaim Soutine's *The Madwoman,* that poor benighted creature staring starkly and insanely out of the canvas, wears, significantly, a full red dress. As does the whore called Desideria in Menotti's operetta *The Saint of Bleecker Street;* Marie in Georg Buechner's *Wozzeck;* and in Puccini's *La Bohème,* the lovely Musetta at the Café Momus with her noisy ovations and fickle wildness usually wears a passionate red dress.

And apparently redheads *can* wear red. The late great Mary Garden, opera singer and dancer whom I saw dance in her old age, still baring her midriff, incidentally, for which she had become famous, at the Boston Arts Festival in the summer of 1964, once told novelist Djuna Barnes in an interview: "Take the splendid Thais, a red-haired woman they say, loved by a hundred men. Well, contrary to the long-established rule, when I personified her, I dressed in red. The red-haired woman never looks so glowing, so ravished by ardor as when gowned in some tone of red. Then she is like a brand plucked from the burning," said Garden. "Her person is one entire glowing whole."

A century before that, it was something of a

different story. "All nurses are required to be plain-looking women," decreed radical philanthropist Dorothea Dix, who not only prevented women under the age of thirty from serving in any government hospitals during the Civil War in that now-famous pronouncement but actually banned the color red and anything bright. "Their dresses must be brown or black, with no bows, no frills, no jewelry, and no hoop skirts."

Incidentally, while Scarlett in Margaret Mitchell's novel *Gone with the Wind* (1936) is given a name taken from her grandmother's maiden name, if used as a surname it would have originated with someone in the Middle Ages who dealt with the very expensive cloth called "scarlet," a special textile worthy of the expense of being dyed bright red, then a rare shade, which transferred its name to the color.

In the 1990s, television has made the red necktie *de rigueur* for politicians, and custom has somehow decreed it as the pontifical red stole of success, a standard accessory for professionals such as politicians, lawyers, TV anchormen, etcetera, and yet it was not long ago that as a sartorial symbol it had other connotations. "The Chicago Vice Commission of 1909," according to Marjorie Garber in *Vested Interests*, "reported that male homosexuals recognized each other by wearing red neckties, a fact that had already been noted in the streets of New

York, Philadelphia, and other cities by the sexologist Havelock Ellis." And in Evelyn Waugh's *Brideshead Revisited* we read of the pampered, somewhat effete Sebastian that his "life was governed by a code of such [personal] imperatives. 'I *must* have pillar-box red pyjamas . . .' " In almost each case there is at one and the same dramatic and overpowering moment, thunderously apparent, that warm, extroverted, fiery, aggressive, impulsive, abrupt, noisy, occasionally optimistic, sometimes sympathetic, but often crude, rude, and overreaching connotation to the flash of this color and its trumpeting appeal. The fact that Roberto Rossellini raced Ingrid Bergman around Rome in 1949 in a flashy red sports car did little to put diminuendo on that scandalous international adultery that shocked the watching world. The very first day that sexpot Jayne Mansfield appeared in Hollywood she wore in the tightest form possible a red lamé bathing suit. Speaking of red neckties, Jack Kerouac was buried—*horribile visu dictuque*—wearing a red plaid sport jacket and a red bowtie.

Greta Garbo would not wear red boots or shoes, the color being too conspicuous, or so, in her self-consciousness, she badly felt, for what mistakenly (and uncharitably) have been perceived over the years as her big feet—8AA—were in fact the proper size for her proportions. But the rumors persisted. And she was sensitive on the subject. Red in shoes can be noble, however. In ancient Rome, the six hundred

senators who wore the *toga praetexta*—a full white woolen garment—also on special occasions wore red leather shoes, of a pattern worn by no other Romans. But more often than not, red shoes are naughty. Marlene Dietrich for her role in *Witness for the Prosecution* insisted for those tarty flashback scenes on wearing platform shoes "with ankle straps, very hussy, red." And remember the *versato macchinatore* of Yeats' "Upon a Dying Lady": ". . . the Venetian lady / who had seemed to glide to some intrigue in her red shoes, / Her domino, her panniered skirt copied from Longhi." And isn't the glaring fact of their outrageous color more obscene when in Proust, just as they are about to set off for dinner, the Duke de Guermantes angrily and pigheadedly insists that his wife in her red dress, but with the wrong color footwear, return to put on her red shoes, all while poor Swann is dying?

At the Elysée Palace, fashion expert Coco Chanel told Claude Pompidou, wife of President Pompidou, de Gaulle's successor, that as First Lady she could no longer wear red. As a high color, it has been avoided, according to fashion designer Edith Head, by actresses Ingrid Bergman, Gloria Swanson ("She never allows color to overpower her"), and Vera Miles, and even by Head herself, who pointed out, "People are forever telling me I should wear red. In red I feel like a lost fire engine." The raspberry wool suit that Jackie Kennedy wore on that fateful day in Dallas

was a Chanel, stained by an even gorier scarlet, the red of blood. ("O mother! / This red gown will make a shroud / Good as any other," wrote Edna St. Vincent Millay.) Of all the colors, it seems, red never fails to be noticed. Charles Dickens had an inexplicable passion for scarlet shirts, bright red waistcoats—and geraniums! British poet Philip Larkin, who often wore red socks, ostentatiously sported at Oxford cerise trousers—a cherrylike color of low brilliance, cerise has a touch of blue—which he wore on the enigmatic, probably Dionysian recommendation given by D. H. Lawrence at the end of *Lady Chatterley's Lover* ("If the men wore scarlet trousers, as I said, they wouldn't think so much of money"). Pitcher John Smoltz of the Atlanta Braves apparently cannot pitch unless his therapist is sitting directly behind the backstop wearing a red blazer. No, there is always something flash in the color. Only recall the lines from William Rose Benét's poem "Jesse James":

> *Jesse James wore a red bandanna*
> *That waved on the breeze*
> *Like the Star-Spangled Banner*

Speaking of which, Willie Mae "Big Mama" Thornton, one of the toughest, saltiest blues singers ever—three hundred pounds, a gold tooth, dressed in

overalls—when she sang onstage always wore a red bandanna.

Red has stood as a color of shame and segregation in all seasons. All through the Renaissance, Jews in the Italian city-states had to wear red, or sometimes yellow, clothing. In Pisa, around 1330, they were forced to wear an "O of red cloth," while in Rome it was insisted that male Jews wear red tabards and Jewish women red overskirts—a rather sad and tragic irony, for in Talmudic times Jewish women methodically shunned red apparel because it was considered a licentious color (Berakot 20a). Hester Prynne in *The Scarlet Letter* had to wear a shameful *A* for adultery on her breast. Even in Rubens' painting *Samson and Delilah* (ca. 1609) the barebreasted temptress, regarding the sleeping Samson in her lap with a mixture of lust and contempt, wears a voluminous scarlet silk garment. Red imagery is constantly associated with the dead, adulterous first wife of Maxim DeWinter in du Maurier's novel *Rebecca* (1938)—the fireworks, her lipstick on the bunched handkerchief, her pink underwear, but chiefly in the blood-red rhododendrons of Manderley. ("They startled me with their crimson faces, massed one upon the other in incredible profusion, showing no leaf, no twig, nothing but the slaughterous red, luscious and fantastic, unlike any rhododendron plant I had seen before.") And it was the "Lady in Red," the

notorious Anna Sage, who betrayed gangster John Dillinger in front of the Biograph Theater in Chicago (*Manhattan Melodrama* was playing, featuring Clark Gable and Myrna Loy) after contacting a cop named Sam Crowley for the prearranged trap. She had long been the madam of a brothel in Dalesville, Indiana, for whom, incidentally, Peggy Alexander, Dillinger's mistress, once worked.

Who can forget the irrepressible Wife of Bath, lewd and gap-toothed and five times married, with her flashy red stockings? And rouge, now called "blush," in relation to its incremental application often has unsavory connotations. Red has always been a color bold and often brash in its overtures of desire. Gloria Swanson's Hollywood dressing room was always lined with red satin, according to contract. And, not surprisingly, it was always the favorite color of tempestuous diva Maria Callas, no shrinking violet, who adored, and obsessively collected, matching shoes and handbags of red. And in early America, before the Civil War, saloon owners in New York City hired barmaids, ages roughly between twelve and sixteen, and clad them in short dresses and red boots with bells that dangled from tassels, a uniform that was soon taken up by waterfront prostitutes.

On the other hand, Queen Elizabeth II, who loves the color, is very fond of bright red dresses and has worn them on many occasions. Scarlet is the

color of the royal livery, and it is said that this color—technically called "pink" in the hunting world—was adopted by huntsmen because fox hunting was declared a royal sport by Henry II. All royals, incidentally, have exclusive use of scarlet livery. And at all coronations, those peers whose family livery includes scarlet unfortunately have to change for the occasion, out of deference to the Queen, to a darker shade known in heraldry as "murrey," a late medieval word for mulberry. The Queen's favorite flowers, it is well known, are long-stemmed pink carnations, and the lipstick she wore on the day of her own coronation in 1952 was concocted especially for the occasion to go with her long crimson and purple robes: it is a gentle red with blue undertones and is known as the Balmoral lipstick.

The premise of the film *Lipstick* (1976) implies by more than the title that lipstick is the embodiment of lewdness as a feminine come-on (". . . whose frothy mouth bepainted all with red," Shakespeare, *The Merchant of Venice*). *"Todos me acosan sexualmente,"* Eva Perón once said with irritation during her early days as an actress. "Everybody makes a pass at me." As V. S. Naipaul points out in *The Return of Eva Peron,* "She was the macho's ideal victim—woman—don't those red lips still speak to the Argentine macho of her reputed skill in fellatio?" Beauty in a woman, according to a French fable, should have three things red: cheeks, nails, and

above all, lips. The favorite lipstick of "Married with Children" 's sexually insatiable TV wife, Peg Bundy, is "Do It to Me" red. But there are so many lipsticks, so many reds, so many variations: "Raven Red," "Fire and Ice," "Brava," "Extra Rose," "Glazed Berry," "Guava," "Watermelon," "Rhubarb Poppy," "Beverly Hills Burgundy," "Bachelor's Carnation," "Cherries in the Snow," "Wet & Wild," etcetera. It is a product sold, so bold are the colors, almost as if it were supposed to be eaten, as in many lengthy gourmandizing kiss sequences, especially on film, it virtually is. Paloma Picasso produced the famous vivid lipstick she sells in such bold red magazine advertisements, simply because it was the only color of lipstick she wanted and insisted she could not find or buy anywhere she went.

Some whimsical lines from a 1927 song, "Red Lips Kiss My Blues Away," go:

> *Any old time that you come cuddlin' near*
> *Isn't it strange the way the blues disappear?*

Red nail polish was long considered scandalous. There was a time in the 1910s when nails had to be short and polished only with a buffer, when even clear liquid polish was frowned on, while red, so new, glamorous, but also tarty and flash— advertising one's morals, or the lack thereof, like

smoking a cigarette—was used by women of easy virtue. Bright red nail varnish went out with the dodo and is now only associated with "common women," according to *Shaft,* a popular transvestite publication in England. Incidentally, August A. Busch, of the beer family, often served his guests suckling pigs with red-painted toenails. And in the thirties, Elsa Schiaparelli had fun in the fashion world with black gloves with scarlet fingernails, and even with red eyelashes.

As to early twentieth-century cosmetics, Mary Pickford had always used pink makeup onstage to deepen the color of her young, very pale skin, but it was quickly discovered that pink has red in it, which comes out black on film, and so, working on various "shorts" for director D. W. Griffith in the old Biograph days in 1910 or so around New York and New Jersey, the ingenious Billy Bitzer, Griffith's great cameraman, concocted creams and powders for her, using light tan instead of pink, and photographed "America's Sweetheart"—who, by the way, was born in Toronto—wearing them.

There is in nature and the natural world a riot of red: salvia, bougainvillea, red tulips, the crimson acres of Oriental poppies in China and northern Algeria, just to name a few, as well as the leaves and berries of the "burning bush" that come brightly aflame every autumn. "I am so stupidly happy, / My

wellingtons / Squelching and squelching through the beautiful red," wrote Sylvia Plath in her ambiguous, possibly morbid poem "Letter in November," a year before she committed suicide by sticking her head in a gas oven. Iron is in all probability a significant constituent of red plants, although the following are said to owe their stained blossoms to the blood which trickled from the sacrificial Cross: the red anemone, the arum, the purple orchis, the bright crimson-spotted leaves of the roodselken (a French legend), and the spotted persicaria, snakeweed. Fireweed splashes the roadsides rose red in Alaska. Crimson poison ivy is Nantucket's answer to autumn foliage—"And this red fire that here I see," noted Edna St. Vincent Millay, "is a worthless crop of crimson weeds"—and there are red tupelo groves sprouting everywhere on the island. In all the streets and gardens of verdant Puerto Rico flourish the lovely brilliant-red Amapola and the Flamboyan de Cayey. It is a color in flowers that sings to the heart and awakens joy. "After the chill virginity of Swiss Alps and snow," wrote Oscar Wilde to Richard Ross in 1899, "I long for the red flowers of life that stain the feet of summer in Italy." Wilde wasn't completely certain about geraniums, a lovely but common flowering plant. "If I do live again," he wrote to H. C. Marillier in 1885, "I would like it to be as a flower—no soul but perfectly beautiful. Perhaps for my sins I shall be made a red geranium." Antho-

cyanin, the pigment that gives red to apples and turns leaves red or reddish violet, is produced by sugars, by the way, that remain in the leaf after the supply of nutrients dwindles, and it varies in strength and color from year to year, depending on the amount of sunlight and temperature.

What splendid woods that are red can be found in our forests: cherry, cedar, mahogany, and rosewood. The large flowering tree of New Zealand called the pahutukawa is a brilliantly vivid Christmas red. Ginseng berries are bright red when they are ripe. And the strung ristras of the Southwest, especially New Mexico and Arizona, bright and waxy with shine, are pepper-hot red. Everything from the hectic leaves of fall to the red gum oozing out of eucalyptus trees to the red eyes of so many of nature's creatures, large and small, that stare at us from water, tree, and brush, hippos, bunnies, the bamboo viper of Formosa, and even the dot-small scarlet eyes of the tiny cicadas who burrow up from the earth like subterranean bumming-tops only once every seventeen years! There are also to be found mole rats, coral snakes, worms, various monkeys, ants, deer, chiggers, murderous pink-eyed ferrets, which I suppose are really ginger, and the strawberry roan in the animal kingdom to remind us of the infinite variety of reds. Are there red cats? No real *gatto scarlatto,* sadly, except in Dr. Seuss. (But why did P. G. Wodehouse call orange cats "lemon-

colored"?) In the tropics there are parrots that can show as bright a red as a scalding-hot capsicum. And as to autumn leaves, the greater the disparity in temperature, cold at night, hot during the day, the deeper the red.

What color is your mulch? Did you know that Southern peas perform better with a mulch that is red? When pea plants were grown using red mulch, according to the Coastal Plains Research Center in Florence, South Carolina, they yielded 3.0 tons per acre. That is compared to 2.8 tons per acre with white and 2.7 tons with conventional black mulch. Two color components of light influenced the plant growth: the percentage of blue in the light and the ratio of far-red to red. Red mulch had the highest far-red to red ratio but a lower blue component. In previous experiments, researchers found tomatoes had the highest yield when grown using red mulch.

And of course flying through our skies, often red at night ("sailor's delight") and in the surly morning ("sailors take warning"), are found flocks of birds with all sorts of pennated variations of pink and scarlet and red, like the rare flamingo, the ruby-crested hummingbird, the summer tanager (the male of which is the only all-red bird without a crest in the United States), the scarlet ibis, and the male cardinal, along with so many others patched and padded with red emblems. Speaking of skies and the color red, a streak of celestial scarlet supposedly portended the

death of Julius Caesar in March of 44 B.C. And according to legend the same occult phenomenon took place in the year 1170 when Thomas à Beckett was slain in Canterbury cathedral.

We have the Red Sea, a translation of the Hebrew word *edom*, meaning red, an evocative name surely given by the ancients for waters tinged by plankton blooms. Sea life probably thrives in reddish water. Then there is the phenomenon of red snow. It is mentioned by Aristotle, even observed a thousand years before him. Saussure found it in the Alps in 1760, and Captain Ross found it extending over a range of cliffs on the shores of Baffin Bay for a length of eight miles and a depth of twelve feet. It is caused by the presence of innumerable plants belonging to a very minute alga, *Protococcus nivalis,* which in its mature state consists of brilliant globules, like delicate garnets, seated on, but not immersed in, a gelatinous mass. It is not at all uncommon to find the phenomenon in arctic and alpine regions, where the sanguine color of the snow caused it to be regarded as a portent of evil.

In earlier times, the mysterious red rains that still are reported periodically in the world's press as "rains of blood" were once believed, especially in matriarchal Sumeria or, say, the Chaldees, to have been the very menstrual blood of the moon goddess. It has a mythological source. Twenty-eight was always a sacred number. The moon was worshipped as

a woman or goddess whose menstrual cycle is twenty-eight days, which is also the true period of the moon's revolution in terms of the sun. Now, didn't the moon receive its name from the fact that men measured time (*mensis*) by her? And isn't the modern medico-genetic symbol for the female, the small plus sign under a circle, actually an ancient pictograph of the Great Goddess—her equiarmed cross topped by the full moon?

In her odd and, not surprisingly, repulsive book *Blood, Bread, and Roses,* a celebration of menstruation, Judy Grahn indicates in a sort of sociological survey how, among other things, blood signals for menstruants are found everywhere—food and utensils, clothes, social behavior, worship, etcetera—and, as part of a general cultural *cosmetikos,* she finds (surprisingly?) that all are invariably red, from painting the body red to plastering it with red clay to staining the teeth red to dyeing the hair, hands, and feet with henna. "Among the Cheyennes," observes Grahn, "at her first menstruation a girl was painted red all over her body," and formerly in China "a woman customarily put a red mark in the middle of her forehead to signal that she was menstruating, and also as a cosmetic."

The red sun rising from the sea is a symbol of the life-force in India, just as it is in the Japanese creation myth, although in India it is associated with Shiva, a male god. In Shinto, however, which bears

traces of a matriarchal culture, it is the other way around: earth is ruled by a male, the spear-carrying Okuninushi. But the source of life is water, and the sun rising from it, the symbol of Japan, is female. The Japanese male gets something of his own back in the existence of the old myth where the phallic god called Sarotahiko is blessed with a long red nose. The island of Madagascar, poetically called "the Red Island," now wears that name with terrible irony, for so many trees have been wantonly cut down during the last decade or so that its entire red topsoil is floating away—it has one of the highest birthrates in the world—and disaster is imminent. What can be grown there when only "red death" is sown?

How scarred the sacred earth! How much poorer modern man! The plowman of Scripture would not begin work until he said his prayer: "Lord, my task is the red, the green is Thine: we plow, but it is Thou that dost give the crop." Red, for the good plowed land of Palestine, is of a warm deep purplish red. Soils erode. And what of faith?

A stupendous phenomenon is the town of Albi in France, on the flanks of the Pyrenees. Driving toward Albi, you can see the corrugated red cliff of its cathedral, Sainte Cecile, a brick fortress dominated by a ruddy tower, its walls like rows of gigantic rockets. The wondrous brick is of a glowing pink-red color made from alluvial clay which the River Tarn created. This river, flowing early in its long

course over Permian (red) sandstone, makes ruddy everything it touches. It is as red as the reddle of Wessex. The whole town of Albi, in fact, is built of this beautiful warm-hued brick, and the ensemble, with the river's waters reddest of all, altogether informs a picture whose pigments are indelible. Survey the town from the top of the tower and you will never forget its rufous hue.

For red vegetables we have radishes, beets, red peppers, tomatoes ("Red-faced tomatoes," wrote Louis Untermeyer, "ample as a countryman's full-bosomed lass"), and Bliss potatoes. Red potatoes may sound silly but one kind called Cherries Jubilee has the shape of big cherry tomatoes, its flesh vermilion streaked with white. For red cherries, we have large dark *anclos,* medium-red smoked *chipotle,* and pea-sized *pequines.* There are red, angry-looking funghi. (Whenever I see any, I always wonder, is that the kind described by Suetonius that poisoned the emperor Claudius?) And for red seaweeds, nori (or laver) and dulse. And what an abundance of red ripe fruits we have: apples—the incomparable apples of Alma Ata are the most magnificent on earth—pomegranates, raspberries, crab apples, cranberries (". . . but," notes Elizabeth Bishop, "crabapples / ripen to rubies, / cranberries / to drops of blood . . ."), and cherries. ("What sap went through that little thread to make the cherry red," asks Mar-

ianne Moore in her poem "Nevertheless.") Cranber-
ries, soaked in sweetened cranberry juice and then
drained and dried, look like red or baby raisins and
are delicious eaten by the handful or used in baked
goods. And of course strawberries, which have a
sharp, luscious red all their own, recall Helen Hunt
Jackson's apostrophe: "O marvel, fruit of fruits, I
pause / To reckon thee, I ask what cause / Set free
so much of red from heats / At core of earth, and
mixed such sweets / With sour and spice . . ." And
what rich red foods. Red kidney beans. An hors
d'oeuvre called carpaccio, so red and so rare it seems
almost cannibal food. We indulge, like Dracula, in
blood in the form of blood sausage, and I am told
that at the dinner of a Chinese mandarin one may be
served blood-cakes. Roman Marcus Tullius Cicero,
although he was passionately fond of oysters and
zesty lampreys, insisted as his first preference over all
other foods dishes of beets. And remember in
Salammbô, Flaubert's novel of ancient days, those
Carthaginian soldiers celebrating the battle of Eryx?
They can be found sitting around in groups eating
"red-haired plumb little dogs fattened on olive-lees,
a Carthaginian dainty which was detested by all
other nationalities."

A grim but legitimate aside. What is the most
nutritious food of any kind on earth, richer in vita-
mins than meat though easier to prepare, available

all over the world, and yet few people use it, you cannot order it in a restaurant or purchase it in a health food store?

The answer is simple. Blood.

There is an especially alluring dish in Natal of a small red fish called a *rouget*. Red snapper almost glows. And sockeye salmon has the reddest flesh of any fish. The meat of all tuna is red when raw, though it turns white when cooked. Mallard duck is an especially rich red meat. So is whale, steer, and eland. Virtually a good half of Asian food is red. (Chinese "red cooking" is a term generally applied to cooking with dark soy sauce.) Szechuan banquets almost always include a platter of large prawns in a sweet red sauce *ganshao mingxia*. Red-cooked or *hongshu* dishes. Almost anything grows in the rich red soil of Szechuan province in the west of China, especially around the central plain around Chengtu, which can produce three crops a year. "The East Is Red," or so the slogan went during the Cultural Revolution. Korean red ginseng, incidentally, actually a mild pink, is considered the world's best. And *mioga*—or "blushing"—ginger (*hajikami*), a cousin of common ginger, is valued in Japan where the spring shoots are pickled and dyed red. Rouille, by the way, a flavor-enhancing sauce or garnish for soups and popular in Provence—it is a combination of bread crumbs, garlic, cayenne pepper, olive oil, and a touch of saffron—is a rust-colored paste.

There is a wonderfully gaudy red to McIlhenny's Tabasco Pepper Sauce—the specific dwarf pepper for which, *Capsicum frutescans,* much hotter than cayenne or jalapeño, must be harvested by hand at the very peak of redness only after matching in color the *baton rouge,* or "stick of furious red," used by the company to eye-test it.

We drink tomato juice, cranberry cocktail, red-currant juice, Dubonnet, and Campari with soda, Oscar Wilde's favorite drink. You can see jars of red and magenta pickle water on outdoor stands in Cairo, Egypt. Ben Katchor, creator of "Julius Knipl, Real-Estate Photographer," in his brilliant underground cartoon, "The Drink of Life," commenting on bugjuice, that cold solid-colored drink always seen spurting in contained plastic fountains in food emporia, points out that in terms of general popularity it is "red, green, and orange—that's the order." And one of my favorite Kniplisms is "Everything looks so appetizing through pink cellophane." Red is a favorite cartoon color for cookies, cakes, and candy. Ribbon candy, invariably red, is so tenacious it sticks to dishes and breaks them when you try to take it out, and you end up throwing away the dish. There is also diner slang, shouted colorfully from counterman to cook: ketchup is "red lead," tomato soup "red noise," and corned beef "red horse." Opium is often referred to in slang, because of its deep rich color, as "Wyoming ketchup." And

Cheshire cheeses which are bright orange-yellow are commonly denominated "red."

Red Turkey hard winter wheat—originally from Turkey, it has a strange red color—was first brought to Kansas around 1874 by the Mennonites, who had grown wheat in Russia, where they had fled to avoid persecution in their native Germany, and each carried a bushel or so of this seed grain in coming to the American plains. Kansas eventually became the nation's leading producer of wheat, accounting for about one-fifth of all the wheat grown in this country.

Ever hear of a red beer? There is one, called Rodenbach, brewed in West Flanders by Roeselare, which, according to expert Michael Jackson in *The World Guide to Beer,* qualifies better for the epithet "red" than any of the copper-colored English brews. "A regular top-fermented brew is blended with a beer which has been aged for at least 18 months in oak," Jackson notes. "Barley, maize grits, semi-dark Vienna malts and caramel go into the brew, the latter two ingredients creating the color." Incidentally, a red alga called *Chrondus crispus,* or Irish moss (carragheen), is often used in beer brewing to clarify the mash, or wort. For sparkling wines, Chambertin of Burgundy has been called the Red King of the Drys. And note: For redness—and taste—Germans rarely drink a glass of Berliner Weisse without a *schuss,* a dash of raspberry syrup that gives it a red tint. It is served in a chalice-like glass bowl and

imbibed with a straw. But, oh, in wines, the splen-
diferous varieties of reds, the Etnas and Graves and
Infernos; the Lambruscos, Tarragonas, and Zin-
fandels; the Nebbiolos, Valpolicellas, and Mon-
tepulcianos. And red was probably the color of the
famous Falernian wine so often mentioned in
Horace, affirmed by certain wine-fanciers to be to-
day's Lacryma Christi, the principal wine of Naples,
direct from the base of Vesuvius. ("O Christ," once
exclaimed a Dutchman who drank, "why didst
Thou not weep in my country?")

The only wine which Homer cites with great
approval was red, a honey-sweet wine produced on
the coast of Thrace—scene of several of the most
remarkable exploits of Bacchus himself—which the
minister of Apollo, Maron, gave to Odysseus. It was
so strong a wine that it was diluted one part to
twenty parts water (to drink wine undiluted in an-
cient Greece was considered, worse than disreputa-
ble, barbaric) and so fragrant that, even when
diluted, it filled the house with perfume (cf. *Odyssey*
IX, 212).

Virtually every popular American food pro-
duct—go to a supermarket sometime and check—if
its label is not completely red, sports the color red at
least somewhere on the package or in its design, from
Cheez-Its to My-T-Fine Pudding to Hawaiian Punch
to Quaker Oats to Hunt's Tomato Sauce to Hills
Bros. Coffee to Kellogg's Froot Loops. Surely there

awaits a graduate student dissertation on the relationship between color and eating. In *Linda Goodman's Star Signs,* the author, who, by the way, believes calories are an "illusion," assures us that if "plumpies" will only bother to eat red foods, along with taking required red cola baths and drinking two glasses of red solarized (room temperature) water per day, they will shed pounds. If you are underweight, you're supposed to do it all with *blue*: blue baths, blue food, etcetera. "Blue yourself," says Linda. She calls all of this the "Forgotten Rainbow Miracle."

A red meal would be fun to serve. Why not start off with the Hungarian drink *egri bikavér,* "bull's blood"? And then trays of appetizers filled with lobster meat with cocktail sauce, jambon d'Ardennes, and hot *chebeh rubyan,* Middle Eastern prawn balls. A cold cherry soup can then follow. For sauce-painting the dishes in elegant whorls or patterns, a good formula for red chile paint is quite simple: one tablespoon of vegetable oil, two garlic cloves, half a cup of red chile powder, three-quarters of a cup of water. Put in plastic bottle and make your designs. (A red roux in Louisiana is as dark as bittersweet chocolate by the time it has cooked.) Suitably colorful red main courses might be the scarlet Indian dish Chicken Vindaloo; or *Manzo al Pomodoro,* beef in tomato sauce, with baked stuffed tomatoes; or Szechuan-style shrimp with flaming-red barbecued spareribs and red peppers—deep red

locoto peppers with their glistening black seeds are beautiful objects to behold—or Cantonese sweet-and-sour pork made with real maraschino cherries. Dessert might be strawberry pie with raspberries or Lebanese nut pastries, accompanied with a famously superb rich red dessert wine from Ticino called Nostrano.

By the way, I have eaten red ice cream made by an Inuk up in the faraway reaches of Deadhorse and Pt. Barrow, Alaska—it's called *agutuk*—which is enhanced with seal oil, vegetable oil, and salmon berries, cranberries, or certain scarlet berries up there called *buegwakuk*.

But whether as a color it is eaten or worn, shunned or feared, seen as a temptation or revered and held as holy, red is a color that is rarely denied an active role, even if one insists upon its gentler connotations. It is never diluted by reflection. It refuses to be pacified. It commands. Demands, even. It seems almost exclusively and energetically masculine, bold, and objective, until one considers the deep and abiding feminine implications in virtually every measure and morph of the color. It is the color of excitement, hypertension, and cardiovascular changes, of nervous and glandular activity, of vital force, of the Pentecostal flame, of sex. It is traditionally the color of the upper ether closest to God, from which Satan was expelled, and the color of Mr. Scratch himself. It is not only the color of Esau and his pottage

(Genesis 25:30) but of the wrath and force he embodied. With its tigerish directness, almost cosmic—even at times comic—irrepressibility, it is also associated with the sun, flame, an expression of that wild Blakean energy which is as potentially destructive as it is creative, a shouting color at war with mere tints. There is something in it of animal power, the hortatory, raw insistent imagination. Blandness or temperance may even serve to provoke it, to taunt it. As Wallace Stevens observes in his masterpiece, *Notes Toward a Supreme Fiction,*

> *The lion roars at the enraging desert,*
> *Reddens the sands with his red-colored noise,*
> *Defies red emptiness to revolve his match . . .*

What behind its mystery will ever be solved in the many fulgurations of the color that maddeningly evade our knowing them as often as they come to us? It is a color with a strange gigantic life, an enigma encompassing everything from sunsets to the roseate tint of our insides. Red confounds us surely in its many meanings, for it is magic itself.

About the Author

Alexander Theroux, who lives in West Barnstable, Massachusetts, has taught at Harvard, MIT, Yale, and the University of Virginia, where he took his doctorate in 1968. He is the author of three highly regarded novels: *Three Wogs* (1972), *Darconville's Cat* (1981), and *An Adultery* (1987), as well as a collection of poems, *The Lollipop Trollops* (1992), and several books of fables.

ABOUT THE TYPE

The display type was set in the
Adobe PostScript Version of Snell Roundhand.
The text of this book was set in the Mergenthaler
PostScript Version of Garamond #3, by
Pagesetters, Inc., Brattleboro, Vermont.

Printed and bound by Berryville Graphics,
Berryville, Virginia.

DESIGNED BY PAULA R. SZAFRANSKI